SOFA CHICAGO 2010
Sculpture Objects &
Functional Art Fair
November 5-7, 2010
Navy Pier

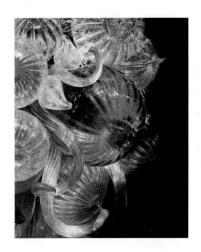

FRONT COVER: Dale Chihuly
Turquoise and Crystal Chandelier, 2010
piece number: 10.337.ch1
blown glass
100 x 99 x 90
photo: Scott Mitchell Leen
represented at SOFA CHICAGO by Litvak Gallery

All dimensions in the catalog are in inches (h x w x d)
unless otherwise noted

Library of Congress – in Publication Data

SOFA CHICAGO 2010
Sculpture Objects & Functional Art Fair

ISBN 978-0-9789206-7-8
2009913079

Published in 2010 by The Art Fair Company, Inc., Chicago, Illinois
Graphic Design by Design-360° Incorporated, Chicago, Illinois
Printed by Unique Active, Chicago, Illinois

SOFA CHICAGO

SCULPTURE OBJECTS & FUNCTIONAL ART

The Art Fair Company, Inc.
Producer of SOFA CHICAGO 2010
372 West Ontario St., Suite 303
Chicago, IL 60654
T: 312.587.7632
F: 773.345.0774
www.sofaexpo.com

Michael Franks
Chief Executive Officer
The Art Fair Company, Inc.

Mark Lyman
President
The Art Fair Company, Inc.
Founder/Director, SOFA Fairs

Anne Meszko
Julie Oimoen
Kate Jordan
Greg Worthington
Barbara Smythe-Jones
Patrick Seda
Michael Macigewski
Bridget Trost
Aaron Anderson
Stephanie Hatzivassiliou
Ginger Piotter
Heidi Hribernik
Erinn M. Cox
Donald Bromagin
Joe Ponegalek
Donna Davies

Conte

SOFA CHICAGO
SCULPTURE OBJECTS & FUNCTIONAL ART

Welcome to SOFA CHICAGO and The Intuit Show 2010!

Welcome to the 17th SOFA CHICAGO and its new sister fair, The Intuit Show of Folk and Outsider Art! We are delighted to partner with Intuit, Chicago's respected Center for Intuitive and Outsider Art to produce The Intuit Show alongside SOFA CHICAGO, and to welcome leading dealers and galleries of self-taught art, outsider art, art brut, ethnographic art, non-traditional folk art and visionary art. The Art Fair Company has always focused on bridging different segments of the art market, and The Intuit Show will complement and broaden the range of artwork on offer.

These two art fairs promise to be high energy gatherings of diverse dealers who have packed up their art and taken a week out of their lives to travel (in some cases, from the other side of the world) to Chicago, because they believe this city has, and attracts, the right mix of people who are smart, sophisticated, art savvy and INTERESTED. SOFA opens its doors to people who will respond to the diversity, creativity and value of the art exhibited, as well as connect with the unique lives and spirits of its creators—whether an 'Insider' or an 'Outsider' artist, a master or a maverick, all artists represented are visionaries in their own right.

We are once again honored to have Chubb Personal Insurance as our sponsor. Now in our sixth year of partnership, Chubb and SOFA have found the right mix of galleries, collectors and exciting programs that bring art closer to a larger audience. Special thanks to Stacey Silipo and Rob McGinley for their support and hard work.

As we approach 2011, it's full steam ahead for The Art Fair Company (TAFC). We will further expand our activities by producing and promoting the prestigious Art and Antique Dealers League of America's Spring Show in May in New York City at the Park Avenue Armory. Our eyes are also directed towards Miami in 2011 and the United Kingdom in 2012.

TAFC's flagship fairs will remain the three SOFAs in Chicago, New York (April 2011) and our latest edition, SOFA WEST: Santa Fe, going into its third remarkably successful show in August 2011. These fairs continue to be strong, focused on the medium-based art and design market, as well as committed to educational and special programming for the casually interested and connoisseurs alike.

We encourage visitors to all our art fairs to view their preferences for one artwork or another as a highly personal and creative act. By bringing their pick of the art on offer into their homes and work-spaces, they become part of the creative process, creating their own unique artistic statements and individualized environments.

SOFA CHICAGO and The Intuit Show will transport you to new places, your mind will sort through much, indeed Outsider and Folk Art may open up a whole new collecting area for many. Some work will inspire you, some will not. But I promise that the creative juice of the art will pulse through the aisles. And you, the visitor, are an important part of this mix. Your imagination, your thoughtful decisions of where and on what to spend your time considering, energizes the art fair experience. You may only look at the works on offer or talk to the artists and dealers. You may even make a quiet decision to acquire. But whatever point you reach, these two worlds of art will enrich your own.

Enjoy!

Mark Lyman
Founder/Director of SOFA
President, The Art Fair Company, Inc.

Anne Meszko
Director of Advertising
and Programming

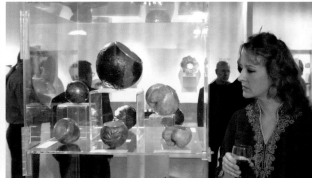

photos: David Barnes

The producers of SOFA CHICAGO would like to thank the following individuals and organizations:

Participating galleries, artists, speakers and organizations
AF Services
Paul Allingham
American Airlines
Archie Bray Foundation
Art Alliance for Contemporary Glass
The Art Institute of Chicago
Art Jewelry Forum
The Arts Club
Association of Israel's Decorative Arts
David Bagnall
The Bailey Family
Linsey Bailys
James Baker
Bannerville USA
Sue Barry
Judy Bendoff
Melinda Bennett
Ginny Berg
Barbara Bluhm-Kaul and Don Kaul
Jim Bradaric
Lou Bradaric
Dagmar Brendstrup
John Brumgart
Timothy Burgard
Bryan Cave LLP
Kay and Matthew Bucksbaum
Winn Burke
Anthony Camarillo
Carol Fox & Associates
Center for Craft, Creativity and Design
Eileen Chambers

Chicago Art Dealers Association
Chicago History Museum
Vice Consul Gunnar Christiansen
Chubb Personal Insurance
Pam Clark
Erin and Matt Cline
Collectors of Wood Art
Camille Cook
Corning Museum of Glass
Keith Couser
John Cowden
Susan Cummins
David Daskal
Peter Debreceny and Jane Humzy
Design-360º
Dobias Safe Rental
Hugh Donlan
Anne and Lenny Dowhie
Bryan Dowling
Bridget Eastman
Catherine Edelman
Marianne Encarnado
Gerry and Sandie Eskin
Glenn Espig
D. Scott Evans
Jane Evans
Carol Fox
Marjorie and Harvey Freed
Friends of Contemporary Ceramics
Friends of Fiber Art International
The Franks Family
Don Friedlich
Carlo Garcia

German Consulate General Chicago
Steve Gibbs
Tim Gillengerten
Andrew Glasgow
Tim Gonchoroff
Judith Gorman
Fern Grauer
Deb and John Gross
Lauren Hartman
Constantine Hatzivassiliou
Bob Hayes
Scott Hodes
Heather Holbus
Michael Hribernik
Consul General Onno Hückmann
Joseph Hunt
Nadania Idriss
Intuit: The Center for Intuitive and Outsider Art
J&J Exhibitors Service
Scott Jacobson
James Renwick Alliance
Howard Jones
Matthew Kangas
Jack Lenor Larsen
Steven Young Lee
Cris Levy
Isaac Levy
Lillstreet Art Center
Linda Lofstrom
Timothy Long
Suzanne Lovell
Ellie Lyman
Nate Lyman
Dian Magie

Sue Magnuson
Jeanne Malkin
Elias Martin
George Mazzarri
Rob McGinley
Bradley Merrick
Bruce Metcalf
Metropolitan Pier & Exposition Authority
Matt Miller
Mint Museum of Craft + Design
Bill Murphy
Mary Murphy
Nancy Murphy
Susan Murphy
Museum of Contemporary Art
Ann Nathan
National Decorating
Navy Pier Exhibitor & Technical Service
Hilde Neumayer
NFA Space Contemporary Art+Exhibit Services, Inc.
Emily Nixon
John Olson
Sherry Pardee
Penland School of Crafts
Bruce Pepich
Karl Piotter
Pilchuck Glass School
Valerie Pistole
Jennifer Poskin
Melissa G. Post
Racine Art Museum
Richard H. Driehaus Museum
Christoph Ritterson

Bruce Robbins
Robert Roth
Ginny Ruffner
Elisabeth and Norman Sandler
Ellen and Richard Sandor
Judy Saslow
Andy Schlauch
Miroslava Sedova
Stacey Silipo
Franklin Silverstone
Dana Singer
Jan Mirenda Smith
D. Snyder
Society of North American Goldsmiths
William Spicer
Cindi Strauss
Dorit Strauss
Surface Design Association
Tattooed Tees
Cappy Thompson
Matko Tomicic
Three Wine Company
Christa C. Mayer Thurman
Howard Tullman
Union League Club of Chicago
UniqueActive
Natalie van Straaten
Commissioner Bobby Ware
James White
Marilyn White
Elizabeth Whiting
Cleo Wilson
Don Zanone
Karen Ziemba

OFFICE OF THE MAYOR

CITY OF CHICAGO

RICHARD M. DALEY
MAYOR

November 5, 2010

Greetings

As Mayor and on behalf of the City of Chicago, it is my pleasure to welcome everyone attending the
17th Annual Sculptural Objects and Functional Art Fair: SOFA CHICAGO 2010 and The Intuit Show of Folk
and Outsider Art at Navy Pier.

This exciting partnership between The Art Fair Company and Chicago's own Intuit: The Center for Intuitive and
Outsider Art brings together the best in contemporary decorative arts and design and the leading galleries and
dealers presenting self-taught art, outsider art, art brut, ethnographic art, non-traditional folk art and visionary art.

Chicago has a long and vibrant artistic tradition and we are proud to host SOFA CHICAGO 2010 and The Intuit
Show of Folk and Outsider Art at our historic Navy Pier.

May you all have an enjoyable and memorable fair.

Sincerely,

Mayor

CHICAGO ART DEALERS ASSOCIATION

730 North Franklin
Suite 308
Chicago, Illinois
60610

Phone
31.649.0065

Fax
312.649.0255

November 4, 2010

On behalf of the Chicago Art Dealers Association, I would like to welcome SOFA CHICAGO 2010 back to our extraordinary city. Now in its 17th year, SOFA CHICAGO brings together dealers from many disciplines showcasing fine and decorative arts.

We are delighted that The Art Fair Company has partnered with Intuit, Chicago's respected Center for Intuitive and Outsider Art to produce The Intuit Show of Folk and Outsider Art alongside SOFA. The Intuit Show will complement and add to the scope of offerings by bringing together leading dealers presenting self-taught, outsider art, and folk art. Visitors will be able to take in another important segment of the art market, which the City of Chicago was seminal in fostering.

The Chicago Art Dealers Association applauds The Art Fair Company and participating galleries and artists in both SOFA CHICAGO and The Intuit Show. Congratulations on your cooperation and best wishes for a successful weekend of art.

Sincerely,

Catherine Edelman, President
Chicago Art Dealers Association

Le

Lectures Series

ctures

Lecture Series

sponsored by SOFA CHICAGO 2010

Admission to the 17th Annual **SOFA CHICAGO** Lecture Series is included with purchase of **SOFA** ticket.

Friday, November 5

9 - 10 am Room 324

SNAG Emerging Artists 2010
Three exceptional emerging artists, **Adam Grinovich**, **Andrea Janosik** and **Eun Yeong Jeong** talk about the development of their jewelry, which draws on a diverse and innovative palette of materials. *Presented by the Society of North American Goldsmiths*

9:30 - 10:30 am Room 327

Reflections on the Past 30 Years: A Conversation with Lino Tagliapietra
Glass maestro **Lino Tagliapietra** reflects on his work and teaching in the United States over the past 30 years. **Jim Schantz**, owner/director of Schantz Galleries, will join Tagliapietra in this illustrated talk.

10 -11 am Room 324

Peering over the Palace Wall: The Neo-Palatial Aesthetic in Contemporary Art
Expanding on his curated *Exhibition in Print* in *Metalsmith* magazine, celebrated author **Garth Clark** explores contemporary twists on palatial grandeur and opulence. The lecture will touch on a broad range of artists, including Cindy Sherman, Jeff Koons, Josiah McElheny, Timothy Horn, Kim Cridler, and Anya Kivarkis. *Presented by the Society of North American Goldsmiths*

10:30 am - 12 pm Room 327

Fiber Art: Unraveling Some Threads
Illustrated, individual presentations by fiber artists **Margaret Cusack**, **Cindy Hickock**, **Kiyomi Iwata**, and **Donna Rosenthal**. **Camille Cook**, president of Friends of Fiber Art International, will announce the recipients of the organization's 2010 grants. *Presented by Friends of Fiber Art International*

11 am - 12:30 pm Room 324

Masters and Apprentices: The European Tradition and Contemporary Jewelry in an American Context
A presentation and panel discussion on the European tradition of goldsmithing; how it contrasts to the American university system, and the relevance of apprenticeship in contemporary jewelry-making. With artists **Ayesha Mayadas**, India; **Peter Schmid**, Germany; **Juha Koskela**, Finland; **Britt Anderson**, USA; **Liz Tyler**, UK; **Christian Streit**, Germany and **Patricia Kiley Faber**, gallery director/owner, Aaron Faber Gallery, NY. Moderated by art historian **Sue Barry**

12 - 1 pm Room 327

Thinking Through Making: Giving Physical Form To Meaning
Artist **Clifford Rainey** articulates the methodology and inspiration for his glass art. The talk includes an historical overview of his art punctuated with images of individual works and the original sources that sparked his initial idea.

12 - 1 pm Room 326

BAM Biennial 2010: Clay Throwdown!
The BAM Biennial, a juried exhibition at the Bellevue Arts Museum (BAM), Bellevue, WA brings attention and exposure to the work of contemporary artists in the Pacific Northwest. The Museum designates a concentration for each exhibition whether it is a specific medium, technique, process, or theme; the focus of this year's exhibition is clay. **Stefano Catalani**, director of curatorial affairs/artistic director at Bellevue Arts Museum, looks at the work of the 34 artists selected for the inaugural exhibition.

1 - 2 pm Room 324

Chubb Personal Insurance Lecture – TBA

2 - 3 pm Room 327

"And Viewers Like You"
Art Jewelry Forum board members **Susan Cummins**, former gallery owner and now director on the Rotasa Foundation Board and Chair of AJF and **Susan Kempin**, Secretary of AJF and a collector of contemporary jewelry discuss the role of active viewing and the development of Art Jewelry Forum as an organization that promotes dialogue regarding viewing, collecting, wearing, owning, and displaying contemporary jewelry. Directly following this talk Agnes Larsson, this year's Art Jewelry Forum Emerging Artist Award winner from Stockholm, Sweden will discuss her work.

Preceding the lecture, SOFA will present the 2010 New Voices: A Grant for Discourse on International Contemporary Decorative Arts award check to Art Jewelry Forum.

2 - 3 pm Room 324

Advocates for the Arts: Polish and Czech Fiber Artists from the Anne and Jacques Baruch Collection
A collector, a curator, and a former assistant gallery director discuss the lives and legacy of Anne and Jacques Baruch, the legendary dealers who introduced Eastern European textile artists, including Magdalena Abakanowicz, to Chicago audiences in the 1970s. The talk is presented in conjunction with the special exhibit at SOFA CHICAGO by the same name. Fiber art collector **Fern Grauer** was a close friend of the Baruchs for 30 years. She is currently president of the Textile Society of the Art Institute of Chicago and a board member of Friends of Fiber Art International. **Christa C. Mayer Thurman**, Emerita, the Art Institute of Chicago, chair and curator of the Department of Textiles (1967 – 2009), founded the Textile Society of the Art Institute of Chicago and initiated the 20th Century textile collection at the Art Institute. She was acquainted with the Baruchs for many years; several textiles that the couple brought from behind the Iron Curtain entered the Art Institute's collection. **Barbara Kalwajtys** is curator of the Baruch Foundation. Formerly assistant director of the Anne and Jacques Baruch Collection, she worked with Anne Baruch for nearly two decades. **Rhonda Brown**, co-curator of browngrotta arts, Wilton, CT, has promoted international contemporary textiles through exhibitions and publications for more than 20 years.

3 - 4 pm Room 326

Deeper than Skin: Battuto Cutting and a Journey in Boats
Artist **Philip Baldwin** talks about his and Monica Guggisberg's new boat sculptures and battuto, a surface finishing technique that opened doors to a world of color and texture. While the boats represent life's journey, filled with companions, possessions and artifacts, the battuto cuts reflect the impressions they make on our lives.

3 - 4 pm Room 324

Is Ornament a Crime? Rethinking the Role of Decoration in Contemporary Wood
In recent decades, surface decoration has played an increasing role in wood art as artists have moved away from the simple, unadorned forms of the past. This panel will debate the role of ornament in contemporary wood as well as the effect of this aesthetic change on the field. Artists **David Ellsworth**, **Christian Burchard** and **Binh Pho**, moderated by **Cindi Strauss**, Curator, Modern and Contemporary Decorative Arts and Design, The Museum of Fine Arts, Houston. *Presented by Collectors of Wood Art*

Saturday, November 6

3:30 - 4:30 pm Room 327

Makers: The First History of Studio Craft in America

An insider's look at the first comprehensive survey of studio craft in the United States, presented by co-authors **Janet Koplos**, freelance critic and **Bruce Metcalf**, studio jeweler and independent scholar; with **Katie Lee**, assistant director, The Center for Craft, Creativity & Design, UNC Asheville. The discussion will be followed by a book signing.

4 - 5 pm Room 326

Pearls of Wisdom

Isaac Levy, designer and owner of Yvel Jewelry Gallery in Jerusalem, will talk about the soon-to-open Andrea Bronfman School of Jewelry and Art at the Yvel Design Center in Jerusalem. The school is devoted to teaching Ethiopian immigrants the art of making fine jewelry. Levy is also a board member of the Association of Israel's Decorative Arts. Introduction by collector **Doug Anderson**

4 - 5:30 pm Room 324

The Rebirth of Craft

An illustrated look at the emerging global nexus of craft, design, and fine art, the evolution of new directions and materials and the effect on the new generation of artists and collectors. **Lewis Wexler**, owner, Wexler Gallery, Philadelphia, PA, former assistant vice president of 20th Century Decorative Arts, Christie's, NY; **Emily Zilber**, Ronald C. and Anita L. Wornick curator of Contemporary Decorative Arts, Museum of Fine Arts, Boston; **Suzanne Lovell**, architect, interior designer and co-founder, Twill Textiles; **Brook Mason**, journalist, *The Art Newspaper* and artnet.com; **David McFadden**, chief curator and vice president of the Museum of Arts and Design, NY; **Timothy Schreiber**, artist, Wexler Gallery

4:30 - 6 pm Room 327

Crafts Writing in a Studio-Based Community

A panel discussion of the recently created Andrew Glasgow Writers Residency Program at Penland School of Crafts, North Carolina. The program provides writers with the opportunity to observe, experience, and write without interruption, using Penland's active crafts community as a catalyst for new ideas. **Andrew Glasgow**, former director, American Crafts Council, NY; **Lydia Matthews**, writer and Academic Dean, Parsons The New School for Design, NY; **Dana Moore**, program director, Penland School of Crafts; **Rob Pulleyn**, artist and founder of *Fiberarts Magazine* and Lark Books; **Ingrid Schaffner**, curator, Institute of Contemporary Art, Philadelphia. Introduced and moderated by **Jean McLaughlin**, director, Penland School of Crafts

9:30 - 10:30 am Room 326

A Wider World: Handmade and Fair Trade

Artist **Peggy Eng** talks about her sculptural jewelry, which she carves out of aluminum and anodizes. In addition to her own work Eng, a long-time advocate of fair trade, will recall her recent involvement with jewelry artisans in Peru on design development for a Western market. *Presented by the Society of North American Goldsmiths*

10 - 11:30 am Room 324

Artist and Collector: The Odd Couple

Master wood artists and major collectors explore the strong and close relationship between artists and collectors and their influence on each other. With master wood artists **William Hunter**, **Jacques Vesery**, and **Stoney Lamar**; major collectors **Ruth Waterbury** and **Arthur Mason**; and **Harvey Fein**, master wood artist and collector. Moderated by **Jeffrey Bernstein**, president, Collectors of Wood Art. *Presented by Collectors of Wood Art*

11 am - 12 pm Room 327

A Chosen Path: The Ceramic Art of Karen Karnes

Renowned ceramic artist Karen Karnes has created some of the most iconic pottery of the late 20th and early 21st centuries. **Peter Held** will provide insights into her work and the communities in which she worked, including Black Mountain College, NC and Gate Hill, NY. Held is curator of ceramics at the Ceramics Research Center, Arizona State University Art Museum and curated Karnes's retrospective exhibition at the Museum.

12:30 - 1:30 pm Room 327

Tammy Garcia: Form Without Boundaries

Artist **Tammy Garcia** discusses her career, from her beginnings as a Pueblo potter pushing the boundaries of tradition, to the limitless possibilities of her geometrical and often architectural, sculptural forms. Garcia will discuss the ways she has bridged the aesthetic divide between different media, and how working simultaneously in them affects her overall sense of design.

1 - 2 pm Room 324

Shinya Yamamura: Creating Infinity Through Design and Technique

Shinya Yamamura will briefly explain the history of Urushi lacquer in Japan and Asia as well as the techniques, materials, and methods used to create his decorative works of art. Introduction by freelance critic **Janet Koplos**

2 - 3 pm Room 327

From the Center to the Edge: Celebrating 60 years of Creativity and Innovation at the Archie Bray Foundation

Steven Young Lee, director of the Archie Bray Foundation for the Ceramic Arts in Helena, MT, traces the threads of innovation throughout the history of the Archie Bray Foundation and shares plans for the Bray's 60th anniversary in June, 2011.

4 - 5 pm Room 326

The Glass Conundrum: Craft, Art, Design

David McFadden, chief curator and vice president of the Museum of Arts and Design (MAD), NY, looks at the eroding boundaries of three fields—craft, art, and design—as revealed in the past half century of glass, focusing mostly on American developments. MAD is the recipient of Art Alliance for Contemporary Glass's annual award for an institution furthering the studio glass movement.

Essays

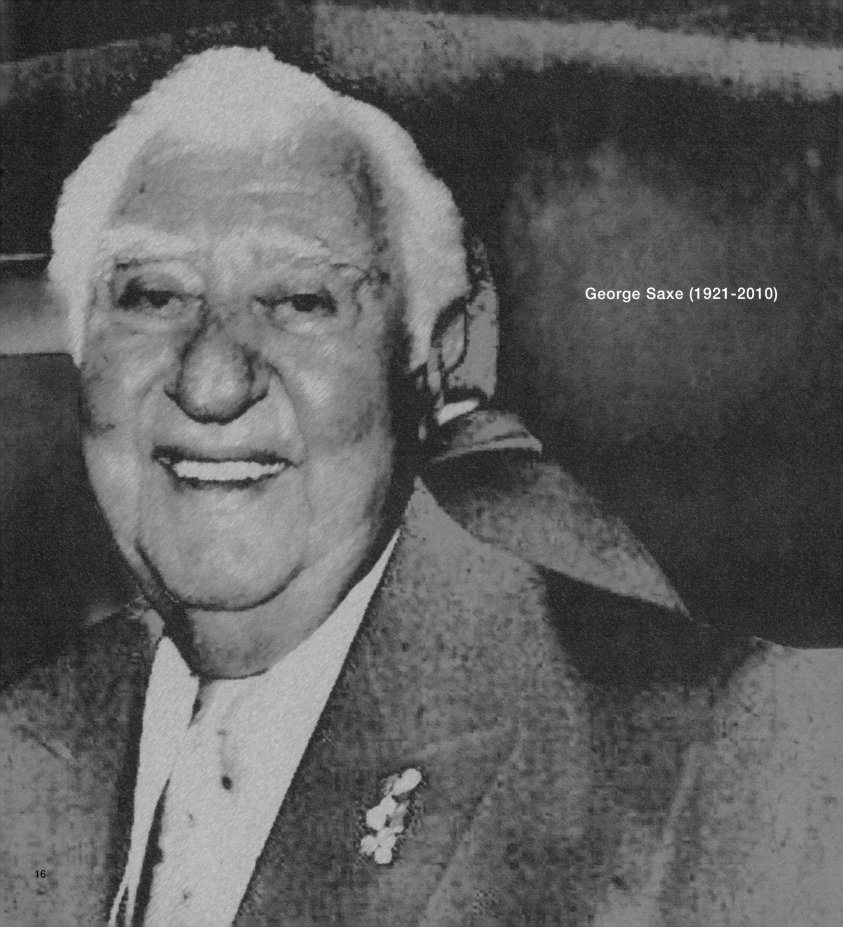

George Saxe (1921-2010)

"George and Dorothy Saxe have been wonderful and enthusiastic supporters of the arts for many years. I am fortunate that I was able to call George a friend – he will be missed by us all." Dale Chihuly

SOFA joins Dorothy Saxe in mourning the recent loss of her husband George, one of the pioneering collectors of contemporary studio craft. George and Dorothy commenced their collecting journey together in 1981, when they viewed the landmark Corning Museum of Glass exhibition, *New Glass: A Worldwide Survey,* in San Francisco. This exhibition proved to be the catalyst for their collection, and they began acquiring studio glass intensively at that time. Recognizing exciting parallel developments in other media, they soon expanded the parameters of their collection to include ceramics, wood, fiber, and metal.

Presciently, the Saxes visited many artists' studios, where they obtained recommendations and referrals that led to new acquisitions. Despite their friendships with many of these artists, they have strongly supported the gallery system, recognizing that this component is essential to the long-term viability of the studio craft movement. In addition to acquiring and commissioning major works by established artists, they also have supported younger artists at the outset of their careers. George and Dorothy also have served as an inspiration to many new collectors and, in the process, have forged lasting friendships among a nationwide community of aficionados.

The Saxes' self-described goal of acquiring "art made using craft materials" has created a collection of extraordinary quality, depth, and diversity, with many major artists represented by works from different stylistic periods in their careers. Their accomplishments as collectors were dramatically demonstrated in the extraordinary exhibition (and accompanying catalogue), *The Art of Craft: Contemporary Works from the Saxe Collection,* which was shown at San Francisco's de Young Museum in 1999. Their partial and promised gift of over 500 artworks, many of which are featured in a beautiful gallery bearing their name, has transformed the Fine Arts Museums of San Francisco into one of the premier national repositories of studio craft.

The Saxes have distinguished themselves not only through the quality of their connoisseurship, but also through the breadth of their philanthropy. As trustees of the Pilchuck Glass School, the California College of Arts and Crafts, The Contemporary Jewish Museum of San Francisco, and the Fine Arts Museums of San Francisco, the Saxes have pioneered the integration of the studio craft movement into wider artistic, academic, and museum contexts. Their shared passion for contemporary studio crafts, and their certainty that these artworks merit serious art historical consideration within a larger cultural context, has helped to ensure the preservation of this important component of America's cultural heritage for future generations.

Timothy Anglin Burgard
The Ednah Root Curator of American Art
Curator-in-Charge, American Art Department
Fine Arts Museums of San Francisco

A.
Dale Chihuly
Silvered Venetian with Spring Green
and Wine Spotted Flowers, 2010
hand-blown glass
30 x 16 x 16
Gift of Dale and Leslie Chihuly
in honor of George Saxe
to the Fine Arts Museums of
San Fransisco
photo: Scott Mitchell Leen

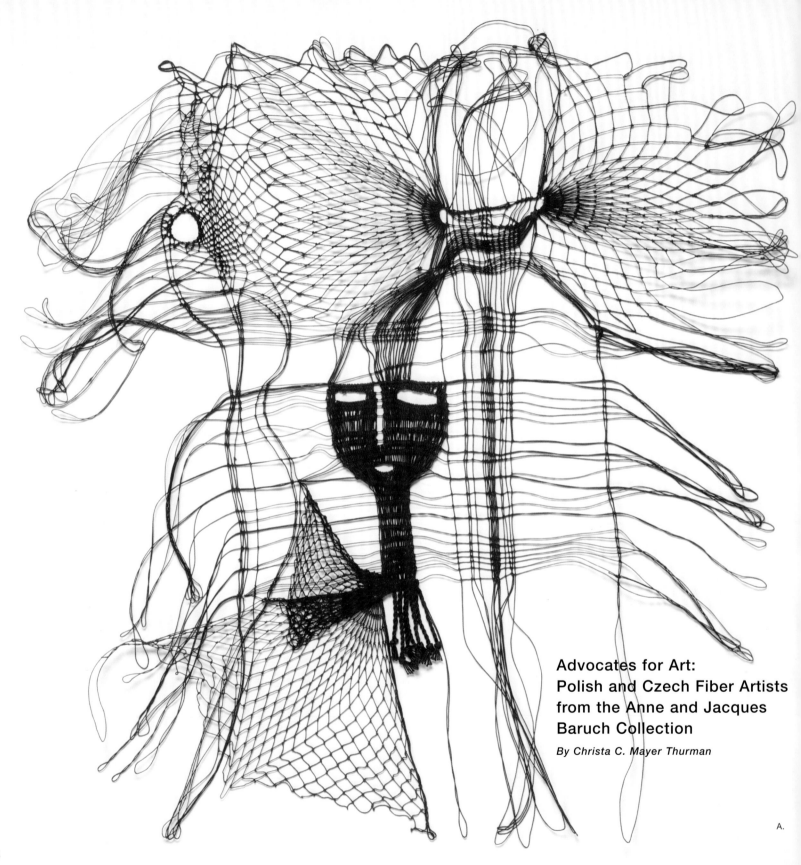

Advocates for Art:
Polish and Czech Fiber Artists
from the Anne and Jacques
Baruch Collection

By Christa C. Mayer Thurman

A.

18

In 1967, an art gallery opened in Chicago. Well established by 1971, it was housed in a 1920s apartment building at 900 North Michigan Avenue in a spectacular baronial duplex on the sixth floor —the apartment of architect Jarvis Hunt (1864-1941), who had designed the building. The gallery carried the name of its owner, Jacques Baruch. Jacques Z. Baruch was a Polish architect and his wife, Anne Baruch, née Lillye Anne Stern, was a Chicago businesswoman of Romanian and Russian heritage. Jacques saw his parents murdered in World War II, survived the underground and ultimately immigrated to the United States in 1946. The couple met in Chicago, where Jacques was working as an architect, and they were married in 1951.

The Baruchs determined that their gallery would focus on contemporary art and artists from Central and Eastern Europe, which Jacques once described as "the finest work of tomorrow...not what is known... the new blood." Works on paper, (drawings, etchings and lithographs), photography, glass, metal and fiber were the gallery's expertise. Occasionally painting was featured, including works by Alphonse Mucha (1860-1939).

Many of the works presented were by artists who had begun their careers under Communist occupation. The gallery's early years coincided with worsening political conditions behind the Iron Curtain. On August 20, 1968, the Baruchs left Prague just five hours before Soviet tanks rolled into the city and brutally ended a brief period of democratic reforms.

Life, which had been difficult for these people, grew worse. One only has to think of the struggle they were exposed to daily and the limited materials and substances they could secure for their artistic expressions. The struggle was overbearing and bare essentials such as food and clothing were hard to find. "The atmosphere in the area was horrible; everybody was depressed, and certain they would never climb out of their jail," Anne recalled later. "The artists were sure they'd never be seen again."

For the Baruchs, making trips behind the Iron Curtain during these years was a complex, taxing, and, at times, dangerous, way of making a living. Importing Czech photography and works on paper, for example, presented particular risks. Many of the artists the Baruchs wanted to work with were not sanctioned by the authorities and so, after the Soviet crackdown, Anne began smuggling art out of the country. The process was deceptively simple: Anne would present a portfolio of inexpensive sanctioned art to be reviewed by government agents for export. They would approve it, tie it with string and seal it with imprinted wax. Before her return to the U.S., however, the artists she worked with would open the parcels, replace the approved items with their unsanctioned works and remake the seals. On more than one occasion, Anne traveled to Prague with a bright red Hartman suitcase equipped with a false bottom. Outgoing, she would fill it with art supplies; on the return trip it would carry hidden artworks. She also established a code to correspond with artists and take notes about pricing and exhibition details.

The trips took a physical toll; Jacques had a heart attack in 1970 and, despite not being fluent in Czech or Polish, Anne made her art trips alone after that, dealing with import issues and artists who desperately needed exposure, support, encouragement and funding from the West. There were also dealings with the government agencies that controlled the export of art. After one trip, the FBI questioned her at the gallery. On another, she was detained at the Prague airport and questioned at length. There were legal formalities to secure in order to export the art, the running of the gallery and the day-to-day issues that would accumulate while she traveled. And last but not least, there was the worry about her life's partner, Jacques, and his health. Nevertheless, she managed to find a significant entourage of artists to become a part of their undertaking, among them a group of internationally important textile artists. It is this group of artists whose work is included in the special exhibition of Polish and Czech tapestries from the Baruch's collection at this year's SOFA CHICAGO.

"We were captivated by their energy, experiments and bold compositions," Anne would write of the Polish fiber artists she and Jacques met in 1970. "Though there were...shortages of studios, materials and most necessities for daily life, all their problems did not hamper their work. Rather, it stimulated their creativity, and their use of sisal, rope, metal, horsehair and fleece as well as the traditional wool, flax and silk, revealed new artistic thought with results which were dynamic, highly personal and original."

The Baruchs exhibited, collected and promoted these artists, including Magdalena Abakanowicz (whose tapestry *Lune de Miel 2* is installed at Chicago's McCormick Place, South Building, Level 2.5 in the southeast corner, and whose sculpture installation, *Agora,* is in Grant Park), Jolanta Owidzka, Zofia Butrymowicz, Anna Sledziewska, and Krystyna Wojtyna-Drouet of Poland as well as Luba Krejci and Jan Hladik of Czechoslovakia. They were unknown to many of the gallery-going audiences, collectors and curators until Jacques Baruch's striking exhibitions, which were magically designed on shoestring budgets—works mounted and framed whenever apt and necessary—introduced them to the West and specifically to Chicago.

B.

C.

D.

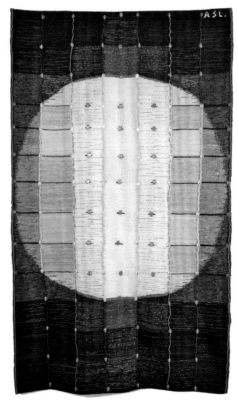

In the years that followed, catalogs were written, traveling exhibitions organized, articles published and works by these exceptional artists added to private and museum collections: including the Art Institute of Chicago, the Metropolitan Museum of Art and the Museum of Modern Art in New York, the National Gallery of Art in Washington, D.C., the Victoria and Albert Museum in London and the Musée d'Orsay in Paris.

As the direction of the Jacques Baruch Gallery became more widely known, budding collectors, museum curators, and university personnel in charge of collections in Chicago and elsewhere in the United States were drawn to the exciting artistic expressions represented and intrigued by the previously unknown repertoire of the artists in the collection. Camaraderie among the young collectors and curators developed. Some provided assistance in hanging the exhibitions, which became exciting social events and legendary evenings at the gallery. Anne would cook memorable and delicious Eastern European meals and in doing so thank those who helped with the installations.

The Baruchs' personal life became that of the gallery and vice versa. Their living quarters were tucked away within the gallery complex, which was where they worked, entertained and dreamed. Their lives were frugal without extravagances or indulgences. I don't recall them ever taking a vacation. The mission of helping the artists in their life's struggles and their difficult existence was primary to them, matched with a keen sense of artistic evaluation and remarkable eyes to judge the art that was being produced by this generation of struggling artists. Their involvement included a human aspect—caring for the artists and their families. Years later, after the conditions in Central and Eastern Europe had improved, this concern was forgotten by some. It was amazing to me how quickly several artists transferred their allegiances to other Western galleries and representatives in the 1980s.

C.
Bella Pais (1985) is by Zofia Butrymowicz (Polish 1904-1987), who began exhibiting her work in Warsaw in 1953. Butrymowicz "paints" within her weavings, letting the colors and shadings flow into one another.

E.
Circle (1973) is by Anna Sledziewska (Polish 1905-1979), who is known for Gobelin and Jacquard tapestries that feature chords of light in white, silver and beige.

D.
Works like Seaside (circa 1970s) are created directly on the loom by Krystyna Wojtyna-Drouet (Polish -1926). "I do not use the painter's approach when creating a work," Wojtyna-Drouet has explained, "because I believe it makes no sense to duplicate painting in tapestry. In my opinion, form should not work against the natural rhythm of the warp yarns."

E.

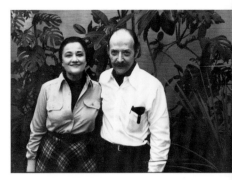

In 1984, despite community efforts, the building at 900 North Michigan was torn down to create commercial space and all the tenants had to leave. The Baruchs and their gallery relocated to the penthouse at 40 East Delaware Place. When Jacques died in 1986, Anne continued to operate the gallery at that location for another seven years and then moved into an apartment on the 15th floor of 680 North Lake Shore Drive.

During that same period, Anne and the Jacques Baruch Gallery received international recognition for their efforts on behalf of the arts. Anne received an honorary degree of Doctor of Letters from Gonzaga University in 1987 for "work done behind the Iron Curtain" as well as The Medal of the Order of Cultural Merit from the Minister of Culture and Fine Arts in Poland. In 1988, she received the Silver Medal of Merit from the Ministry of Foreign Affairs in Prague and in 1989, she received the Karel Plicka Medal from the Czechoslovakian Minister of Culture. In 1990, she met President Vaclav Havel in Washington, D.C. and she returned to Czechoslovakia for the first time since the country's authoritarian regime was overthrown in late 1989.

In 1993, the gallery became the Anne and Jacques Baruch Collection, available only by appointment; this arrangement continued until Anne's death in October of 2007. The Baruch Foundation (baruchfoundation.org), a 501(c)(3) entity, was established shortly thereafter. It includes Anne's personal art collection and the artwork inventory of the Anne and Jacques Baruch Collection, Ltd.

The Foundation has two missions: to foster interest in and knowledge of the visual arts of Eastern and Central Europe through donations of artwork to museums and schools and to fund educational programs and scholarships by the sale of art. The Foundation has partnered with browngrotta arts and The Art Fair Company to promote the works and artists in the Collection through a special exhibition,

Advocates for Art: Polish and Czech Fiber Artists from the Anne and Jacques Baruch Collection, at SOFA CHICAGO 2010. The special exhibition features a selection of 21 works from the Collection, by 14 artists, including tapestries and drawings by Lilla Kulka, Magdalena Abakanowicz, Wojciech Sadley, Jolanta Owidzka and others. Through the Foundation's efforts and the *Advocates for Art* exhibition and the accompanying catalog, the Baruchs' legacy will continue.

Christa C. Mayer Thurman was the chair and curator of the Department of Textiles at the Art Institute of Chicago from 1967 through 2009. She is the author and co-author of numerous books about textiles, including *European Tapestries in the Art Institute of Chicago* (2008), for which she oversaw the collection's conservation, became the general editor, and contributed to the resulting volume as an author. Christa and her late husband, Lawrence S. Thurman, were friends of the Baruchs for many years. Jacques and Lawrence both fought in World War II and suffered compromised health as a result. During Christa's tenure at the Art Institute, several textiles from behind the Iron Curtain entered the collection either as gifts, bequests, or purchases. Several Baruch-connected pieces are included in the exhibition she has just curated, *Contemporary Fiber Art—A Selection from the Permanent Collection* at the Art Institute of Chicago through February 7, 2011.

Adapted from the catalog for *Advocates for Art: Polish and Czech Fiber Artists from the Anne and Jacques Baruch Collection,* published in conjunction with the SOFA CHICAGO 2010 special exhibit of the same name presented by the Baruch Foundation and browngrotta arts.

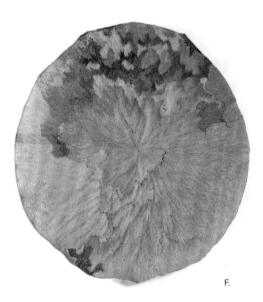

F.

F.
Agnieszka Ruszczynska-Szafranska (Polish - 1929) is known for her unique weavings of linen, wool and sisal like Podroz (Journey) *(1986) from the* Kolidia *series. Their circular, semi-transparent designs have intrigued many a textile historian, weaver and admirer.*

G.
The Baruchs, 1978 Rochester, NY photographer unknown

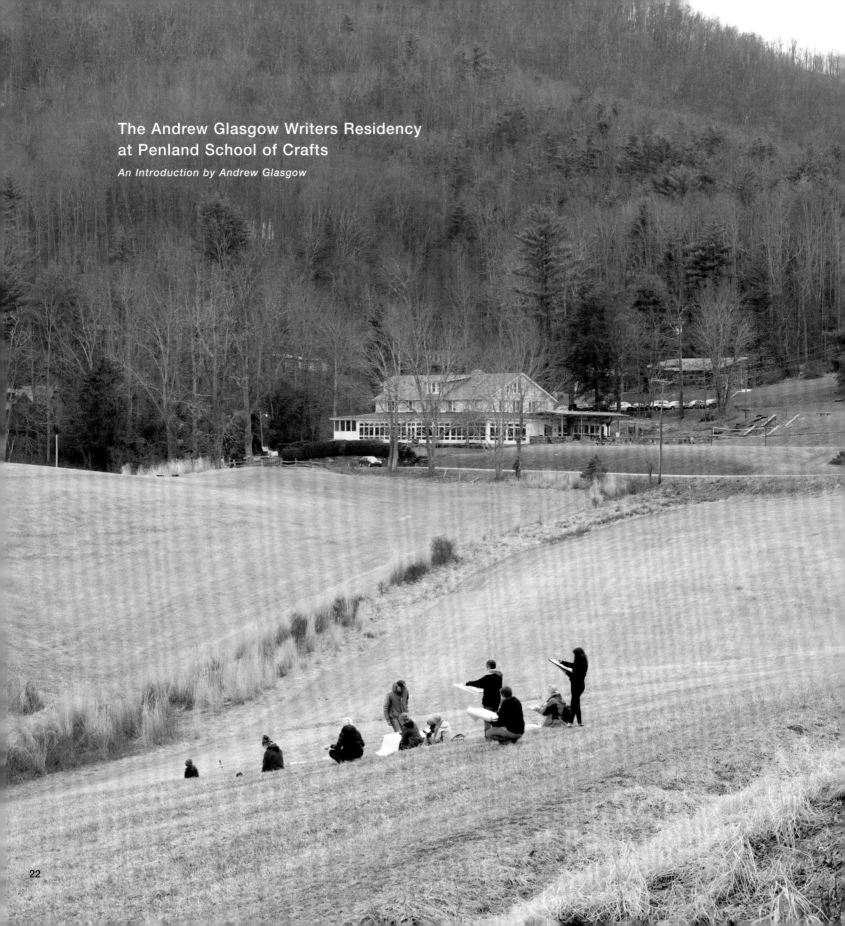

The Andrew Glasgow Writers Residency
at Penland School of Crafts

An Introduction by Andrew Glasgow

Writing in the craft world has had its ups and downs. There was amazing literature written in the 1950s as crafts were being taken into the academy and everything was in flux. *American Craft* magazine, under editor Rose Slivka, produced much of the provocative and intelligent writing of the period. In the 1960s, however, critical writing about fine art clearly overtook writing about craft, and all has not been the same since. (This is not to say those advancements were not positive, merely that it may be time again for change.)

The past decade has shown a resurgence in writing about art, craft, and its making, which encourages a broader look into its 21st-century context. As we see more acclaimed fine artists utilizing craft materials and more self-identified craft makers using fine art material, this sphere has become less defined and, I would argue, much more interesting.

I passionately believe that what craft needs most is to encourage a wide spectrum of writers to engage in professional and thoughtful research and writing about this art form. Such an opportunity now exists. I am humbled and very excited to announce the Andrew Glasgow Writers Residency at Penland School of Crafts.

In the fall of 2009 I had to retire as Director of the American Craft Council for a medical reason— my cancer had returned. While I would never wish cancer on anyone, my experience with this illness brought a depth to my many friendships that I could never have imagined. Two close friends, John and Robyn Horn, in consult with my dear friend Stoney Lamar, gave me a rare gift. They decided to establish a residency in my name because they know how much of my life I have devoted to craft. As we began working together on the details, it became clear that we needed a host institution. The natural fit, I felt, was Penland School of Crafts. I know many artist friends who were positively challenged and encouraged by the magic that is Penland.

With that beginning, I started thinking about how we as historians, makers, administrators, curators, and collectors could elevate craft within the newer contexts we all face and how advances in craft writing might have an effect on the art world, specifically, and the public in general.

A.
An early-spring Penland drawing session in progress

B.
Student Keiko Ishii working in the Penland glass studio

C.
Student Itchel Arriaga working in the Penland iron studio

D.
Printmaking instructor Robert Mueller conducting a critique in his Penland workshop

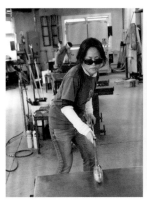

B.

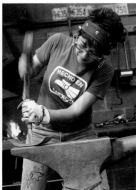

C.

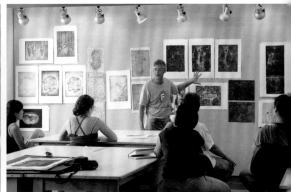

D.

Considering the potential for a unique discourse, and with Penland as a willing partner, I was able to think far beyond the normal parameters of a writer's residency in craft. One person I turned to was Lydia Matthews, who I so admired after meeting her at a program at the Center for Craft, Creativity and Design. Lydia is a writer, curator, and professor at Parsons The New School for Design. Her way of thinking about critical writing made so much sense to me. A respected teacher on the subject, I truly valued Lydia's input. Together we talked about the importance of broadening the audience for craft as well as deepening cultural insights related to contemporary craft practices.

Lydia and I began to discuss writers who had written interesting works addressing a broad range of subjects: the environment, community, makers, objects, and so on. The writer selected for the 2010 residency, Ingrid Schaffner, and for 2011, Barry Lopez, are prime examples.

Ingrid, who comes from a fine arts background and works with the Institute of Contemporary Art in Philadelphia, has produced excellent exhibitions and catalog essays on exhibitions using craft media that explore her areas of interest such as feminism, photography, and historic surrealism. She will bring her keen sense of exploration to craft media and expand the boundaries of curatorial concepts beyond the individual object. Her work as a curator in this vein will surely enliven the two weeks she will spend at Penland.

Barry Lopez writes about subjects as diverse and connected as language, the American landscape, the environment, and community, as well as craft. We believed he could share similar insights during his residency, drawing those subjects together in a meaningful way. Because of his experience as a teacher, he will bring a bounty of gifts to the Penland community during his two weeks in 2011.

I felt Penland School of Crafts, located in North Carolina, is an ideal host for the writers residency program. Writers interested in art, craft, environment, and culture will have an unparalleled opportunity to do something totally new. The views and experiences of the school's residents, core students, workshop students, instructors, and administration are mixed with artists who chose to permanently live nearby. The level of personal and professional creative investment within the artists' community that is Penland provides a depth of exposure in craft that is unattainable in most other places.

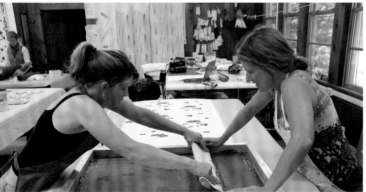

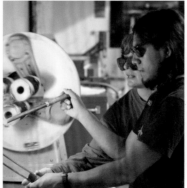

E.

F.

Penland School of Crafts welcomes the opportunity to host the Andrew Glasgow Writers Residency. We want to find excellent writers who are original thinkers and give them a context in which to explore the meaning and value of handmade objects. We also hope they will be inspired by our method of education and the kind of learning that takes place here.

The residency does not dictate how the writers should spend their time or what exactly should result. Our hope, however, is that each residency will bear fruit that will find readers and that these readers will learn something about craft, about process, or about education. Perhaps they will be inspired in their own making or educational pursuits or, at very least, will pay a different kind of attention to the next beautiful handmade object they encounter, whether that is a rocking chair or a Brancusi.

We also look forward to the possibility that these writers will see things we have not seen and, as a result, give us new ways of thinking and talking about what we do here. An excellent outcome would be for Penland itself to gain new language and ideas about craft and education.

–Jean McLaughlin, Director, Penland School of Crafts

Andrew Glasgow is an art historian with over 25 years of experience in the decorative arts and craft fields, primarily in curatorial, writing, and development and administration. Andrew most recently was Executive Director of The American Craft Council with prior appointments with The Furniture Society and The Southern Highland Craft Guild. He lives in Asheville, NC.

Published in conjunction with the SOFA CHICAGO 2010 lecture, *Crafts Writing in a Studio-Based Community*, a panel discussion with Andrew Glasgow, Lydia Matthews, writer and Academic Dean, Parsons The New School for Design, NY; Dana Moore, program director, Penland School of Crafts; Rob Pulleyn, artist and founder of *Fiberarts Magazine* and Lark Books; Ingrid Schaffner, curator, Institute of Contemporary Art, Philadelphia. Introduced and moderated by Jean McLaughlin, director, Penland School of Crafts.

E.
Instructor Jennifer Angus and one of her students making screen-printed wallpaper in the Penland textiles studio

F.
Student Emmanuel Galvez and instructor Sally Prasch working on the glass lathe

G.
The Craft House (built 1935-1938), one of the many historic buildings on the Penland campus

H.
Penland photography students washing a giant photograph made in a walk-in camera obscura on the Penland campus photo: Jeff Goodman

I.
Instructor David Clemons in the Penland metals studio

J.
A student in a stained glass class taught by British artist Mark Angus

All images courtesy of Robin Dreyer unless otherwise noted.

G.

H.

I.

J.

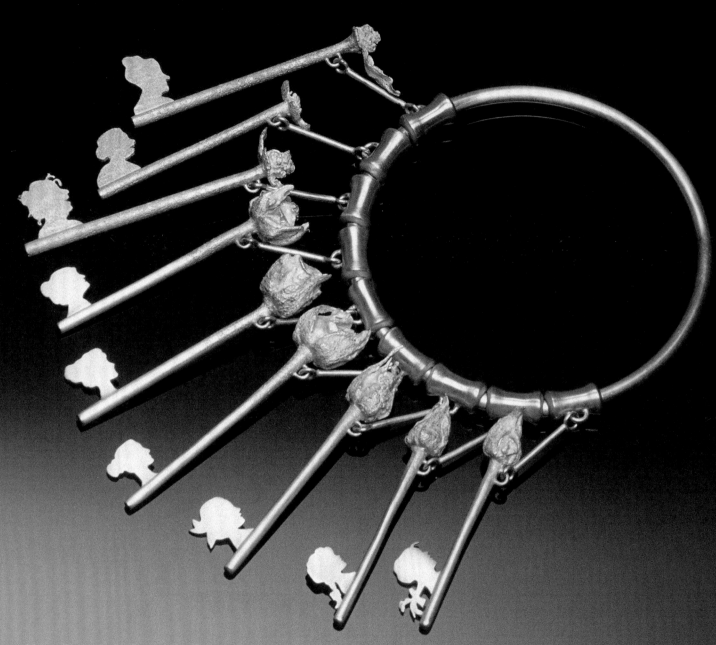

Neo-Palatial: Peering Over the Palace Wall

By Garth Clark

B.

C.

Public attitude towards palace culture has radically transformed in the short span of three years. Until the recent collapse of the global economy, corporate aristocrats were viewed enviously as the Capitalist dream, their lifestyles closely followed and emulated. They were allowed to play with little criticism of their excesses and elephantine compensation. Employment levels were high and enough wealth trickled down to keep the serfs content. The palace was not yet an explosive political issue. Now in the developed nations (including America) around one in six breadwinners is jobless while unemployment for the palace folk is only three percent. Inequity in wealth distribution has steadily grown. In the United States the top one percent own nearly fifty percent of all private assets, while the top twenty own eighty-five percent. The top five percent have seen their wealth grow fivefold in twenty-five years, while that of the middle class has steadily declined. Fifty years ago a CEO earned a salary forty times that of their workforce's average wage; today it is four hundred times greater. The egregious manipulation of toxic assets has resulted in a massive number of foreclosures, destroyed retirement plans, and decimated savings. This class has become, for the first time in decades, the target of populist dissatisfaction and anger.

Given this climate, why celebrate the palace now? This is indeed the ideal moment to parody and critique the religion of ultra-materialism, a perfect storm in fact. With this in mind I have selected work that is eccentric, often deliberately vulgar and with an overall aura of wit and wickedness that delights in the faux opulence of fabricated glamour. But a warning to those with more traditional taste: this palace is much more Lady Gaga than Lady Diana.

The eighteenth century was the *belle époque* of exaggerated style, a time when the standards for craftsmanship, luxury, and invention were unparalleled and devotion to fashion was paramount. For the contemporary maker seeking to comment on his or her own time, the detritus of this *ancien régime* is a magical resource. History is wont to repeat itself; these two gilded ages are squinting uncertainly at each other. But do not expect a tidy dénouement. No matter how socially activist our views are, we are all complex, with conflicting love-hate relationships with privilege. Even in denouncing it there is a latent smudge of envy and desire.

In selecting works for *Metalsmith's* "Exhibition in Print," from which this essay derives, I initially looked for gates, large ornamental vases, serving dishes, objects of curiosity, chalices, and candelabras. But few contemporary works matched my vision of a twenty-first-century Pop palace parody. With rare exceptions the work was prosaic and unexciting. Jewelry, which I had initially decided to exclude, proved a revelation. Here I found just the right balance between style and content, exactly what I imagined for this show.

For the magazine, I conceived of a "curatorial imaginarium" set in an 18th-century European palace. The virtual tour through this printed palace included rooms such as the Vestibule of Keys, the Treasury, the Dining Hall and Service Vault, the Treasure Vault, and the Gallery of Adornment, each with splendid contemporary examples befitting their palatial surroundings. What follows are highlights from this imaginary tour with stops at some of the prime rooms and holdings.

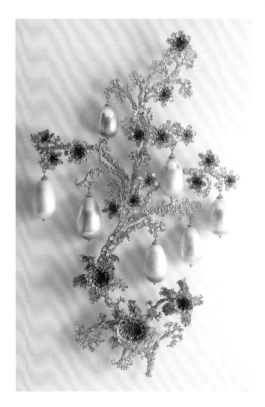

D.

A palace is all about keys. It is the way in which access is controlled, wealth and privacy protected, and status established. Keys are used to lock away treasure and to keep the silverware out of the hands of felonious servants. Keys keep the wine cellar out of bounds, lock the caddies that hold tea (then costing around $300 a pound), and determine which wings and rooms one is allowed to access. In the Vestibule of Keys you can picture hundreds on display, big and small, one more fanciful than the other. Like the elaborate keys by Anika Smulovitz, each has its own narrative and purpose, and each denotes a privilege and responsibility. "When you hold a key," Smulovitz says, "you hold power. In many cultures, traditionally in Scandinavia and today in Nepal, keys are displayed on the body like jewelry to show status."

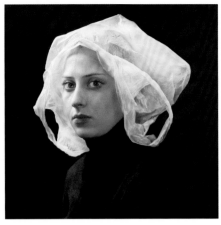

E.

F.

Beyond a large vault with a massive door studded with multiple locks and bolts, we enter the Treasury, once a place to guard valuable objects. Inside we find the distinctive jewelry-themed sculpture of Timothy Horn. At more than five-feet tall, it is installed on the wall and dazzlingly lit by powerful narrow-beam spotlights. Horn's works give treasure a strangely bloated quality, removing preciousness and coarsening the jewelry aesthetic but in a way that is satiric and deliciously neo-Pop. When I sought out jewelry on steroids, this is exactly what I had in mind.

Moving on to the main palace, we arrive at the grand Dining Hall and Service Vault. Today we are totally removed from the gory realities of the food chain; slaughtering takes place outside our purview. But 300 years ago, animals were slaughtered on the palace grounds, their cries clearly audible, the scent of fresh blood in the air. Serving dishes were traditionally decorated to connect the meal to its source, such as a fish-shaped tureen for bouilla-baisse. A stew of wild boar would similarly be served in a tureen with the beast's tusked head as its form, not only to contain the soup, but to also celebrate the hunter's prowess. Interestingly, the urn is a form that seems to have disappeared from the hollowware tradition.

The dining hall abuts the Service Vault, which in turn connects to the kitchen. The vault is where costly serving vessels, gold and silver flatware, expensive porcelain dinnerware. Jeffrey Clancy's "Ornamentalware," the series to which Bread for All belongs, is a sophisticated blend of utility, fragments of eighteenth- and nineteenth-century ornament, and a skeletal, open modernist under-structure; a deconstruction of past conventions. In this new body of work, Clancy explores progress

and regress and the mobility between. Clancy's appreciation of the history of metalsmithing and mechanical abilities melds with his "desire to contribute, invent, and move the language and lineage of the craft forward." I found this piece appealing because of its callous "let them eat cake" resonance (Marie Antoinette's infamous riposte to the starving poor). There is something disturbingly patronizing and dissonant in "bread for all" being served from a cardboard box with a finely crafted ornamental silver handle. This is finely tuned social commentary with a dash of sardonic acid.

Amelia Toelke's stacked Tower makes a great and fanciful addition to the Service Vault. The plate has recently become Toelke's canvas, which she chose because it "plays multiple roles: utilitarian for the food we eat, it is decorative when it adorns walls, commemorative when it celebrates events and places. It is a keeper of memories as an heirloom or souvenir. The stack of plates feels precarious and unsafe but at the same time this gesture feels familiar. Tower is both rising and falling. It embodies the complicated layers of emotion and experience …beauty, desire, social class, belonging, longing, sadness, and pride."

Continuing on to the Gallery of Adornment, we encounter small, exposed spotlights angled to make the jewelry seem as glamorous and expensive as possible, less DIY and more Van Cleef and Arpels in presentation. Everything about the display of this work is designed to heighten a sense of preciousness and value that, at least in terms of costly materials, does not actually exist.

A photograph by Hendrik Kerstens sets the tone of contemporary transformation of court dress. Self-taught, Kerstens specializes in tronies (a

common type of Baroque painting focused on the facial expression). Within his portraits his model, daughter Paula, is always depicted as austere and serene, illuminated with a characteristically Dutch light that Vermeer was able to capture so subtly. Kerstens's Bag was conceived in New York, where he noticed the excessive amount of plastic bags given away in shops. As a humorous reaction to this environmental problem, he photographed a plastic bag in the style of a seventeenth-century cap. It is this clash between modernity and history that empowers much of the jewelry in this gallery. A similar aesthetic feeds Shana Astrachan's work, but with the authority of accomplished jewelry. At first glance the necklace is certainly palace-worthy, with its giant pearls, lavish styling, and bejeweled clasp, but upon closer inspection it has, aside from a small amount of silver, no intrinsic worth. It is made from plastic and comprises 90 percent recycled materials, as the name (and color) suggests. Astrachan seeks materials outside the context of traditional jewelry, and experiments with unconventional approaches in working with them.

Elliot Gaskin's necklace is a blend of meticulous engineering and futuristic art. It has a similar quality to Santiago Calatrava's structures, conveying the Spanish architect-engineer-sculptor's ability to levitate form through pulleys, cables, and other forms of suspension. Inspired by early machinery, Elliot creates works (not all jewelry) that challenge the viewer's often fixed perceptions about modern-day mechanical devices, transforming them into objects of beauty and desire. What I found uplifting (no pun intended) was the regal extravagance of the work, its soaring presence, transparency, and suggestion of ritual, as though it is to be worn to a social event of exceptional importance and stylistic edge. It bridges two worlds: the futuristic, with

its sci-fi resonances, and the past, with its era of pomp and circumstance.

In emiko oye's work I found the essence of "Neo Palatial," comic with its witty pomposity, the powdered face, the eighteenth-century wig, and her outlandish, parodic view of trophy jewelry. oye's series titled "My First Royal Jewels" involves modern-day reinterpretations of jewelry by some of the great design houses—Louis Boucheron, René Lalique, Cartie, and Harry Winston, purveyors of body ornamentation to the royals and the social elite. Her take on René Lalique's necklace is funky and irreverent; her choice of LEGOs to reinvent these works is sly. It refers to the mobility of gemstones, components, like LEGOs, that move from one setting to another.

The notion of the Grand Vase is what initially led to the idea for the theme of this exhibition. It set the palace as my location and drew on my lifetime of enjoying and analyzing vessel forms. In the 18th century, these huge vases were made as centerpieces for entry halls, parlors, or ornamental gardens. In the nineteenth century, when private commissions were less common, they were brought back into vogue by the World's Fair. The "exposition vase," as it became known, was designed to awe with its huge scale and fulsome virtuosity.

My search for Grand Vases within contemporary metalsmithing eventually proved fruitless, with the exception of Kim Cridler's exciting work. Vases are expensive to make and store, and they cost a fortune to ship, so unless they are commissioned most artists will not risk making them. Nonetheless, Cridler continues to mine the expressive potential of monumental vessels and in this imaginary palace her work is exhibited in an outdoor colonnade, one vase standing between each column. In the center of the colonnade there is a shallow reflection pool that appears to double the number of vases on display.

The Palace of Versailles is the quintessential palatial creation, and the setting of Jeff Koons's controversial 2008 exhibition "Jeff Koons, Versailles." It is a match made in heaven: art by the contemporary kitsch-meister of Pop Art shown in the world's most historionic example of kitsch architecture. Some of Koons's work could pass for being period-worthy, such as his portrait of Louis XIV in stainless steel, or a white marble *Self-Portrait* bust. But it is his sculptures based on balloon toys, notably *Balloon Dog* (Magenta) installed in the Salon d'Hercule, which dramatically fit this baroque confection like a glove.

The seeming banality of these pieces prompted conservative critics to argue that Koons's work belonged in Disneyland and not this "sacred" palace.

The irony escaped them. Koons in Versailles demonstrates the negligible line between this historic home and Disneyland; both are an exercise in fantasy, just for different classes and at different times. Insofar as this exhibition is a critique by Koons, it is only one of taste and aesthetics. He is too implicated, as much an aristocrat of today's Palace Establishment as Louis XVI was in his time. Koons briefly held the record for the highest price paid for a work by a living artist when his *Hanging Heart* (1994–96) sold at auction in 2007 for $23.6 million. The connection between wealth and ambitious art has been with us for millennia, and navigating the dichotomies between art, wealth, and power will always be as perilous as they are inevitable.

The chateau's director, Jean Jacques Aillagon, dealt with the critics perfectly when he pointed out that Versailles is a living place that "deserves respect but not blind devotion, a laboratory for tastes and not something frozen in formaldehyde." Certainly, deep respect belongs to the ingenious craftsman, artists, architects, and designers who built this astonishing work. But its residents remain the natural prey and satiric fodder of the socially conscious arts. It is not a direction that all artists comfortably follow, nor that all collectors can appreciate. There is a concern that participation in this aesthetic equals complicity in its politics. This is too literal a view. As the noted film critic Pauline Kael once said to me, "art is amoral." It goes where it finds stimulation and embraces anything that nourishes its muses, whether that be a tyrant's baubles or a saint's halo. As such, sumptuousness can be an antidote to the clinical oft-sanctimonious austerity of modernism's more fundamentalist strains. The palace is a place that appeals to the voyeur in all of us. Love it or hate it, we all want to peak over the walls.

Garth Clark is a writer, historian, and lecturer, and has been an art dealer for the past three decades. Clark has written, edited and contributed to over fifty books and is author of more than two hundred essays and articles. For his contributions to modern and contemporary ceramics he has received numerous honors, among them the 2004 College Art Association's Mather Award for distinguished achievement in art criticism. Clark has also curated many significant museum exhibitions for such venues as the Smithsonian Institution, Washington, D.C.; the Cooper-Hewitt Museum, New York, and the Victoria and Albert Museum, London.

This is an abridged version of an essay that first appeared in the 2010 "Exhibition in Print" issue of *Metalsmith* magazine, published by the Society of North American Goldsmiths. This is published in conjunction with the SOFA CHICAGO 2010 lecture, *Peering Over the Palace Wall: The Neo-Palatial Aesthetic in Contemporary Art* given by Garth Clark and presented by the Society of North American Goldsmiths.

G.

E.
Hendrik Kerstens
Bag, 2007
C-print
59 x 47.25

F.
emiko oye
Cygne Noir, 2009
repurposed LEGOs,
rubber cord, sterling silver
24 x 5 x 3.5

G.
Amelia Toelke
Tower, 2009
found plates, sterling, fake
pearls, fake crystals, table
15 x 15 x 4

CHIHULY: The Old Made New Again

By Matthew Kangas

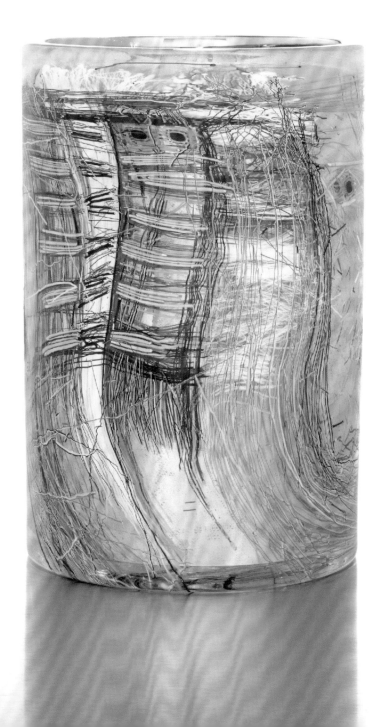

A.

Building on record-breaking attendance at events like "Chihuly at the de Young" (407,000 visitors) in 2008 and "Chihuly in the Light of Jerusalem" (more than 1 million visitors) in 2001, American artist Dale Chihuly continues to expand the limits of what glass can do in studio, museum, gallery and outdoor settings. Constantly moving forward while periodically revisiting earlier series and styles, Chihuly has reignited his interest in silvering, which began as early as 1968 when he visited the *specciai* or master mirror-makers on Murano Island during his epochal Fulbright fellowship year in Italy.

In the Litvak Gallery booth at SOFA CHICAGO 2010, viewers will find that what has appeared to great effect on some of the exteriors of Chihuly's sculptures now adorns their inner surfaces. The process seems to double the amount of light reflected off each piece. Beginning in 1998, Chihuly utilized silvered components blown by Joseph DeCamp and Team Chihuly in numerous architectural commissions and exhibition installations, including *Crystal Gate* (1998) at Atlantis on Paradise Island in the Bahamas.

The new *Silvered* series, begun in 2009, counts as an extraordinary examination of the artist's past as well as a virtuosic accomplishment of the present because selected pre-existing objects (some of which were completely clear) have been reconceptualized by the artist and given new clothing, so to speak, thanks to an interior silvering process. These works mark the first time the 69-year-old artist has used silver as a base color rather than a surface accent. As a result, familiar shapes such as the early *Venetians* are given a chromatic jolt wherein reflectivity is favored over transparency. Light is still transmitted through a variety of approaches (pouring, pooling, dripping, and spattering), but it is refracted, divided and focused differently. Yet even with a focus on the reflective qualities of the glass, color comes forth as never before.

For an artist whose entire oeuvre has involved discovery followed by re-discovery of certain successive explorations, the *Silvered* series can be seen as both an experimental advance and a greater historical tribute to and examination of the Venetian mirror-makers. Other contemporary artists, though, such as Michelangelo Pistoletto and Keith Sonnier, have also employed the eerie reflective power of mirrors in their large-scale sculptures, but use it to catch the viewer's image rather than to bolster, as does Chihuly, the inherent qualities of light in a smaller object. All three are of the same generation; Sonnier's combination of

mirror glass and neon (a material Chihuly has also worked with) shares with the two others a concentration on the nature of seeing and perceiving.

With Chihuly's works in general, the viewer's contact is intimate and absorbing. Gazing into a *Cylinder* or *Venetian,* the viewer enters the artwork or, in the case of an installation, is enveloped by the myriad elements. Furthermore, the intricacy of construction and fabrication of the object is appealing without the psychological implications present in Pistoletto and Sonnier.

Chihuly's art exists in two art-historical worlds; the contemporary and the not-so-distant past of 20th-century European and American decorative arts history. While building on precedents using silver, such as the Italian interwar glass designers Napoleone Martinuzzi and Ercole Barovier, not to mention, Louis Comfort Tiffany and Frederick Carder, Chihuly's new works also reflect trends in postwar abstract painting (pointed out by Henry Geldzahler and Barbara Rose) such as the Color Field stain painters. Sculptural advances of the 1970s, such as those by Claes Oldenburg and Eva Hesse, are also pertinent to Chihuly. The latter two favored "soft sculpture," eschewing mass and volume. Whereas Oldenburg and Hesse depended upon flexible tactility of materials, Chihuly's glass becomes delicate yet firm, sharing with them the appearance of softness and pliability.

By borrowing and expanding the streamlined Art Deco shapes and edges of the interwar Italians for his *Venetians,* Chihuly did not rehabilitate art of a politically tainted era so much as redeem or atone it to more humane, creative ends. In the larger *Venetians* such as *Silvered Venetian* with *Silvery Blue Blossoms,* floral appendages invade the basic vessel form with blossoms that are silver-spotted on highly curled stems. The smaller *Piccolo Venetians* tend to have less ornate additions while others like *Silvered Piccolo Venetian with River Green Feather* have only a single coil that curves around the entire vase. Contrasts between *Silvered Piccolo Venetian with Baltic Amber Handles* and a bubbly, silvered surface in another work attain greater impact on a smaller scale. Its multiple bulges recall the interface between the *Venetians* and *Persians,* reminding us of Venice's Byzantine territories and the cultural heritage of Middle Eastern and Persian glass that found its way to Venice.

A.
Dale Chihuly
Silvered Blanket Cylinder, *2010*
blown glass
14 x 10 x 10

B.
Silvered Ikebana with Three
Pale Jade Stems, *2010*
blown glass
57 x 50 x 35

C.
Silvered Olive Ikebana with
Two Sterling Stems, *2010*
blown glass
51 x 53 x 20

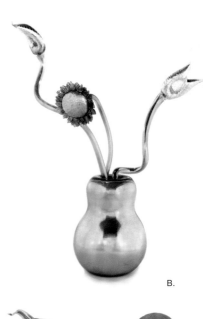

B.

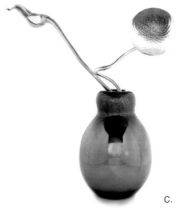

C.

The private collection of 1923-45 Italian glass that initially inspired Chihuly had few if any allusions to this importation of Asia Minor into Venice. By emulating such shapes, including extraordinarily long-necked vases *(Piccolo Venetian with Celadon Handles)*, Chihuly reintroduces a different aspect of Byzantine and Ottoman art into the Venetian tradition of glassblowing that went largely unexplored by earlier Italians who were more drawn to copying enameled decorations on Byzantine goblets.

Before the *Venetians* were silvered, the *Blanket Cylinders* used thin glass strands to better advantage. The new silvering not only emphasizes the illusion of real threads found in a Navajo blanket, but also complicates the patterns beyond the relative simplicity of the earliest *Blanket Cylinders*. Gleaming through, the silvered interior of each now better offsets the glass threads, granting them an element of playful spontaneity absent in the careful construction of the first versions done nearly 40 years ago.

By silvering examples of his *Ikebana* series, Chihuly simultaneously enriches and simplifies the original inspirations that drew on the Japanese art of flower arranging. When Chihuly was first approached by an Ikebana master in Japan who wanted to use his vessels for flowers, he thought, "Why not make the flower, too?" In his hands and those of Team Chihuly, a new series that tends toward greater restraint and elegance was born. Viewers at SOFA see the interpolation of stems and blossoms, but these arrangements are longer, taller and with more elaborate treatments than before; leaves are grooved; blossoms are speckled; and containers are smoothed to allow the spontaneous soda bubbles to create random patterns made more visible thanks to the silvered interiors. As with Chihuly's other inspirations from far-flung cultures, the final result could never be mistaken for real Japanese art. They are, rather, tributes and extensions of aspects of older traditions. Just as 19th-century Russian and French ballet drew upon dance steps from distant lands and transformed them into elaborately technical over-the-top pirouettes, Chihuly's art pays brief homage to sources with the interventions of the master and team, as a means to seek and achieve spectacular effects.

Chihuly has established himself as an international cultural figure whose aesthetic and sensibility have always been nomadic and eclectic. Tuned into the global culture we are all now so much a part of, Chihuly's infusion of exotic cultural traditions place him in the company of artists and writers interested in the nature of global influences as well as their translations. Like Tiffany, or perhaps more pertinently Czech Art Nouveau founder Alfonse Mucha, Chihuly is also a curator and a collector; an art book publisher and designer; a music lover and scenic designer for operas and symphonies; and an educator and trusted adviser to arts organizations like Pilchuck Glass School which he co-founded in 1971. His forays into Japan, Italy, Israel, the Czech Republic and Mexico, to name but a few, have led to collaborations with artists, technicians, writers, conductors and composers. Chihuly is an artist working with glass who has used the material as a cultural and diplomatic tool as well.

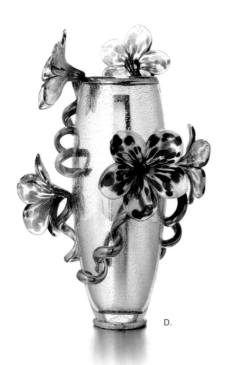

D.

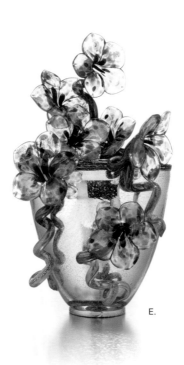

E.

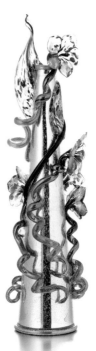

F.

A good example of this is the new *Silvered Jerusalem Cylinders* series. Building on his earliest experiences on a kibbutz in 1963 at age 22, the artist returned to Jerusalem in 2000 for "Chihuly in the Light of Jerusalem," an exhibition at the Tower of David Museum. Insisting on construction crews that included Arab and Jewish Israelis, Chihuly did his own part at attempting to heal rifts. Those who attended brought together numerous citizens and tourists to a site within the contested, ancient city.

The *Silvered Jerusalem Cylinders* are stark by comparison to Chihuly's other work. With few higher than three feet, they benefit from the poured and silvered interiors that draw attention to snake-skin-like patterns in the formerly clear glass. Chunky blocks of crystal are attached to the sides. They recall the rocky earth of the Holy Land. Sleek and rough together, they symbolize perhaps seemingly incompatible forces within Israel coming together and coexisting.

Chihuly has shied away from such interpretations in interviews ("I don't use metaphors to describe my work."). Nevertheless, the symbiotic relationship of crystal chunks to smooth cylinder cannot help but suggest contextual meanings and the possibilities of peace.

A centered, newly silvered blue-and-white chandelier and mirrored *Mille Fiori* elements comprise Litvak Gallery's main installation at SOFA. These pieces have been silvered individually to give an overall glowing, rapturous appearance. Seen as a giant suspended floral blossom surrounded by upright reeds and undergrowth, the assembly of individually hand-blown elements coheres into a bold and inviting collective presence.

Glistening when seen from a distance, looking down the main causeway at SOFA, the installation draws the eye magnetically with its part-metallic and part-transparent appearance. With the newly reconceived *Jerusalem Cylinders, Ikebanas, Venetians* and *Piccolo Venetians* flanking the centered chandelier, the overall display is one of intensified brightness and color. A complement of eight drawings on paper rounds out the selection and enhances this new direction.

Globally nomadic and eternally restless, Chihuly commented on the Litvak display stating that "Silvering older works or creating anything new is about continuing to develop ideas—with new or old works." As with late-period Picasso, to understand new Chihuly is to contemplate the old made new again.

Matthew Kangas is an independent Seattle art critic and curator, and is also the author of *Chihuly in the Hotshop* (Portland Press, 2007). A corresponding editor at *Art in America*, Kangas has three collections of his essays including a full-length study of Chihuly in *Craft and Concept: The Rematerialization of the Art Object* (Midmarch Arts Press, 2006).

Published in conjunction with Litvak Gallery's SOFA CHICAGO 2010 exhibition.

G.
Silvered Jerusalem Cylinder
with Gilded Oak Crystals, *2010*
blown glass
35 x 19 x 17

H.
Silvered Jerusalem Cylinder
with Sienna Crystals, *2010*
blown glass
10 x 13 x 13

Images courtesy of
Litvak Gallery, Tel Aviv

D.
Silvered Venetian with
Amber and Burgundy
Spotted Lilies, *2009*
blown glass
26 x 15 x 16

E.
Silvered Venetian with
Mauve Flowers, *2009*
blown glass
28 x 15 x 16

F.
Silvered Venetian with
Steel Blue Flowers, *2009*
blown glass
41 x 12 x 12

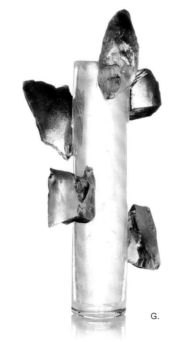

G.

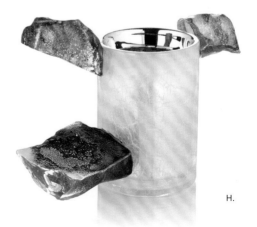

H.

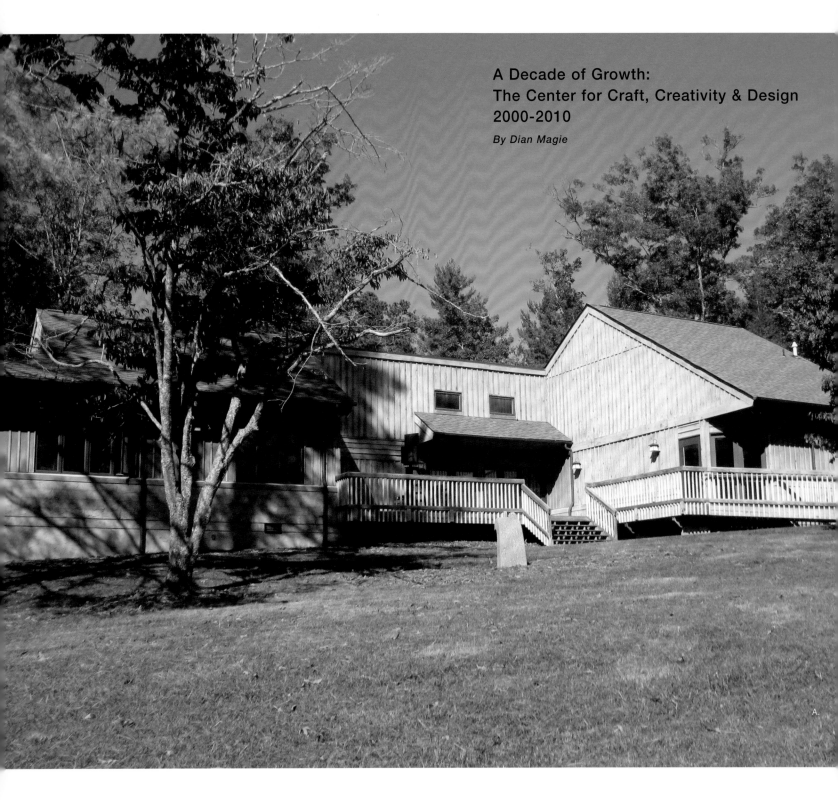

A Decade of Growth:
The Center for Craft, Creativity & Design
2000-2010

By Dian Magie

A.

A.

CCCD building located on
50 acres 20 miles south of
Asheville, NC at the UNCA
Kellogg Center

B.

Makers: A History of
American Studio Craft
cover

B.

During SOFA CHICAGO 2010, The Center for Craft, Creativity and Design (CCCD) will be associated with the recently released publication, *Makers: A History of American Studio Craft,* the first comprehensive survey of leading studio craft artists, movements, and programs from the 20th century in the United States. We are truly proud to claim this accomplishment. *Makers,* along with the grant programs CCCD administers, puts forward the mission of this public/private center to advance the understanding of craft by encouraging and supporting research, scholarship, and professional development through funding, programs, and outreach to international, national and regional craft artists, organizations, schools and the community.

Makers began in 2002 at the first craft-focused Think Tank convened by CCCD to identify and prioritize initiatives that will advance studio craft. Each year since the first Think Tank, approximately 22 curators, artists, academics, directors and scholars meet annually in the conference center adjacent to the CCCD facility, located on fifty wooded acres in the Blue Ridge Mountains just south of Asheville. The top four initiatives of that first Think Tank provide a benchmark for measuring the advancement of studio craft. They are:

Initiative #1: To publish a history of American studio craft that will be used as an undergraduate text so students graduating with a BFA in studio craft can place their work in a relevant historical context. In 2004, CCCD contracted co-authors Janet Koplos and Bruce Metcalf to research and

write the history. This was followed by identifying and gathering image rights, editing, a peer-review process, indexing, and finally the release of *Makers: A History of American Studio Craft;* published by the University of North Carolina Press with 529 pages and over 400 images. Many private foundations, individuals, and the National Endowment for the Arts contributed to this project, without which the project would never have happened. It took a village. And to take it one step further, the CCCD developed a website, www.americanstudiocrafthistory.org, with curriculum resources for both professors and students, including a glossary, image database, instructional videos, and a password protected area where professors can access chapter-based learning objectives, sample discussion topics, classroom activities, and quiz and essay questions.

Initiative #2: To publish a peer-reviewed journal focused on studio craft. The Journal of Modern Craft was launched in 2008 and is edited by two past Think Tank attendees, Glenn Adamson, now Head of Graduate Studies at the Victoria & Albert Museum, London and Ned Cooke, Professor of Art History at Yale University. Many additional scholarly books and articles are now available, in part due to the Craft Research Fund, administered by CCCD annually since 2005, which awards grants for scholarly research in the field. More than $600,000 has been granted to 29 Project Grant recipients (for scholars, academics, and curators) and 21 Graduate Research Grant recipients whose MA thesis or PhD dissertation relates to American Craft.

Initiative #3: To encourage and support Craft Studies within academia, placing craft in a broader context. Programs focused on Craft Studies are now planned at UNC Asheville and other universities for students to better incorporate their craft studio courses with craft history, museum studies, business, and other programs that reflect studio craft as a profession.

Initiative #4: To support studio craft in museum acquisitions, traveling exhibitions, and educational programs. Since 2002, several private craft collectors have donated collections to major fine art museums, which in turn have become the focus of major exhibitions and museum holdings. The Windgate Foundation created a grant program in 2008 that supports traveling exhibits focused on retrospectives of established studio craft artists. Additionally, CCCD has frequently traveled its exhibitions to regional universities and museums. The Windgate Museum Internship program, administered by CCCD, began in 2006 supporting interns in partner museums throughout the country. Since then, 20 future curators have had the opportunity to work with crafts in museum collections and/or exhibitions, helping young professionals foster an understanding of the value of work by craft artists.

Beginning with the first Think Tank in 2002, the bar was set high and each following year participants discuss initiatives that will advance the field. Studio craft leaders from Canada, UK, Sweden, and Australia alongside those from the U.S. have helped place U.S. craft within a global context.

These countries have major federal support for craft, but face some of the same challenges as U.S. studio craft artists. The UK Craft Studies Centre, very similar to CCCD in structure, operates as a public/private partnership with a Memorandum of Agreement between the University for the Creative Arts, Surrey and the nonprofit Crafts Studies Centre. The University of North Carolina Asheville and the nonprofit Center for Craft, Creativity and Design have a similar relationship. And the two centers are working on a joint agreement to identify future collaborative programs that will advance research, scholarship, international artist residencies, and traveling exhibitions.

The Center for Craft, Creativity and Design operates with a small staff and an active, visionary board who understand that advancements to the national craft field will also impact regional craft artists (over 2000 professional studio craft artists live and work in western North Carolina). CCCD refuses to be bogged down with the "fine art/craft" conundrum. As a university affiliated Center, CCCD can work within academia to raise the visibility and respect for studio craft as an important component of the visual arts in America.

There is one other significant grant program administered by CCCD that must be mentioned specifically relating to our support of professional development—the Windgate Fellowship program. Since 2006, the CCCD has annually awarded 10 graduating seniors working in a craft media with $15,000 to complete an 18-month proposal that will propel their career forward after they complete their undergraduate degree. To date, the Windgate Fellowship program has awarded a total of $750,000 to 50 graduating seniors working in a craft medium representing 30 colleges and universities in 20 states. These emerging craft artists will no doubt prove to shape the next generation of makers in the field.

No review of The Center for Craft, Creativity and Design would be complete without acknowledging the support, guidance, and partnership of the Windgate Charitable Foundation. This amazing foundation, known to all in the craft world, sets a high standard for their understanding and support of the often-intangible programs that advance craft. They have invested in programs like the Windgate Fellowships and Museum Internships as well as research focused on the history of studio craft—all with measurable results far in the future. Like Johnny Appleseed, these programs are seeding the next generation of craft artists, curators, faculty, and scholars for the future.

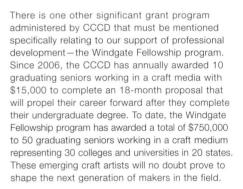

C.

D.

C.
*Andrea Donnelly
(2007 Windgate
Fellowship recipient)
Holding In, 2009
handwoven cotton,
pigment-painted warp,
dyed weft
77 x 209 x 29*

D.
*Andrea Donnelly,
installation view of thesis
exhibition at Anderson
Gallery, Richmond, VA
Left: The Weaver's Bench, 2010
handwoven cotton,
pigment-painted warp
120 x 120 x 192
Right: Shift, 2010 handwoven
cotton, pigment-painted
warp, dyed warp and weft
140 x 89
photo: Taylor Dabney*

Dian Magie became Executive Director of the CCCD in 2000, following a long career of leadership as Executive Director of local arts agencies in Florida and Arizona. She has authored numerous publications on public art and has a strong relationship with the National Endowment of Arts as a grant review panelist for grants and as a consultant.

Published in conjunction with the SOFA CHICAGO 2010 lecture, *Makers: The First History of Studio Craft in America,* presented by co-authors Janet Koplos, freelance critic and Bruce Metcalf, studio jeweler and independent scholar; with Katie Lee, assistant director, The Center for Craft, Creativity & Design, UNC Asheville. The discussion will be followed by a book signing.

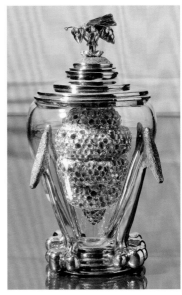

E.

F.

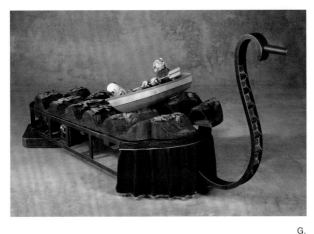

G.

E.
Elizabeth Staiger
(2009 Windgate
Fellowship recipient)
Honey Home: Queen Bee
Honey Dipper, *2007*
bronze, silver plating, glass;
cast, fabricated, blown
10 x 5 x 5

F.
Elizabeth Staiger
Nectar Nest: Fuel Station
for Humming Birds, *2009*
copper, bronze, silver,
patina; cast, fabricated,
formed, raised,
CAD/CAM. P
9.5 x 5.5 x 5.5
photo: Walter Staiger

G.
Dustin Farnsworth
(2010 Windgate
Fellowship recipient)
The Myth of Life and
Truth of Love, *2010*
mild steel, bendable plywood,
poplar, paint, stain, lacquer,
fabric, fur, walnut, HDPE
84 x 32 x 26
photo: Peter McDaniel

Masters and Apprentices: The European Tradition and Contemporary Jewelry in an American Context

By Sue Barry

A.

There is a significant difference between 'tradition' and 'traditional.' Traditional carries the connotation of older styles and a fidelity that negates innovation. Tradition, on the other hand, encodes a set of social customs handed down from one generation to the next; it must embrace change, or it will lose its relevance.

One of the purposes of this exhibition is to examine the relevance of the master and apprenticeship system in a contemporary American context. Is goldsmithing in a living 'tradition' or merely 'traditional'? This question is crucial, as there is a clear conflict between the ways in which goldsmiths are trained in Europe, as opposed to the pedagogy in North America.

In Germany, goldsmiths begin their education in college—but their training is only complete after an 18-month apprenticeship under a master goldsmith. At the end of their apprenticeship, as part of their final exam, they must design and make a complex piece of jewelry. In this way, knowledge is passed from one generation to the next.

In North America, however, there is a distinct bias against the 'traditional.' In the 1960s, the contemporary jewelry movement rejected traditional jewelry in favor of radical practice. The 'new' radical jewelry movement was based on conceptual practice and objects made from non-precious materials. It embraced a generation of liberated women, and to a lesser extent men, who proclaimed themselves to be in charge of their sexuality, education, and lifestyle. In the process, it called for a new nomenclature—and it divorced itself from the tradition of goldsmithing.

If goldsmiths were no longer working with precious materials, but rather with steel, plastics, and found objects, then they had to be trained like other abstract artists. This meant they would be educated solely in the university system, rather than in both the university and the studio. The objectives of the 'new' jewelry movement were clearly expressed in 1980 by Otto Kunzli with his black rubber bracelet entitled *Gold Makes You Blind.* In this piece, black rubber envelops a ball of gold, denying the wearer the conspicuous symbolism of gold (but not the expense).

This 'new' jewelry movement, freshly divorced from the new gold standard, ignored a generation of goldsmiths and stonecutters from around the world, Germany in particular—people who were making artistic statements using precious materials

and gemstones. Rushing to dismiss all that had gone before, the 'new' jewelry naively dismissed gold in all forms. However, the aim of the 'new' jewelry movement was merely to subvert the heavy symbolism that traditional gold jewelry carried; the statement, "Look at me, I am wearing gold therefore I am rich, or belong to a rich man."

This exhibition brings together the work of eighteen goldsmiths who create unique statements using precious materials and were trained through the tradition of the master and apprentice system. For more than 30 years, Michael Zobel, Barbara Heinrich and Michael Good have helped train a generation of goldsmiths in their studios, teaching young jewelers technique, design vocabulary, and life experience. This exhibition highlights the work of these three masters and 15 apprentices, selected by Patricia Kiley Faber, curator and owner of Aaron Faber Gallery. They are: Britt Anderson, Jordan Barnett-Parker, Sabine Dessarps, Claudia Geiger, Insa Grotefendt, Regina Hiestand, Juha Koskela, Stephen LeBlanc, Ayesha Mayadas, So Young Park, Peter Schmid, Simon Spinoly, Christian Streit, Liz Tyler and Liaung Chung Yen. Each of these goldsmiths has gone on to build their own studio and continue the evolution of the European tradition.

Michael Zobel and Barbara Heinrich were trained in Germany at Studium an der Kunst-und Werkschule Pforzheim (now Pforzheim University) under Professor Klaus Ullrich. "Ullrich was a giant in his field".[1] Under the directorship of Karl Schollmayer, Ullrich and colleague Reinhold Reiling offered a new spirit of design and creativity at a time when the field of jewelry was exploding.

"The aim of the School [...] is not to define what design is and catalogue the techniques: it is to show the close link between the spiritual and the material, to recognize the unity of the form in a whole, both without and within."[2]

This exhibition statement from 1961 sits comfortably within the thesis of the 'new' jewelry movement— though, for Ullrich, 'materials' included gold, silver, and platinum. Ullrich's own experimental jewelry involved the risky technique of overheating gold, fusing rather than soldering constructed forms, and using the reticulated surfaces as a design element; making the statement that precious materials don't need to be treated preciously.[3]

Clearly, Ullrich influenced Michael Zobel's early work. The other key early influence was his

A.
Michael Good
Sculpture, 2008
22k and bronze patinated b-metal

B.

B.
Michael Zobel
Brooch/pendant, *2009*
oxidized sterling silver, 100.76
carat round citrine cut by
Tom Munsteiner; 24k gold Tahitian
mabe pearl, ruby, black

C.
Barbara Heinrich
Cuff, *2008*
18k gold, diamonds
photo: Hap Sakwa

D.
So Young Park
Brooch/pendant, *2010*
sterling silver, 24k keum-boo,
peridot, citrine, garnet

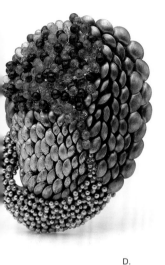

D.

colleague Bernd Munsteiner, now recognized as the world's most influential stonecutter. Pioneering the context cut and the Spirit Sun diamond, Munsteiner applied Ullrich's design philosophy to cutting gemstones. He was the first modern stonecutter to think about faceting the interior of the stone, as well as the body.

Michael Zobel drew on this, and his early work consisted of soft sculptural metalwork, a language borrowed from Ullrich and set with the geometric stones carved by Bernd Munsteiner. But this simple contrast evolved quickly into a playful tension between the gemstone and the metalwork. Zobel expressed the inner composition and emotional state of the stone with fine metals. Then he situated the composition erotically on the body, creating both a jewel and a spectacle. He developed the directions that had been passed onto him by Ullrich, Georg Lauer, Wilhelm Buchert, and others. Then, in keeping with the European tradition of goldsmithing, he began training apprentices a year after opening his own studio in 1968. His first apprentice, Bettina Sauerbruch-Meese, is currently Deputy College Principal at the State Technical School for Glass and Jewelry, Neugablonz (Staatliche Berufsfachschule für Glas und Schmuck Neugablonz).

The work of Peter Schmid, Sabine Dessarps, Claudia Geiger, Insa Grotefendt, Regina Hiestand, Christian Streit, and Simon Spinoly presented in this exhibition illustrates the breadth of the knowledge passed from the master to the apprentice. While the influence from Zobel is apparent, the apprentices are not working from Zobel templates. Each goldsmith received and contributed something different to their studio experience. Simon Spinoly learned, "Never care about technical issues while in the design process. There will always be a solution for it when the design is worth being implemented into a piece of jewelry."[4] Others have complemented their knowledge by working with alternative materials like Sabine Dessarps, or innovative forms like Regina Hiestand. Christian Streit went on to study with Ramon Puig Cuyàs at the Escola Massana and developed a romantic spirit in his collection. Claudia Geiger stopped using Zobel's techniques altogether before she made her first piece after leaving Zobel's studio. Each goldsmith took what they learned and continues to evolve the concepts, techniques, and spirit, keeping goldsmithing in a 'living' tradition.

Although Michael Zobel has influenced the work of more than 20 apprentices and goldsmiths in his studio, the apprentices equally play an important

role in his creative process—indeed, the structure of the workshop created a collaborative environment. Zobel sketched out an idea; an apprentice contributed, suggesting an alternative composition or form; or the apprentice contributed by refining a technique.

In 2005, Michael Zobel retired and passed his studio onto Peter Schmid, who had apprenticed and worked with Zobel since 1995. Schmid continues to innovate the formal design language introduced by Zobel while also continuing the master and apprentice system. As a result, his designs continue to lead change, evolution, and innovation. Like Master Goldsmith Barbara Heinrich, Schmid believes that apprentices keep the work fresh and the atmosphere in the studio creative and optimistic.

In addition to Prof. Ullrich, Barbara Heinrich studied with Prof. Herman Stark and worked for Prof. Reiling. She graduated with High Honors from Pforzheim University, achieving an MFA in Jewelry and Hollowware Design. In 1986 she founded her studio in America and began to accept apprentices immediately. In the beginning, she traded apprentices for studio time. They worked 20 hours for her and 20 hours for themselves in her studio. Twenty-five years later, Barbara Heinrich has given dozens of goldsmiths a jumpstart. Not only does she offer professional training, but she also provides opportunities—helping international jewelers immigrate to the USA.

"There's no strings attached. I invite them to just add as much know-how as they can while they're here and then go fly and do something great. I really do believe in the One Good and that if it's good for one, it's good for all. That's pretty much the spirit of the studio. It's neat to see what somebody does with what they've learned. An ex-student from Taiwan now teaches at University there and designs jewelry for a major company while developing her own work. I'm proud of that whole teaching process because young people really need opportunities and this studio has been a place for that."[5]

Heinrich admits that apprentices have left her studio and copied her work, but she sees this as a spur to continue creating. She says, "It's important to overcome that fear because there is a cross-pollination that goes on." So Young Park, Ayesha Mayadas, and Liaung-Chung Yen emerged from Heinrich's with positive memories and a strong foundation for their own studio

careers. Liaung-Chung Yen, a former apprentice from Heinrich's studio comments:

"Barbara Heinrich studio is a very collaborative environment. Every jeweler contributes their ideas. Barbara may have an idea of a piece and she assigns the project to you. You have the freedom to develop it from start to finish along the discussions with her during the working process. You have the chance to encounter the problems and solve them yourself. The freedom, the challenge and the sharing information are the great memories in the BHS."[6]

Heinrich's inspiration comes from far and wide; elements of tribal jewelry, fashion, and even Grimm's fairy tales have influenced Heinrich's diverse design vocabulary. Her early work, "...used wood and anodized aluminum to make avant-garde head jewelry, light jewelry, and performance pieces that featured nude models. Although critically well received, they only reached a small audience of cognoscenti. Heinrich then focused on creating classically proportioned gold jewelry with a contemporary look using traditional techniques."[7] Heinrich's complex surface textures add to the magnetism of her jewelry. Surfaces are rolled with paper or organic materials, brushed, then go through a process of depletion gilding she learned from Prof. Ullrich.[8]

Michael Good had a very different training compared to Zobel and Heinrich. His early apprenticeship took place during the 1960s revolutions and rebellions in New York City. Robert Peerless taught him a few basic techniques in exchange for help with his sculpture. Then, Good and his partner started making jewelry and sold their work to stores in Greenwich Village: "We hardly made a living." A year later, Good and his partner split, leaving Good with some gold and a few tools.

In 1975, a few years and dozens of craft shows later, Good came across a draft of Heikki Seppa's *Form Emphasis for Metalsmiths,* which illustrated the secret to anticlastic raising. Michael sought Seppa out and received his first formal apprenticeship.

"What I saw was the greatest innovation in two thousand years of metalsmithing. Up until then, nothing new had been discovered. This is hugely important, it meant that you could put non-definitive curves directly into the sheet and guide it anywhere you want it. Just like when you could raise gold and make different things, but you ended up by being confined by the fact that they were definitive forms. This way it gave you huge freedom, and all anticlastic movements are non-definitive, it means all the forms you often did, very much (like) nature, goes from the center out, like the big bang. So the forces dissipate, and at a certain level the form will semi-buckle into a new organized state. Then it goes into a state of chaos and rebuckles into a more sophisticated state. That's what happened to the universe, this movement we're talking about."[9]

It is the perpetual discovery (and rediscovery) of movement that continues to inspire the work of Michael Good. He is indifferent about scale. Working in smaller scale, he learns faster; working in larger scale, he learns about non-definitive movement in greater depth. His jewelry is figurative. Classic lines emerge from chaotic states as if they were patterned upon Nature herself.

Good could have guarded the techniques he discovered—many goldsmiths have—but he is so passionate about anticlastic raising, he has chosen to share his knowledge with anyone who wants to learn. Today, he trains students both through workshops and in his studio in Maine. Stephen LeBlanc, a former apprentice of Michael Good commented:

"Apprenticeship honed my critical eye by cutting out the fudge of creating my own designs. The item was only complete and saleable if it was as designed originally; I was to create their design particularly."[10]

Some of Good's apprentices, including Liz Tyler and Britt Anderson, have continued to evolve the anticlastic raising technique in their own voice, while others, like Carleton Leavitt, have become collaborators. Jordan Barnett-Parker incorporated the technique into unique voluminous forms. According to Juha Koskela, "The biggest challenge was to make designs that looked like me, which was very difficult because the technique was so recognizable."[11]

There is no space in this essay to make a definitive assessment of the success of the master and apprentice system, as opposed to a university-based education. However, some main points are clear.

The North American university-based pedagogy places emphasis on the individual (the artist) and his or her conceptual development and creative process. Clearly, this places an emphasis on originality, perhaps at the expense of learned craft.

On the contrary, the European apprenticeship-based system focuses on the traditions of goldsmithing—materials and technique. In this system some apprentices 'graduate' and evolve or complement the style and/or techniques of their masters. Others, like So Young Park, find new directions in earlier bodies of their own work. These apprentices, like Peter Schmid, owner and designer for Atelier Zobel, go on to train new jewelers. With each generation, new ideas and techniques evolve. Of course, there can also be drawbacks to this system. After apprenticing with a master and working through his or her ideas and design language, practitioners can find it difficult to emerge as an individual artist with a fresh direction. In the words of Insa Grotefendt and Liaung-Chung Yen respectively:

"In my opinion—it is very important to see and to get as most as possible impressions, executions, and experiences from different masters..."[12]

"Watching other artists' new work keeps me motivated. What is the challenge of their new work? And do I challenge myself? And trying to stay in the game?"[13]

To go back to the beginning: goldsmithing is a 'tradition,' and not an anachronistic, 'traditional' craft. It is a living, working discipline. As Glenn Adamson said, "In order for interdisciplinarity to exist, individual disciplines must also be carried forward."[14] Goldsmithing is a discipline: it is an adaptive system that responds to new developments in technology, philosophy, and marketplace. Goldsmithing, in this context, carries forward knowledge in the form of art.

Sue Barry is a historian of craft and a lecturer. She received a M.A. degree from the University of Sussex, UK and a BFA in jewelry and metalsmithing from the Nova Scotia College of Art and Design. Sue has taught at the Art Institute of Chicago and the California College of the Arts, served as assistant curator at the Museum of Arts & Design, and is currently partner with Peter Schmid in Atelier Zobel.

Published in conjunction with Aaron Faber Gallery's exhibition at SOFA CHICAGO 2010 and the lecture, *Masters and Apprentices: The European Tradition and Contemporary Jewelry in an American Context,* a presentation and panel discussion on the European tradition of goldsmithing; how it contrasts to the American university system, and the relevance of apprenticeship in contemporary jewelry-making. Speakers include artists Ayesha Mayadas, India; Peter Schmid, Germany; Juha Koskela, Finland; Britt Anderson, USA; Liz Tyler, UK; Christian Streit, Germany and Patricia Kiley Faber, gallery director/owner, Aaron Faber Gallery, NY. Moderated by art historian Sue Barry.

[1] A. Revere, personal correspondence, June 17, 2010.
[2] Daniel Giralt-Miracle, in Orfebres FAD (1987): *Joieria Europea Contemporània,* (Barcelona: Fundacio Caixa de Pensions, 1987), 54.
[3] Ursula Ilse-Neuman, "New," in: *A to Z: 40 Years Atelier Zobel,* (Unpublished, 2008).
[4] Simon Spinoly, personal correspondence, July 28, 2010.
[5] Nina Graci, "Classical Proportions," Lapidary Journal August (2003): 20.
[6] Liaung-Chung Yen, personal correspondence, May 26, 2010.
[7] Graci, "Classical Proportions," 20.
[8] Barbara Heinrich, personal correspondence, August 18, 2010.
[9] Michael Good, interviewed by Sue Barry, June 6, 2010.
[10] Stephen LeBlanc, personal correspondence, July 6, 2010.
[11] Juha Koskela, personal correspondence, June 7, 2010.
[12] Insa Grotefendt, personal correspondence, June 7, 2010.
[13] Liaung-Chung Yen, personal correspondence, May 26, 2010.
[14] Glenn Adamson, personal correspondence, August 18, 2010.

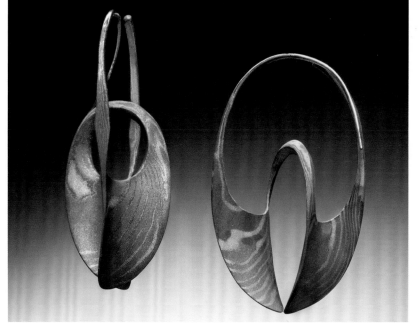

E.

E.
Stephen LeBlanc
Earrings
18k and sterling mokume gane
photo: Ralph Gabriner

Is Ornament a Crime? Rethinking the Role of Decoration in Contemporary Wood

By Cindi Strauss

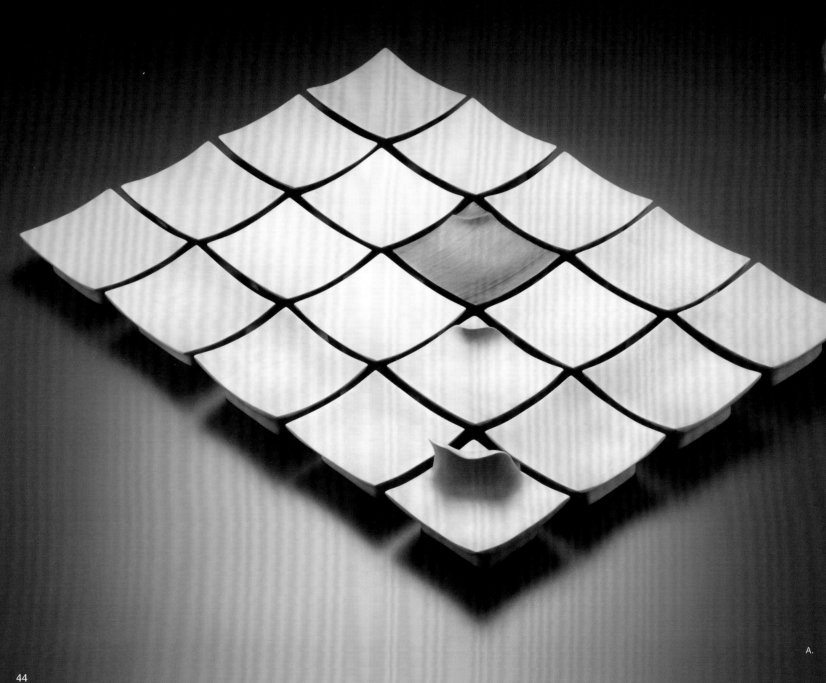

A.

B.

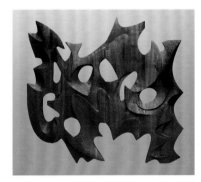

C.

In 1908, the Austrian architect, designer, and theorist Adolf Loos published an incendiary treatise entitled "Ornament and Crime." The essay equated the use of ornamentation in late nineteenth and early twentieth century architecture and design with the destruction of culture and society. Loos felt strongly that ornament had no meaning or place within contemporary culture, even going so far as to argue that ornament actually hindered society's progress. Specifically, Loos viewed superfluous ornament as an epidemic, one that contributed to the obsolescence of objects. He advocated for simplicity, because simple objects never go out of style and therefore would be treasured for all time.

Even today, Loos's questioning of the role of ornamentation still resonates within the architecture and the decorative arts communities. Academics, critics, students, artists, and curators regularly discuss and debate the topic, asking themselves such questions as: What purpose does ornament serve the design of an object? Is it simply a function of style? Does ornament contribute anything meaningful to objects today?

And so on the occasion of the one hundredth anniversary of Loos's treatise, the opportunity to test the relevancy of his ideas in a twenty-first century context presented itself in the form of *Is Ornament a Crime?: Rethinking the Role of Decoration in Contemporary Wood,* a special exhibition for SOFA CHICAGO organized under the auspices of the Collectors of Wood Art. This show challenged wood artists today to create a work that responds to Loos's advocacy of unornamented form without sacrificing creativity or technique.

While the theme of the exhibition came as a shock to many in the wood community because of the preponderance of carving, inlaying, coloring, segmenting, and other surface-altering techniques of wood today, the history of the field makes clear that objects of unornamented design have always played a major role in defining style. Pioneering artists of the 1940s and 1950s, such as James Prestini, Bob Stocksdale, Emil Milan, and John May, established the aesthetic roots of wood art through their creation of geometric, functional, and sculptural forms that formally addressed wood's natural properties. Second-generation artists such as David Ellsworth, Edward Moulthrop, Stephen Hogbin and others built upon this philosophy by introducing new techniques and sharing methods and began to shape the field themselves.

By the 1980s, wood art, while still focused largely on the vessel, had completely embraced a more freeform style. Natural edges, burls and knots, spalting, and decayed elements were celebrated rather than eradicated altogether. From there, it was a short leap for artists to incorporate color and all-over texture in their work as well as to introduce narrative and figurative forms. Some artists pushed the boundaries of acceptability even further by adding alternative materials to their compositions. For a field whose basic premise is subtractive, rather than additive, the swing of the pendulum so far in the direction of a "more is better" style was shocking indeed. As John Perrault said in a recent written exhibition review, "Am I alone in suspecting a kind of wood rococo—a lessening of formal and therefore expressive standards?"[1]

A.
Holly Tornheim
Unfolding Wave, *2010*
holly, pacific yew
1.75 x 16.75 x 12
represented by del Mano Gallery

B.
David Ellsworth
Pine Pot, *2006*
ponderosa pine
6 x 9 x 9.5
represented by del Mano Gallery

C.
David Groth
Marinus, *2007*
myrtlewood
50.25 x 56w x 5.25
represented by del Mano Gallery

Is Ornament a Crime? is a reaction to the recent predominance of this type of turned and sculptural wood. In response to the call for entries, over forty artists submitted pieces for consideration, sixteen of which were accepted into the show. The final group is comprised of both turners and sculptors and features work by Christian Burchard, Hunt Clark, David Ellsworth, Liam Flynn, David Groth, Robyn Horn, Tex Isham, Ron Kent, Stoney Lamar, Harry Politt, Norm Sartorius, Betty Scarpino, Steve Sinner, Holly Tornheim, and Joël Urruty. Many of these artists already prioritized form without added decoration. For others, the challenge of the exhibition theme provided the impetus to stretch in a new direction.

Turned vessels in the exhibition include David Ellsworth's *Pine Pot,* which with its spherical ovoid shape, is a direct descendent of James Prestini's style, symbolically honoring his concepts of pure form as well as Christian Burchard's *Multiple Offerings* with its nest of simple, graduated, and open forms. On the other end of the spectrum, abstract sculpture is represented by David Groth's monumental wall sculpture *Marinus,* which emphasizes the dynamic interplay of solid and void, organic curve and hard lines and Harry Pollitt's fluid, mobius strip-based totem flows and builds upon itself. Holly Tornheim's *Unfolding Wave* as well as Joël Urruty's *Swan Lady* demonstrates the figurative or representational impulse.

These works as well as the pieces by the other artists underscore the fact that the range of forms and aesthetics represented in the exhibition is extraordinary. Turned vessels are displayed side-by-side with figural sculptures, architectonic works, and narrative pieces. Abstract and organic shapes play a major role as does an emphasis on fluidity and movement. Boldness, a sure handling of material, and a desire to create harmonious relationships between material, technique, and form mark each of the works. Not one of the pieces suffers from a lack of decoration.

Overall, the work in *Is Ornament a Crime?* asks the viewer to contemplate his or her own feelings about the role of ornament in contemporary wood, to put a stake in the ground on the subject the way Loos once did. As wood art continues to evolve aesthetically, technically, and intellectually over time, artists, critics, and observers alike should engage in this type of rigorous public discourse, regardless of what style is in vogue at the time. The success of any field depends on it. *Is Ornament a Crime?: Rethinking the Role of Decoration in Contemporary Wood* serves as a reminder of this and highlights the importance of diversity in wood today.

Cindi Strauss is the curator of Modern and Contemporary Decorative Arts and Design at The Museum of Fine Arts, Houston, Texas.

Published in conjunction with the SOFA CHICAGO 2010 special exhibit, *Is Ornament a Crime? Re-Thinking the Role of Decoration in Contemporary Wood* curated by Cindi Strauss and presented by Collectors of Wood Art.

[1] John Perrault, "Out of the Woods," *American Craft 66,* no. 5 (October/November 2006): 60.

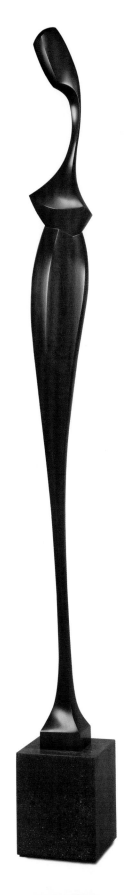

D.
Joël Urruty
Swan Lady in Dark Mahogany, *2010*
mahogany, concrete
77 x 8 x 8
represented by del Mano Gallery

D.

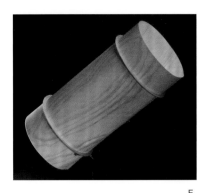

E.

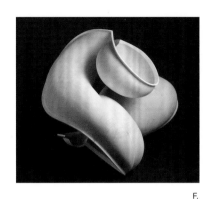

F.

G.

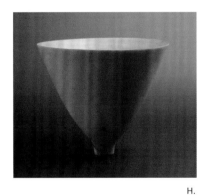

H.

I.

J.

E.
Steve Sinner
Kylindros, *2010*
sugar maple, cotton thread,
epoxy, stainless steel
11.5 x 10 x 4.625
represented by del Mano Gallery

F.
Hunt Clark
bpn610, *2010*
pear
18.5 x 22 x 16
represented by Wexler Gallery

G.
Liam Flynn
Vessel with Spine, *2010*
brown oak
11 x 14
represented by del Mano Gallery

H.
Ron Kent
Untitled (XR), *1995*
norfolk island pine
10 x 11
represented by del Mano Gallery

I.
Norm Sartorius
Homage, *2010*
cocobolo, steel
14 x 11 x 5
represented by del Mano Gallery

J.
Robyn Horn
Angled Planes, *2010*
redwood burl
14 x 16 x 13
represented by del Mano Gallery

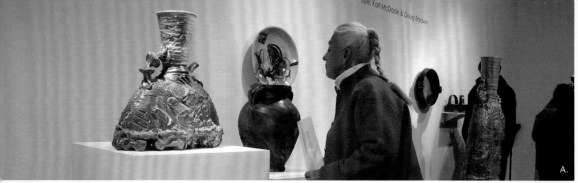

A.

B.

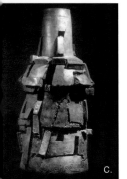

C.

Incubator: Revisited
Sixty Years at the Archie Bray Foundation

By Steven Young Lee

F.

E.

D.

G.

H.

I.

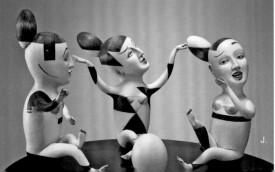

J.

K.

L.

> "The Bray years were the most valuable developing years in my career. All of the experiences were relevant, vital. There wasn't anything impossible in ceramics after you had been at the Bray."
>
> Rudy Autio, Resident Director, 1951–56

M.

Recently, while looking through the Archie Bray Foundation's (Bray) historic archives, a film was found labeled "Summer of 1955." It was footage of a very young Peter Voulkos and an even younger Rudy Autio, the first two Bray directors, working in the studio during the beginnings of the artist-in-residence program. Voulkos' thrown and altered pottery and Autio's painted vessels could be seen in their very raw form, both men seemingly unaware of the significance of their ideas and the implications of their creative exploration. They were simply two young artists in Helena, Montana seizing a unique opportunity to work, and as a result, would change ceramics in America forever.

As part of the 2001 Bray 50th anniversary, Garth Clark published an essay titled *The Bray Incubator* that reflected on the Bray's contribution to the development of ceramic art in the United States. Now, almost 10 years later, the essence of his essay remains true: "The Bray's special role has long been to develop nascent ceramic talent." He reflects on the importance of the seminal meeting between Bernard Leach, Shoji Hamada, Soetsu Yanagi, Voulkos, and Autio during a workshop in the newly minted "Pottery" in 1952. Speaking to the iconic black-and-white photograph of the five individuals, Clark writes:

> "If one looks beyond the brio of the snapshot, one can see that it records more than just a passing moment of clay-club fellowship. In ceramic terms, it is symbolically momentous—the meeting of the old world and the new on the very eve of the changing of the guard. It can be argued that at this moment, the fuse of America's ceramic revolution first began its slow burn."

"Voulkos and Autio were, relatively speaking, promising youngsters. Leach and Hamada, on the other hand, were the most famous potters in the world when the photograph was taken."

It cannot be overlooked that this revolution in clay came at a time and place where the opportunity and environment first allowed for innovation to take place. The Bray, at its brick-lined core, became the battlefield where freedom from tradition was fought.

Since its inception, the Archie Bray Foundation for the Ceramic Arts has represented a unique opportunity for artists to work in an environment unlike any other in the United States. The freedom to explore new ideas in ceramics has been central to the Bray experience and maintaining a breadth and variety of resources available to residents is an integral part of that freedom. Located near the foothills of the Rocky Mountains in Helena, Montana, the Bray began on the grounds of what was once the Western Clay Manufacturing Company. Archie Bray Sr., a brick-maker and an avid patron of the arts, envisioned an art center along with friends Peter Meloy and Branson Stevenson and built the Pottery in the spring of 1951. The establishment of the Bray in 1951 can be considered "innovative" or "cutting edge" in itself as the first residency program in the United States devoted solely to ceramics. These types of assessments are generally best evaluated in hindsight, but the Bray has remained at the forefront of this type of supported studio experience. Over the years, the Bray has continued its commitment to providing young, talented artists with a depth of resources.

A.
Archie Bray Foundation exhibition opening in North Gallery

B.
Tara Wilson firing a wood kiln, artist-in-residence 2003, 2005-2007

C.
Peter Voulkos Anasazi S13, 1999 bronze, ed.5 photo: schoppleinstudio.com

D.
Chris Staley Half Moon Covered Jar, 2009 stoneware 14 x 13 x 13

E.
Rudy Autio with horse head sculpture. Still image from "Summer of 1955" video filmed by Maxine Blackmers

F.
Kurt Weiser, Bray Director 1976–1988 Image taken in 1987

G.
Peter Voulkos demonstrating in Bray Pottery Studio. Still image from "Summer of 1955" video filmed by Maxine Blackmers

H.
Akio Takamori working in Bray studio, 2008

I.
Jacob Foran working in his studio at the Bray, summer 2010

J.
Patti Warashina Pecking Order, 2009 white ware, mixed media 21 x 40 x 25.5

K.
Workshop at the Archie Bray in 1952 left to right: Soetsu Yanagi, Bernard Leach, Rudy Autio, Peter Voulkos and Shoji Hamada

L.
Rudy Autio Mission Mountain, 2005 stoneware, 27 x 24 x 12

M.
Bray Pottery Building

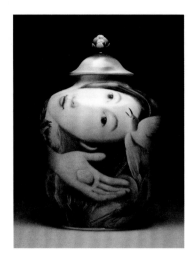

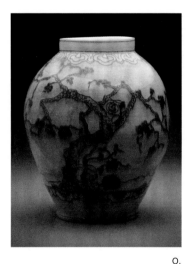

N.
Kurt Weiser
Bird Report, *2006*
porcelain

O.
Steven Young Lee
Granary Jar, *2008*
porcelain with Inlaid cobalt pigment
16 x 14 x 14

The Bray's role as expressed in Clark's essay remains, but in an ever-changing landscape. The demand for this distinctive experience has only grown as the Bray has seen applications to its program steadily increase despite the proliferation of ceramic residency programs throughout the country. With an increasing number of students graduating from BFA and MFA programs, residency programs like the Bray have become an essential part of the development and growth of future ceramic artists. However, the question remains, "How does the Bray best serve promising artists in today's world?"

As the field of ceramics has evolved, the Bray has continued to prepare itself to support artists who are taking risks through new technologies, processes, and materials; much in the same vein as Voulkos and Autio in the 1950s. These risks cannot be predicted, nor should they be, but rather borne from environment, creative exploration, and community—the latter of which has defined the Bray throughout its history. At the center of the Bray's mystique are dedicated people—artists who come together from throughout the nation and world with a shared ove of clay and a commitment to exploring their creative voices.

Only 20 artists are selected annually for a three-month summer residency or a long-term residency that may extend up to two years. Resident artists are chosen competitively based on the quality and potential of their work as well as the special contribution they can make to the Bray's artistic community. They come with a diverse range of experience, aesthetic approaches, and cultural backgrounds. Increasingly, applications for Bray residencies come from an international pool of emerging and established artists.

Each resident artist receives a studio space, access to materials and extensive firing facilities. There are no formal critiques, syllabi, or rules—simply a historic working environment that encourages and challenges each individual. The result is a synergy that defines what most Bray resident alumni consider a seminal experience in their careers. In the words of past resident Lucy Breslin, "I think of the Bray as a central terminal where passengers are always coming and going. Each time someone new arrives, they bring with them a new perspective, a new talent. Each time someone leaves, they take with them a piece of accumulative experience."

As Clark states, "The loyalty of those who have worked at this informal institution, housed within several acres of rambling brickworks, is remarkable. When the Bray comes up in conversation among potters, as it often does, there is a palpable affection for Archie Bray's vision." It is in the strength of those who have worked at and experienced the Bray that much of its success lies. Even Voulkos and Autio, after watching Hamada, were profoundly influenced by his approach. Neither had seen clay treated so loosely and freely—it was an approach that changed their whole attitude toward ceramics. The volume and quality of their work in turn drew attention to the new program and attracted many talented and ambitious potters. This confluence of ideas has continued over the years with many artists pushing one another to new heights during their time at the Bray.

In 2011, the Archie Bray Foundation will celebrate 60 years of leadership in the international ceramics community. The Bray will mark this significant milestone with the same innovative spirit that led to its inception. A distinctive fusion of visiting artists in June 2011 will culminate in a three-day international anniversary gathering, *2011: From the Center to the Edge, 60 Years of Creativity and Innovation at the Archie Bray Foundation,* June 23–25. The event will look both backwards and forwards, celebrating growth, evaluating where it has led us, and looking toward what lies ahead. The Bray's most crucial role has been to cultivate the space between the *center* and *edge,* an often overlooked space that is defined only through the passing of time. However, by gathering the right individuals in the right environment, the stage is set for cultivating new ideas.

At the center of the three-day 60th anniversary event, a core group of accomplished artists will represent the spectrum of what is happening in ceramics today. Robert Brady, John Buck, Deborah Butterfield, Beth Cavener Stichter, Josh DeWeese, Julia Galloway, Sarah Jaeger, Jun Kaneko, Richard Notkin, Don Reitz, Sandy Simon, Chris Staley, Akio Takamori, Tip Toland, Jason Walker, Patti Warashina, and Kurt Weiser will, through a series of demonstrations, lectures and, panel discussions, share their thoughts and perspectives on clay. They are living proof of the opportunities that the Bray has provided and continue to individually influence and challenge the field.

The Bray also will bring together leading innovative thinkers who are pushing the edge of ceramics. These artists will work at the Bray in a collaborative and communal studio setting with no structured agenda for the entire month of June. They then will share their perspectives and experiences as part of the anniversary event. While innovation takes many forms, the 60th anniversary-visiting artists represent fresh and original thinking in areas of technology, culture, design, education, studio

practice, and interdisciplinary collaboration. The artists who have committed to be in residence in June are: John Balistreri, Andy Brayman, Caroline Cheng, Chad Curtis, Ayumi Horie, KleinReid (James Klein and David Reid), Linda Sormin, Bobby Silverman, Steven Thurston, John Williams, and Jennifer Woodin. They will have full access to the Bray's ceramic facilities, including the new state-of-the-art kilns in the Shaner Resident Studio complex. Each artist was chosen specifically for his or her contributions to the field and ability to look beyond tradition. They have forged new paths in their creative processes that have led to artistic and technological innovations.

Statewide exhibitions and a benefit auction will take place during the event and will include all of the past and current resident artists who have spent time at the Archie Bray Foundation. This will allow the public to see the influence of the Bray in the form of the highest quality of ceramic art from artists over the past 60 years. Ultimately, it is through the artwork that the success of the Bray as an incubator will be measured.

Clark's essay concludes, "Now the Bray faces the challenges of being a mature organization with a growing community, a history and a future. This reevaluation of the achievements of the Archie Bray Foundation is a timely first step in celebrating the past 50 years, just as the Bray begins to take on the promise and challenge of new roles in the twenty-first century."

Meeting new challenges has always been and always will be integral to the Bray; it is only in this way that our promise can continue to be fulfilled. From the first day that Archie Bray opened the doors to the Pottery to the upcoming 60th anniversary, the Bray has evolved, as artists and their ideas have evolved. It is the Bray's commitment to the role as an incubator of talent, however, that must never change. That commitment is what makes the Bray both crucial and unique in the past, present and future. The Archie Bray Foundation will always be, in the words of Archie Bray, Sr., "A place to make available for all who are seriously and sincerely interested in any of the branches of the ceramic arts, a fine place to work."

Steven Young Lee received his MFA in Ceramics from the New York State College of Ceramics at Alfred University in 2004. In 2004-5, he lectured and taught at numerous universities throughout China. While there, Lee created a new body of work as part of a one-year cultural and educational exchange fellowship in Jingdezhen, Jianxi Province. He has taught at Interlochen Center for the Arts in Michigan, the Clay Art Center in New York, the Lillstreet Studio in Chicago, and Emily Carr Institute of Art and Design in Vancouver, B.C. Lee is currently the Resident Artist Director of the Archie Bray Foundation.

Published in conjunction with the SOFA CHICAGO 2010 special exhibit, *Archie Bray Foundation—60 Years of Creativity and Innovation* presented by the Archie Bray Foundation.

P.
John Balistreri
Model Comparison of Tea Bowl
The original ceramic tea bowl is on the top left and the ceramic prototype is on the top right, the bottom images is of the 3D model of the piece. In 2006, John Balistreri and others at Bowling Green State University began research into 3D Rapid Prototyping machines, creating printed ceramic art objects. This research has led to the invention of ceramic powders and binder systems that enable clay material to be printed form a computer model and kiln fired for the first time.

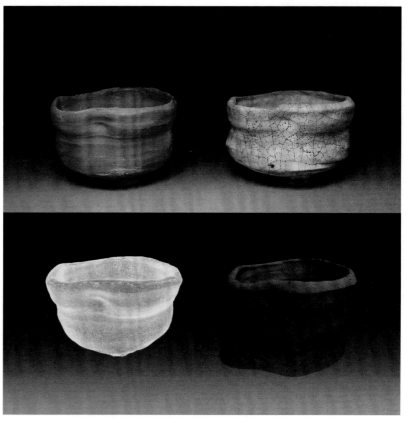

P.

Icy and Red Hot Peter Bremers

By Dagmar Brendstrup

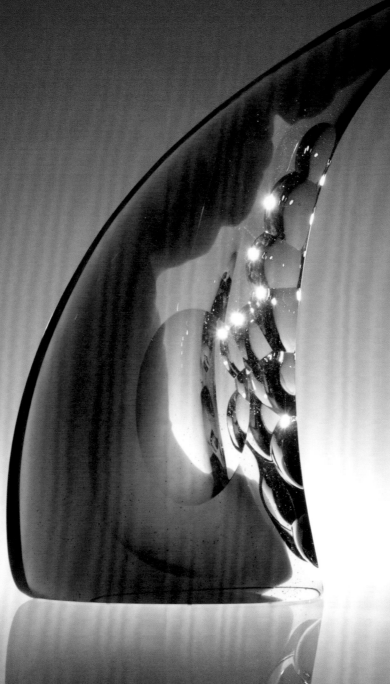

A.

I have had the pleasure of meeting Peter Bremers on a number of occasions. Rarely have I met a person who is so attentive and "switched on." He is a very committed person and involves himself in his surroundings wherever he goes—right from the very people he meets to the different aspects of art and nature he discovers. He is a man of contrasts: he loves company and publicity, but also highly appreciates the stillness and wonders of nature. He also seeks and explores the contrasts in nature—from expeditions to the bitter cold arctic to treks in red-hot canyons and deserts. Peter Bremers' sculptures are characterized by a timeless modern touch. At first glance, they seem simple and understandable. The journalist Rüdiger Otto von Brocken expressed this in an essay "antARCTIC", Glasmuseet Ebeltoft, DK 2008:

They tell no stories, yet stories take shape in them. In his works, he shares the original peoples' admiration for nature without glorifying it. Thus his sculptures reflect—without copying—the light, shadow, grace, texture, form and color of these unreal but (still) real places from which they spring. What singles him out as an artist is the fact that he never loses his balance. His works never deteriorate into mere decorative quotations from nature. Peter Bremers' art—like the man himself—is down to earth, whether he is floating on an iceberg in the Arctic Sea, staying at the edge of a canyon, or climbing a wandering sand dune in the Sahara desert.[1]

Development

In order to understand the art of Peter Bremers today, it is interesting to watch the development and changes in his work since he graduated from the University of Fine Arts in Maastricht in 1980, where he studied three-dimensional design. As a sculptor, he was constantly in search of light, which he tried to capture in his light sculptures. During this search he discovered glass as an ideal medium for giving form to his ideas. His first designs were realized by Lino Tagliapietra and Bernard Heesen.

Peter Bremers traveled a lot during this time and continues to do so, not necessarily because he is restless, but to explore other cultures. He has had many experiences on his travels. He has stayed in a Buddhist monastery in Thailand and assisted with the making of a crystal *stupa* (a Buddhist monument for storing relics); later he met a mask-maker in Bali; visited the Dajak tribes in Borneo, and sailed the oceans. These journeys had, and still have a great impact on Peter Bremers' life and work:

"Traveling brings me to new places and always initiates new ideas, encounters, sounds, smells, tastes, thoughts, dreams, etcetera. It accumulates in "landscapes," four-dimensional "realities" that exist only as a result of the world and me in continuous ever-changing relationships. I look at it but am an intricate part of it as well. Being in Antarctica made me aware of this relationship. It changed my look upon nature as I felt more part of it than ever before. It helped me understand that man is not only part of nature but therefore also part of creation itself and its continuous evolution. It gave more depth to my life and thus my art work. My *Icebergs and Canyons and Deserts* series express this deep process. These glass sculptures are landscapes, the reflections of my inner travels mirroring my outer travels. They invite the viewer to share my experiences and inspiration. That to me is what my art is about."

Until 2001, Peter Bremers worked solely with blown glass. However, after his return from Antarctica, he was changed forever. The journey was his first meeting with the Arctic's wide, snow-covered landscapes, magical nights, freezing wind, icebergs, whales, and flocks of penguins, albatrosses, and seals. Confronted with the rough powers of nature, he was struck by awe and humility. He decided to concentrate on kiln-formed glass, which he felt best to express his impressions and experiences from his meeting with the greatness of nature. In Antarctica, he observed the kaleidoscopic effects

A.
Peter Bremers
Icebergs & Paraphernalia 196, *2010*
kiln-cast glass
photo: Paul Niessen

of the daylight on and around the ice for the first time. Glass is the material naturally closest to ice and the intensifying and reflecting qualities inherent in glass are also very similar to those of ice. One year later he made the first sculptures in kiln-formed, cast glass. Since his initial journey to Antarctica, Peter Bremers has visited Greenland and Spitsbergen by ship. During the last few years, Bremers has made a changeover from water, ice, and icebergs to canyons, deserts, stone, and rock. One feels tempted to say that Bremers has moved from frost to heat. He has moved from the blue, bright, and clear colors to warm yellow and orange colors. Looking at the *Icebergs and Paraphernalia* sculptures, one can look from the outside in, and where the thickness of the glass guides your eye along the structure back to the surface.

The *Canyons* let the eye penetrate the polished but rough surface, revealing the structure and the outside form. Rock is not transparent but the glass is allowed to "crawl" into the mountain, to move through it, experiencing time. A distinguishing difference. You know when you see a Bremers sculpture. The color is bright, the surface is both soft and rough, and the shape is organic, strong, and yet sensible. In a work like *Sedona Sunset,* measuring 68 cm high, looking into the rough-cut surface makes you feel as if you were in the red hot canyon.

Peter Bremers is the artist and the composer, but, like a conductor, he could not do it without the musicians and skilled technicians like Neil Wilkin (GB), Michael Behrens (D) and Studio Lhotsky (CZR). Together they create magnificent masterpieces.

In 2008/2009, The Ebeltoft Glasmuseet in Denmark featured a solo-exhibition of Peter Bremers called "antARTIC," showing a group of large-scale sculptures from his *Icebergs & Paraphernalia series.* In 2009, Bremers also exhibited at SOFA and, later that year, in a group exhibition at the Litvak Gallery, which is dedicated to representing and promoting the world's finest artists working in mainly glass as their medium of expression. This year at the booth, Litvak Gallery proudly presents an extensive collection of new works by Bremers, specially created for SOFA CHICAGO 2010. Apart from his stunning new *Icebergs*, this will also be the first major display of outstanding sculptures inspired by the extraordinary beauty of America's Canyons and Deserts.

Dagmar Brendstrup, executive director, Glasmuseet Ebeltoft, Denmark.

[1] Brocken, Rüdiger Otto von. "antARCTIC", Glasmuseet Ebeltoft, DK 2008

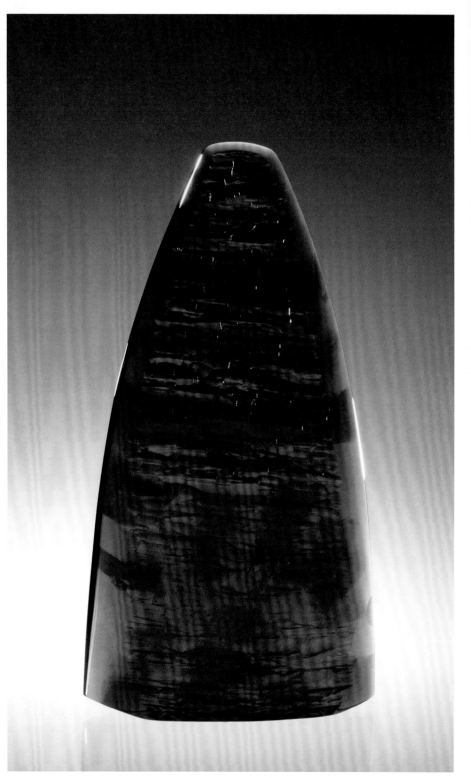

B.

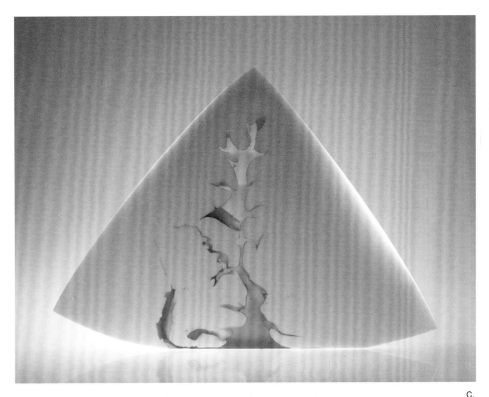

C.

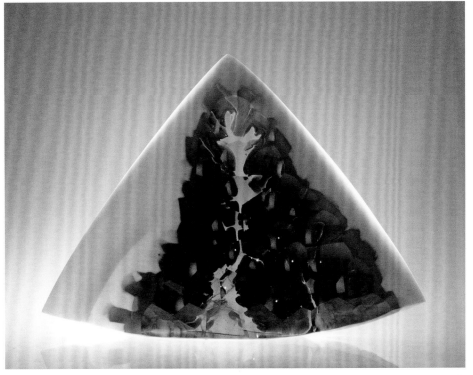

D.

SOLO
S AT O F A

A singular introduction to new artists, new works. Dedicated spaces for one-person and themed shows on the cutting-edge of concept, technique or materials.

Presented by SOFA CHICAGO dealers in addition to their booth exhibits

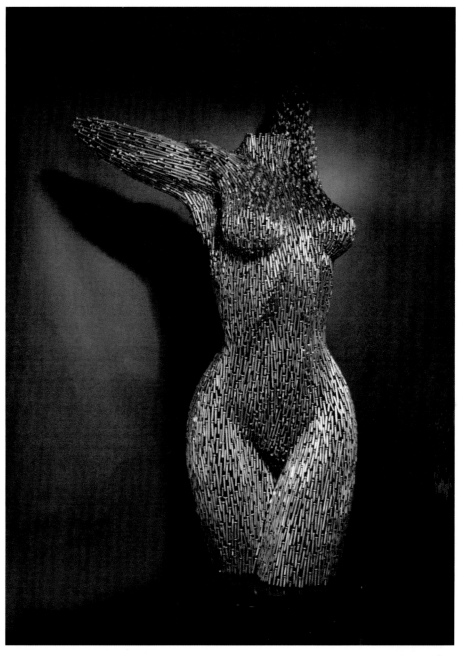

Female Torso, *2010*
steel nails
112 x 58 x 36

Ferrin Gallery
Christa Assad

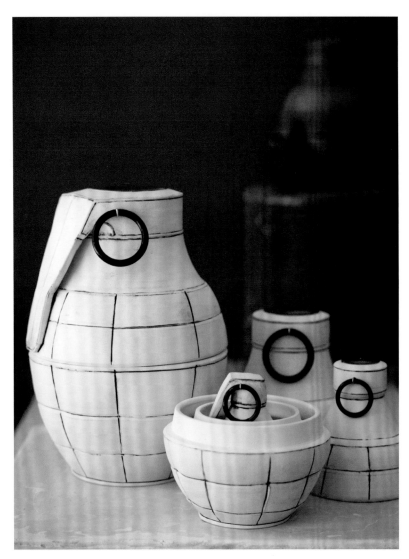

Nesting Grenades, *2010*
stoneware, oxides, glaze
tallest: 12.5 x 8.5

Study of Michaelangelo's David, *2008*
graphite pencil on paper
22 x 30
photo: Norbert Heyl

Next Step Studio & Gallery
Joan Rasmussen

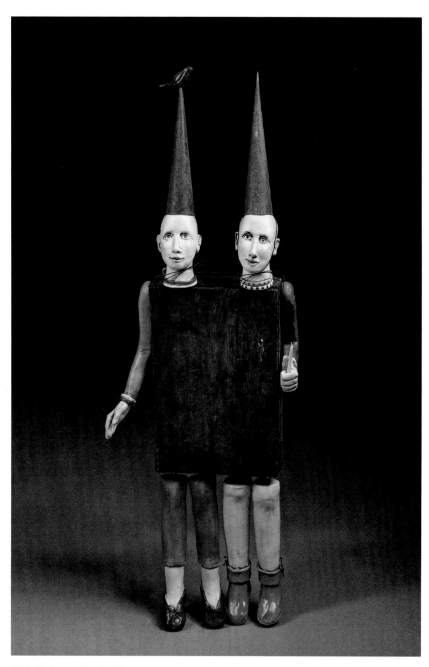

Wish Maker + Son, *2010*
ceramic, wood, found objects
30 x 14 x 7

Next Step Studio & Gallery
Michael Schunke

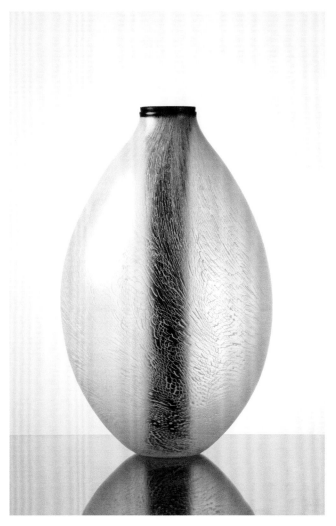

Crucible, *2009*
blown glass, sandblasted and acid-polished
21 x 11

Option Art
Susan Rankin

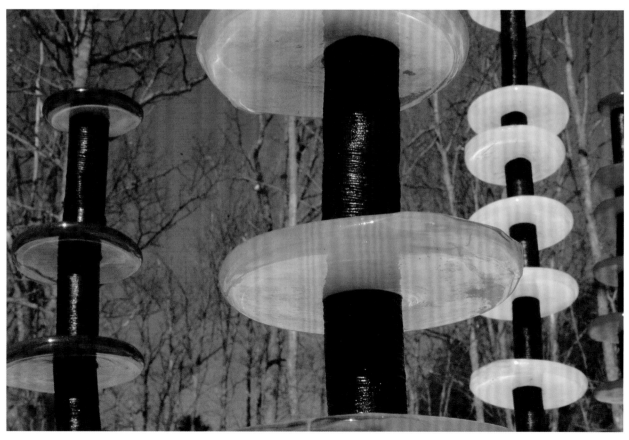

Garden Installation, *2010*
glass, metal

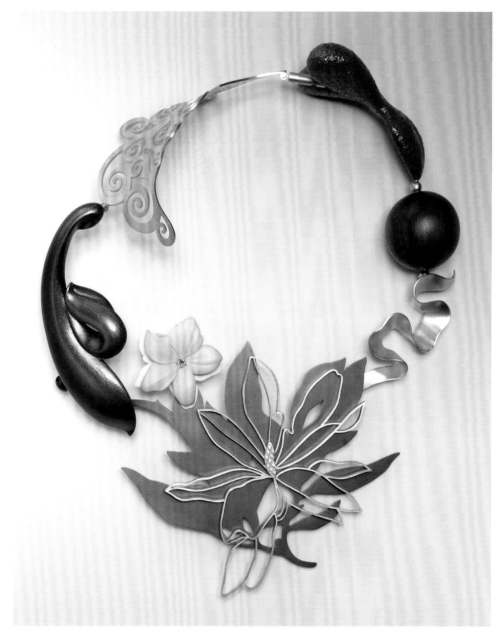

Lucia's Leaves, *2010*
carved and painted maple, sterling silver, 24k gold and nickel-plated brass,
14k yellow gold, rosewood, color core micarta

Thomas R. Riley Galleries
Ricky Bernstein

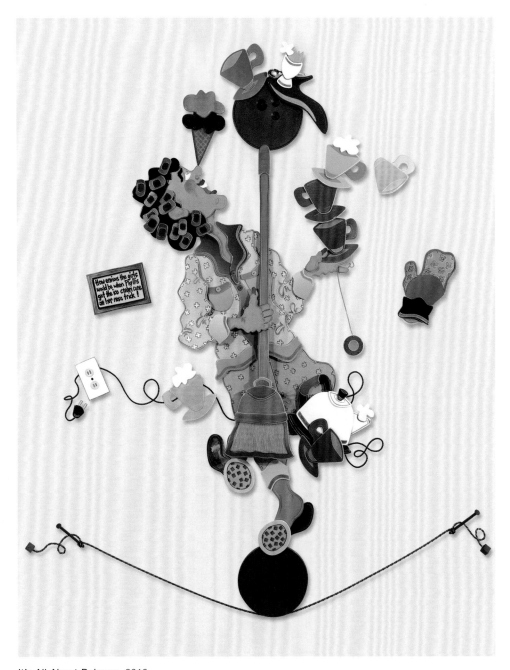

It's All About Balance, 2010
painted glass and aluminum, oil and acrylic paint,
color pencil, mixed media objects
81 x 69 x 49
photo: Michael Flower

Exhibitor Information

xhibitors

Arata Fuchi, Ring, *2010*
oxidized silver, silver powder, fine gold, 3 x 1.25 x 1

Aaron Faber Gallery

20th and 21st century jewelry and timepieces; special SOFA focus Masters and Apprentices
Staff: Edward Faber; Patricia Kiley Faber; Tamara Leacock; Felice Salmon

666 Fifth Avenue
New York, NY 10103
voice 212.586.8411
fax 212.582.0205
info@aaronfaber.com
aaronfaber.com

Exhibiting:
Rami Abboud
Britt Anderson
Glenda Arentzen
Jordan Barnett-Parker
Marco Borghesi
Claude Chavent
Petra Class
Marilyn Cooperman
Sabine Dessarps
Peggy Eng
Arata Fuch
Claudia Geiger
Michael Good
Insa Grotefendt
Barbara Heinrich
Lucie Heskett-Brem
Regina Hiestand
Juha Koskela
Stephen LeBlanc
Ayesha Mayadas
Enric Majoral
Brooke Marks-Swanson
Bernd Munsteiner
Tom Munsteiner
Earl Pardon
Tod Pardon
So Young Park
Linda Kindler Priest
Peter Schmid
Susan Kasson Sloan
Simon Spinoly
Christian Streit
Liz Tyler
Ginny Whitney
Liaung-Chung Yen
Michael Zobel/Peter Schmid

Tom Munsteiner, **Ring,** *2009*
17.03ct green tourmaline, 18k yellow gold, .5 x .75 x .75

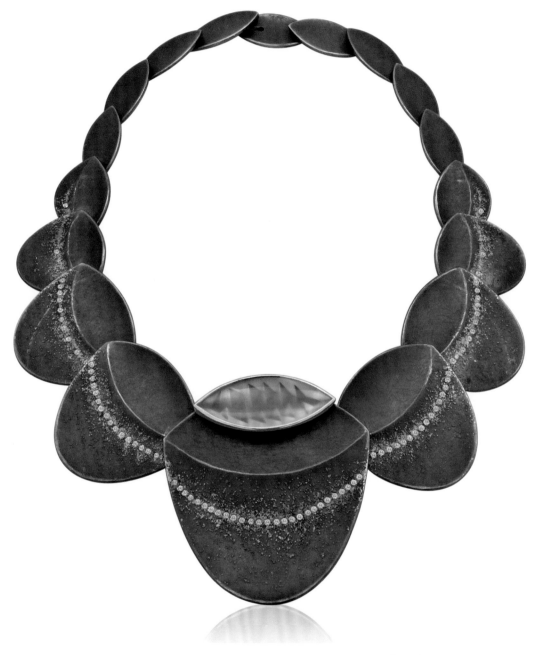

Peter Schmid, **Necklace,** *2008*
oxidized sterling silver, 24.3ct moonstone by Tom Munsteiner, 0.91ct diamonds, 17 inches in length

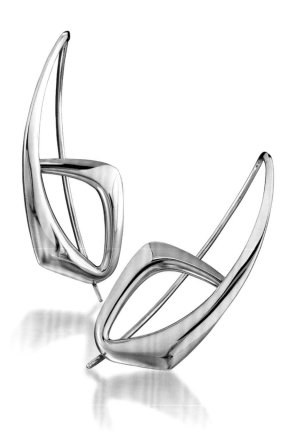

Britt Anderson, **Earrings**
18k white gold, 1.5 x .5 x .5

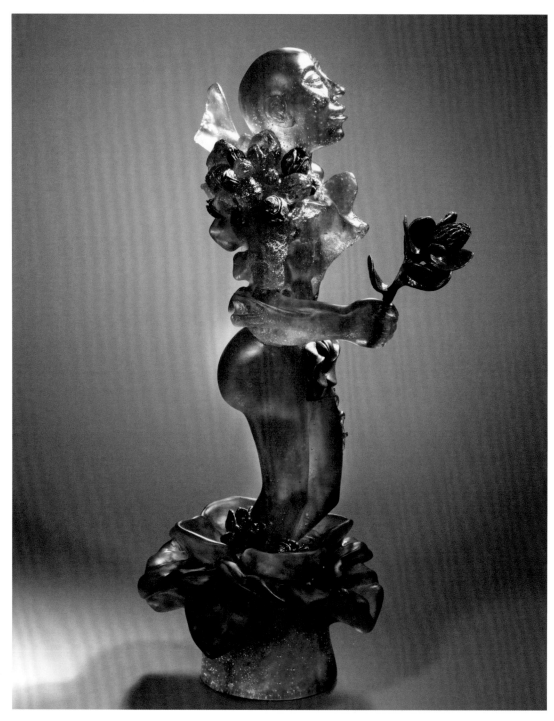

Susan Silver Brown, **The Emergence of Hyacinth's Offering of Honor,** *2010*
cast lead crystal glass, bronze, 23 x 12 x 8

Adamar Fine Arts

Contemporary paintings and sculpture by established and emerging national and international artists
Staff: Tamar Erdberg, owner/director; Adam Erdberg, owner

4141 NE 2nd Avenue
Suite 107
Miami, FL 33137
voice 305.576.1355
fax 305.576.1922
adamargal@aol.com
adamarfinearts.com

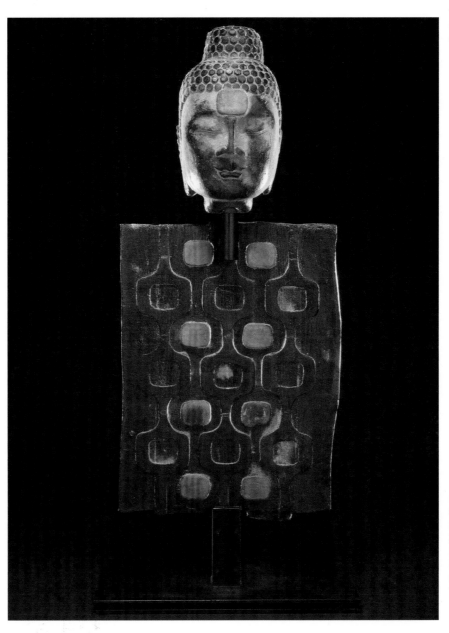

Exhibiting:
Susan Silver Brown
Brad Howe
Zammy Migdal
Niso
Rene Rietmeyer
Marlene Rose
Tolla

Marlene Rose, **Brazilian Mosaic Buddha,** *2010*
cast glass, 39 x 19 x 6

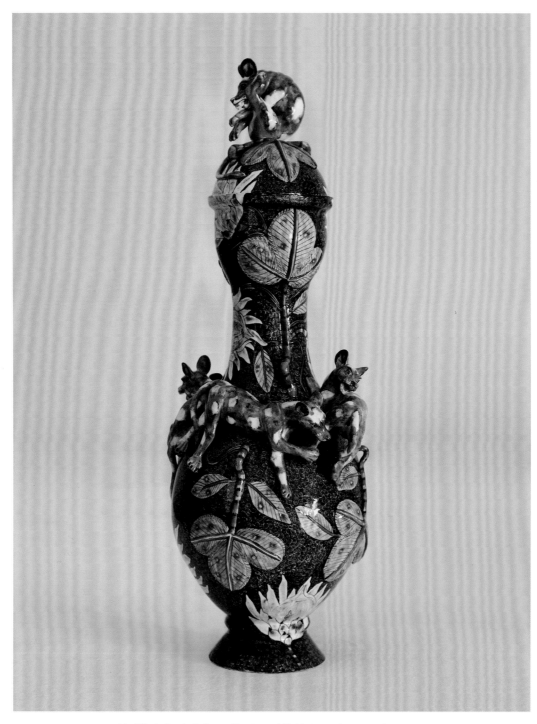

Vusi Ntshalintshali, Benet Zondo and Zinhle Nene (Ardmore Ceramic Art), **Wild Dog Urn,** *2009*
hand-painted ceramic, 28 x 13 x 12
photo: David Ross

Amaridian

Contemporary ceramic art, vessels and sculpture from Sub-Saharan Africa
Staff: Fraser Conlon; Christiana Masucci; Alena Marajh; Robert Selby

31 Howard Street
New York, NY 10013
voice 917.463.3719
fax 917.463.3728
info@amaridianusa.com
amaridianusa.com

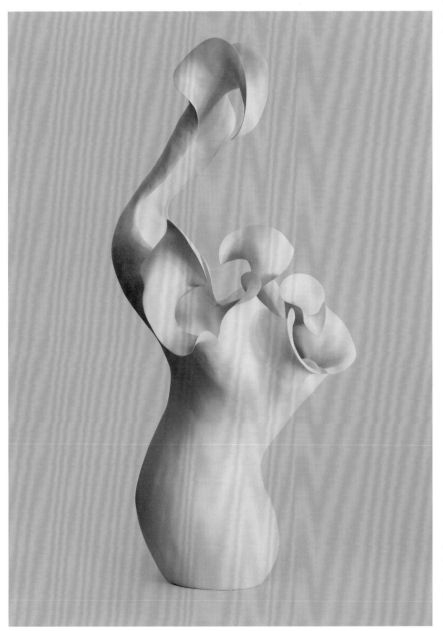

Exhibiting:
Ardmore Ceramic Art
Astrid Dahl
Katherine Glenday
Nic Wells Bladen
Ubuhle

Astrid Dahl, **Dendrobium Unicum,** *2010*
earthenware, 32 x 17 x 16
photo: David Ross

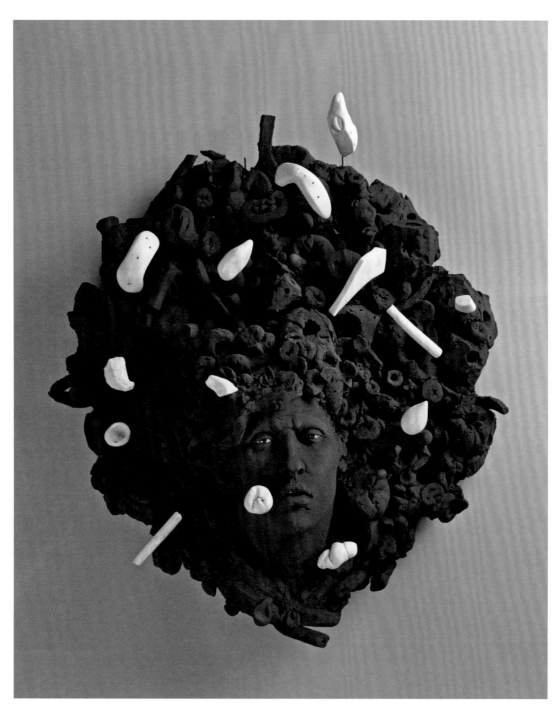

Cristina Cordova, **Vestigios**
ceramic and mixed media, 29 x 28 x 13

Ann Nathan Gallery

Contemporary figurative and realist painting, sculpture, and artist-made furniture by established and emerging
Staff: Ann Nathan, owner/director; Victor Armendariz, assistant director;
Jan Pieter Fokkens, preparator; Julie Oimoen

212 West Superior Street
Chicago, IL 60654
voice 312.664.6622
fax 312.664.9392
nathangall@aol.com
annnathangallery.com

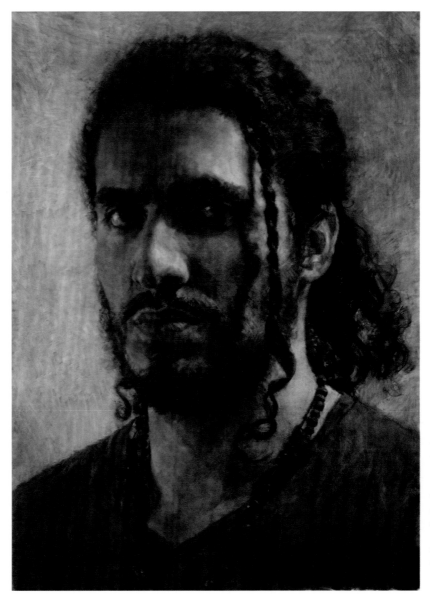

Exhibiting:
Pavel Amromin
Mary Borgman
Gordon Chandler
Cristina Cordova
Michael Gross
Peter Hayes
Chris Hill
Jesus Curia Perez
Jim Rose
Marc Sijan
John Tuccillo
Jerilyn Virden

Mary Borgman, **Portrait of Federico Guendel**
charcoal on Mylar, 58 x 42

Michael Glancy, **Uranium Undulation,** *2009*
deeply engraved blown glass with uranium veil, blue industrial plate glass, copper, silver, 10.5 x 18.5 x 18.5

Barry Friedman Ltd.

Contemporary decorative arts including glass and ceramics; design, painting and photography
Staff: Barry Friedman, owner; Carole Hochman, director; Osvaldo DaSilva, associate director

515 West 26th Street
2nd floor
New York, NY 10001
voice 212.239.8600
fax 212.239.8670
contact@barryfriedmanltd.com
barryfriedmanltd.com

Exhibiting:
Cristiano Bianchin
Jaroslava Brychtová
Wendell Castle
Ingrid Donat
Michael Glancy
Brian Hirst
Takahiro Kondo
Stanislav Libenský
William Morris
Yoichi Ohira
David Regan
Laura de Santillana
Akio Takamori
Tip Toland
Kukuli Velarde
František Vízner
Toots Zynsky

Yoichi Ohira with Maestro Andrea Zilio and Maestro Giacomo Barbini, **Cristallo Sommerso Scolpito N.68, N.69, N.67,** *2009 handblown glass canes, partial battuto and inciso surface, tallest: 13 inches high*

Jeremy Lepisto, **Familiar Surroundings (Crate Series),** *2010*
kilnformed glass, 12 x 12 x 6

Beaver Galleries

Contemporary Australian fine art and craft
Staff: Martin Beaver, director

81 Denison Street, Deakin
Canberra, ACT 2600
Australia
voice 61.26.282.5294
fax 61.26.281.1315
mail@beavergalleries.com.au
beavergalleries.com.au

Exhibiting:
Brenden Scott French
Holly Grace
Jeremy Lepisto

Brenden Scott French, **Predator - 1 am cnr Hamburg and Hindley**, *2010*
kilnformed and coldworked glass, 12.25 x 26.75 x 3.25

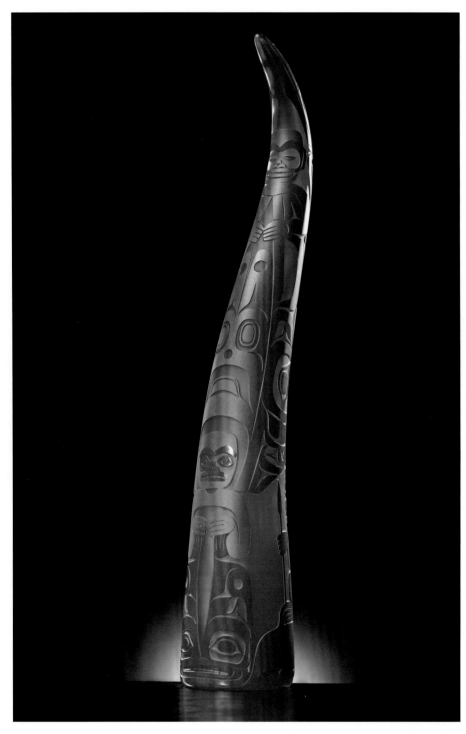

Preston Singletary, **Lazy Boy/Strong Man,** *2010*
blown and sandcarved glass, 31 x 5
photo: Russell Johnson

Blue Rain Contemporary

Staff: Leroy Garcia, owner and president; Denise Marie Rose, vice president of business development; Peter Stoessel, executive director

130 Lincoln Avenue
Suite C
Santa Fe, NM 87501
voice 505.954.9902
info@blueraingallery.com
blueraingallery.com

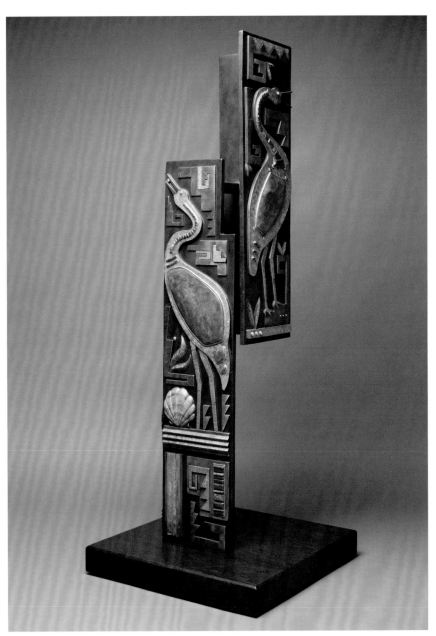

Exhibiting:
Rik Allen
Tammy Garcia
Shelley Muzylowski Allen
Preston Singletary

Tammy Garcia, **The River Delivers,** *2010*
bronze, 47 x 18 x 18 including base
photo: Addison Doty

Sara Brennan, **Broken White Band with Pin,** *2007*
linen, wool, cotton, 41.5 x 36
photo: Tom Grotta

browngrotta arts

Focusing on art textiles and fiber sculpture for more than 22 years
Staff: Rhonda Brown and Tom Grotta, co-curators; Roberta Condos, associate

By Appointment
Wilton, CT
voice 203.834.0623
fax 203.762.5981
art@browngrotta.com
browngrotta.com

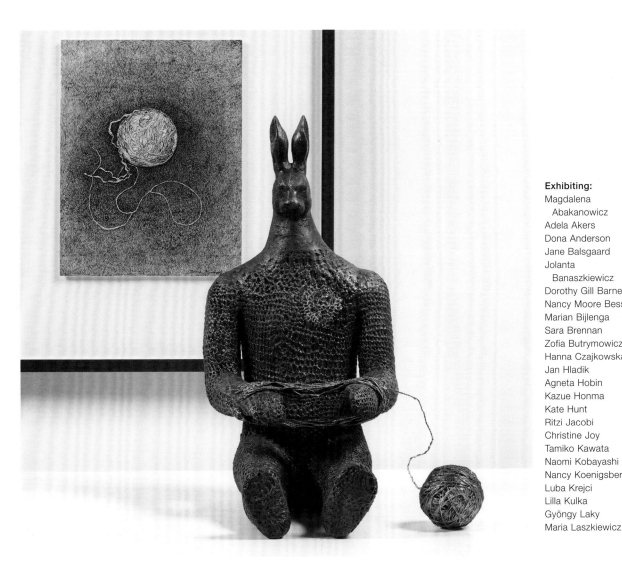

Norma Minkowitz, **I Give Myself**, *2010*
mixed media, 28 x 32 x 23
photo: Tom Grotta

Exhibiting:

Magdalena Abakanowicz
Adela Akers
Dona Anderson
Jane Balsgaard
Jolanta Banaszkiewicz
Dorothy Gill Barnes
Nancy Moore Bess
Marian Bijlenga
Sara Brennan
Zofia Butrymowicz
Hanna Czajkowska
Jan Hladik
Agneta Hobin
Kazue Honma
Kate Hunt
Ritzi Jacobi
Christine Joy
Tamiko Kawata
Naomi Kobayashi
Nancy Koenigsberg
Luba Krejci
Lilla Kulka
Gyöngy Laky
Maria Laszkiewicz

Jennifer Falck Linssen
Mary Merkel-Hess
Norma Minkowitz
Keiji Nio
Jolanta Owidzka
Axel Russmeyer
Agnieszka Ruszczynska-Szafranska
Wojciech Sadley
Toshio Sekiji
Hisako Sekijima
Anna Sledziewska
Jin-Sook So
Noriko Takamiya
Anna Urbanowicz-Krowacka
Ulla-Maija Vikman
Wendy Wahl
Lena McGrath Welker
Merja Winqvist
Krystyna Wojtyna-Drouet
Chang Yeonsoon
Jiro Yonezawa
Carolina Yrarrázaval

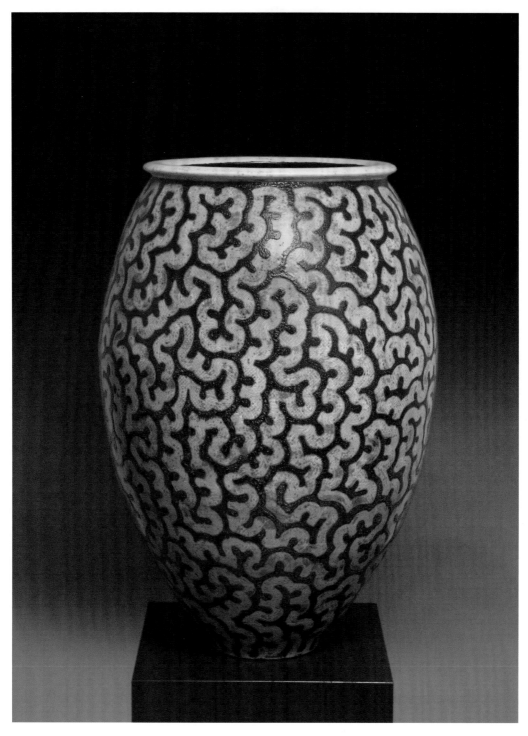

Per Weiss, **Untitled,** *2010*
ceramic, 46 inches high

Bruno Dahl Gallery

Contemporary fine art
Staff: Bruno Dahl, owner

Stockflethsvej 12
Ebeltoft 8400
Denmark
voice 45.86.259.594
info@brunodahl.dk
brunodahl.dk

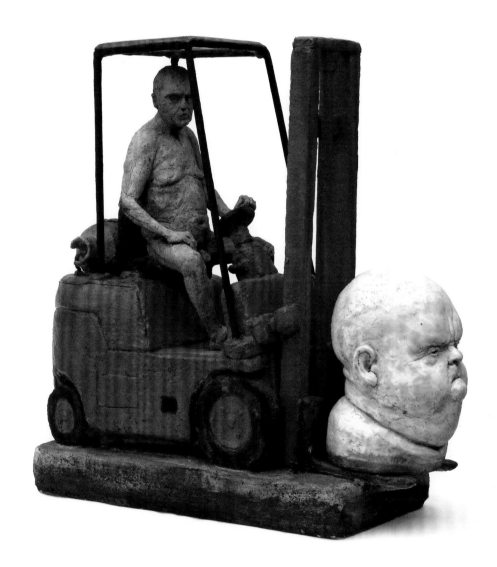

Exhibiting:
Lars Calmar
Keld Moseholm
Per Weiss

Lars Calmar, **Truck,** *2010*
ceramic, 22 inches high

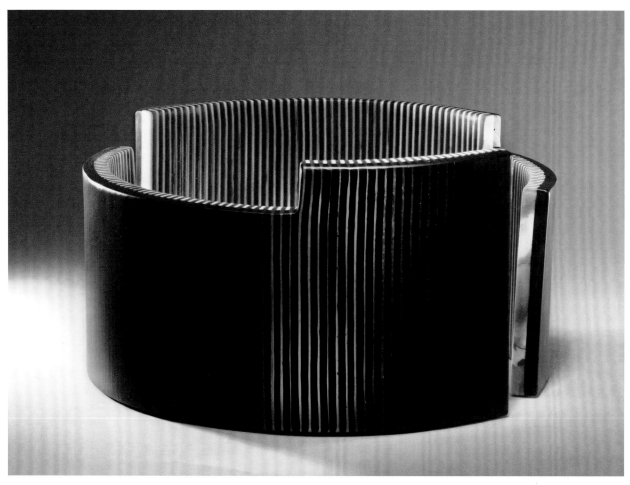

Steve Klein, **Shelter 3**, *2010*
kilnformed glass, 8.5 x 16 x 16
photo: J. Van Fleet

Bullseye Gallery

Contemporary works in Bullseye Glass by established and emerging artists
Staff: Lani McGregor, director; Jamie Truppi, assistant director; Ryan Boynton, preparator

300 NW 13th Avenue
Portland, OR 97209
voice 503.227.0222
fax 503.227.0008
gallery@bullseyeglass.com
bullseyegallery.com

Exhibiting:
Karen Akester
Kate Baker
Joseph Harrington
Steve Klein
Klaus Moje
Catharine Newell
Richard Parrish
Bruno Romanelli
Nathan Sandberg

Richard Parrish, **Penumbra***, 2010*
kilnformed glass, 9.5 x 15 x 1.25
photo: R. Cummings

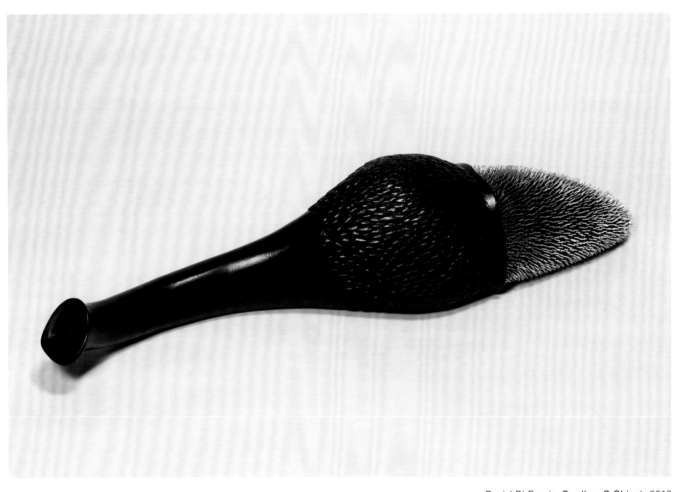

Daniel Di Caprio, **Swallow C Object,** *2010*
wood, paint, silver, 11 x 3 x 2

Charon Kransen Arts

Contemporary innovative jewelry and objects from around the world
Staff: Adam Brown; Lisa Granovsky; Charon Kransen

By Appointment Only
817 West End Avenue, Suite 11C
New York, NY 10025
voice 212.627.5073
fax 212.663.9026
charon@charonkransenarts.com
charonkransenarts.com

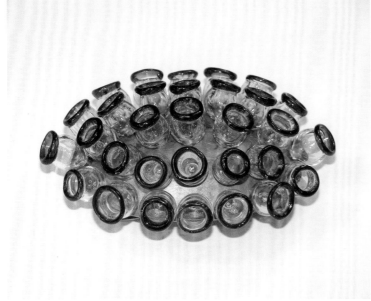

Barbara Paganin, **Fiore Di Luce Acquamare Brooch,** *2009
oxidized silver, gold, blown lampworked aquamarine and topaz glass*

Exhibiting:

Efharis Alepedis
Alidra Andre de la
 Porte
Ralph Bakker
Michael Becker
Liv Blavarp
Julie Blyfield
Sophie Bouduban
Florian Buddeberg
Anton Cepka
Yu Chun Chen
Moon Choonsun
Lina Christensen
Giovanni Corvaja
Simon Cottrell
Ramon Puig Cuyas
Annemie De Corte
Jaclyn Davidson
Saskia Detering
Daniel Di Caprio
Babette von Dohnanyi
Sina Emrich
Anna Frohn
Willemijn de Greef
Suzanne Golden
Birgit Hagmann
Sophie Hanagarth
Mirjam Hiller
Marian Hosking
Meiry Ishida
Reiko Ishiyama
Hilde Janich
Andrea Janosik

Mette Jensen
Eun Yeong Jeong
Machteld van Joolingen
Junwon Jung
Yeonmi Kang
Masumi Kataoka
Martin Kaufmann
Ulla Kaufmann
Jimin Kim
Yael Krakowski
Shana Kroiz
Kristiina Laurits
Gail Leavitt
Dongchun Lee
Felieke van der Leest
Nicole Lehmann
Kathrine Lindman
Nel Linssen
Susanna Loew
Sim Luttin
Stefano Marchetti
Vicki Mason
Sharon Massey
Leslie Matthews
Christine Matthias
Wendy McAllister
Timothy McMahon
Sonia Morel
Carla Nuis8
Angela O'Kelly
Daniela Osterrieder
Barbara Paganin
Liana Pattihis

Natalya Pinchuk
Jo Pond
Sarah Read
Anthony Roussel
Jackie Ryan
Lucy Sarneel
Isabell Schaupp
Marjorie Schick
Claude Schmitz
Debbie Sheezel
Roos van Soest
Elena Spano
Betty Stoukides
Barbara Stutman
Danni Swaag
Janna Syvanoja
Salima Thakker
Silke Trekel
Fabrizio Tridenti
Catherine Truman
Chang-Ting Tsai
Myung Urso
Flora Vagi
Christel Van Der Laan
Karin Wagner
Julia Walter
Caroline Weiss
Francis Willemstijn
Jasmin Winter
Susanna Wolbers
Annamaria Zanella

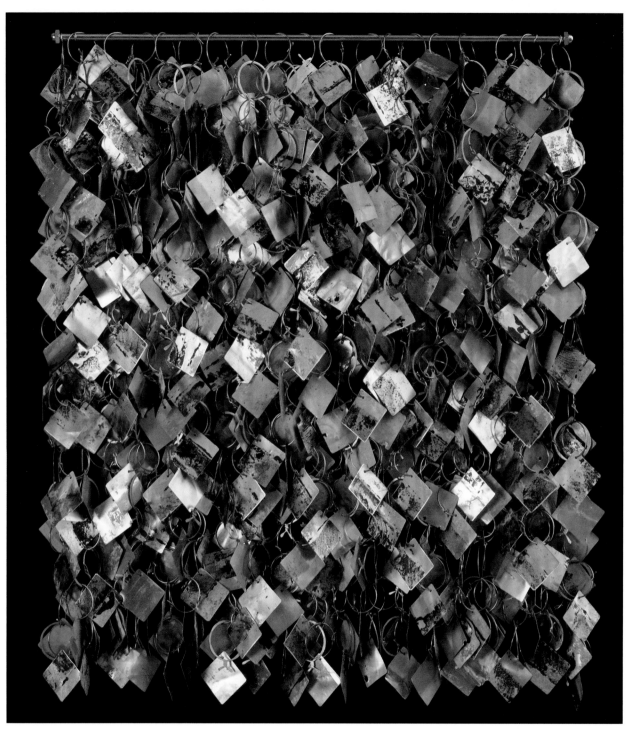

John Garrett, **Flash Armor,** *2010*
recycled aluminum, 26 x 22 x 2
photo: Margot Geist

Chiaroscuro Contemporary Art

Contemporary abstraction and contemporary Native American art in all media
Staff: John Addison, director; Frank Lux

702 1/2 Canyon Road
Santa Fe, NM 87501
voice 505.992.0711
fax 505.992.0387
john@chiaroscurosantafe.com
chiaroscurosantafe.com

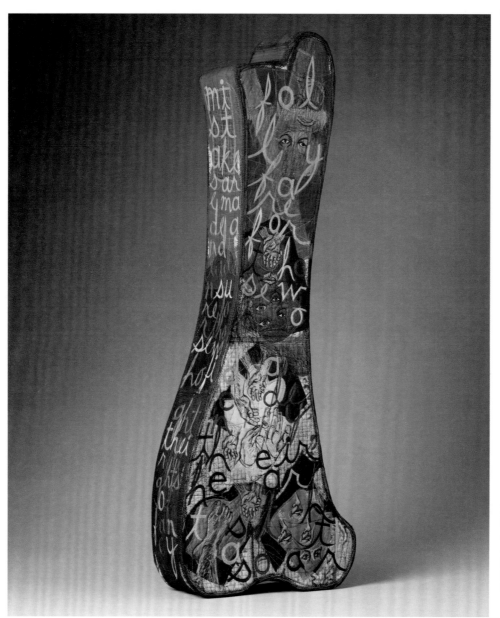

Exhibiting:
Rebecca Bluestone
Joe Feddersen
John Garrett
Kay Khan
Peter Millett
Flo Perkins

Kay Khan, **The Saga,** *2010*
quilted, pieced, appliqued, stitched fabrics, 42.5 x 15 x 16
photo: Wendy McEarhern

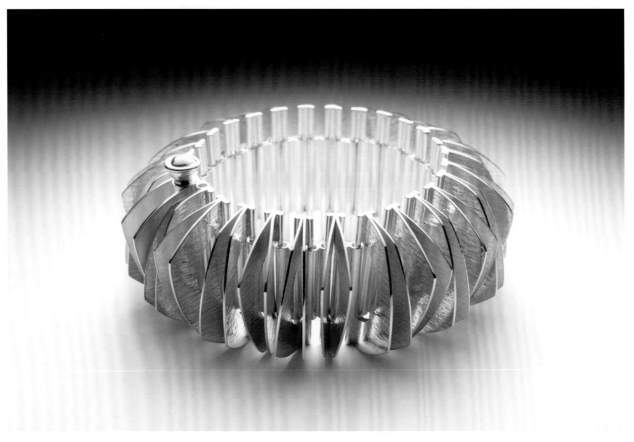

Christine Larochelle, **Bracelet,** *2009*
sterling silver, 7 x 1.25 x .75
photo: Anthony Mclean

Crea Gallery

Contemporary fine craft in a variety of media by emerging and established Quebec artists
Staff: Linda Tremblay, director; Kimberly Davies

350 St. Paul Street East
Montreal, Quebec H2Y 1H2
Canada
voice 514.878.2787, ext. 2
fax 514.861.9191
crea@creagallery.com
creagallery.com

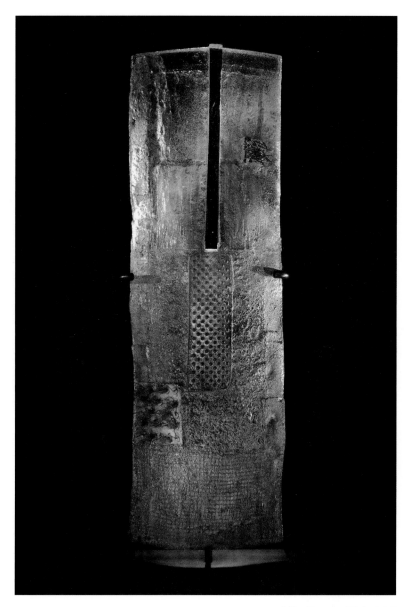

Exhibiting:
Chantal Gilbert
Karina Guevin
Christine Larochelle
Lynn Légaré
Paula Murray
Gilles Payette
Stephen Pon
Colin Schleeh
Luci Veilleux

Gilles Payette, Wink, *2010*
sand-cast glass, 10 x 30
photo: Gilles Payette

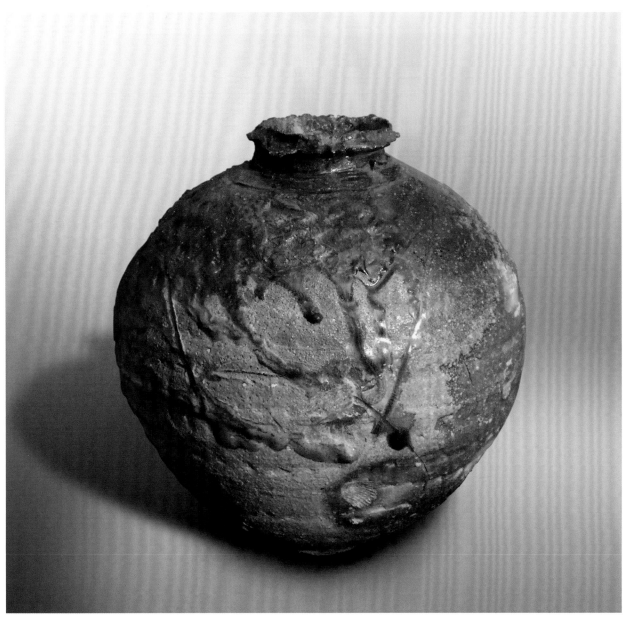

Yasuhiro Kohara, **Large Jar,** *2009*
woodfired stoneware, 15.5 x 14.5 x 14.5
photo: Alexandra Negoita

Dai Ichi Arts, Ltd.

Contemporary Chinese and Japanese ceramics; jewelry
Staff: Beatrice Lei Chang, director

By Appointment Only
New York, NY
voice 212.230.1680
fax 212.230.1618
info@daiichiarts.com
daiichiarts.com

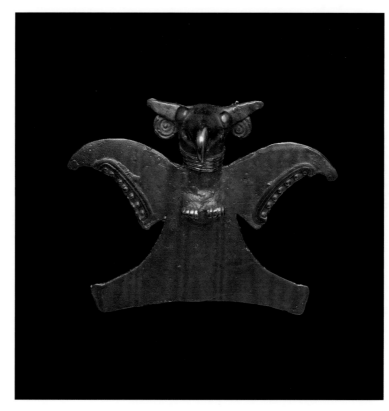

Van Cleef & Arpels, **Pre-Columbian Pendant Brooch**
18k gold, 2.25 x 2.5 x 1
photo: Gary Lau

Exhibiting:
Sueharu Fukami
Shoji Hamada
Yasuo Hayashi
Shigemasa Higashida
Toshimi Imura
Kosuke Kaneshige
Tsubusa Kato
Yasuhiro Kohara
Shoko Koike
Lihong Li
Yuriko Matsuda
Kyusetsu XII Miwa
Kazuhiko Miwa
Akira Miyazawa
Hiroaki Taimei Morino
Harumi Nakashima
Ayumi Shigematsu
Haruko Sugawara
Kazuo Takiguchi
Asuka Tsuboi
Toshisada Wakao
Hua Wei
Fiona Wong
Hongbo Xu
Kazuko Yamanaka

Lisa Cahill, **Sailor's Warning #2,** *2010*
kilnformed and carved glass panel, 24 x 44 x .75
photo: Greg Piper

David Richard Contemporary

Contemporary art in a variety of media by international artists
Staff: David Eichholtz and Richard Barger, directors

130 Lincoln Avenue
Suite D
Santa Fe, NM 87501
voice 505.983.9555
fax 505.983.1284
info@davidrichardcontemporary.com
davidrichardcontemporary.com

Exhibiting:
Philip Baldwin
Lisa Cahill
Ben Edols
Kathy Elliott
Monica Guggisberg
Ben Sewell
Harue Shimomoto

Philip Baldwin and Monica Guggisberg, **Anecdotes in Laughter,** *2010*
blown glass spheres with coldwork, 6 x 27.5 x 10
photo: Christopher Lehmann

William Hunter, **Free Vessel,** *2003*
cocobolo, 12 x 14 x 18
photo: Alan Shaffer

del Mano Gallery

Contemporary sculpture in wood, fiber, metal, ceramic and glass
Staff: Ray Leier; Jan Peters; Kirsten Muenster; Kate Killinger

2001 Westwood Boulevard
Los Angeles, CA 90025
voice 310.441.2001
gallery@delmano.com
delmano.com

Stoney Lamar, **Midnight's Blanket,** *2010*
white oak, steel, milk paint, 74 x 14 x 12 (largest of three)
photo: Tim Barnwell

Exhibiting:

Amber Aguirre	Guy Michaels
Gianfranco Angelino	William Moore
Michael Bauermeister	Matt Moulthrop
Jerry Bennett	Philip Moulthrop
Roger Bennett	Pascal Oudet
Christian Burchard	Stephen Mark Paulsen
David Carlin	Gordon Pembridge
Cindy Drozda	David Peters
David Ellsworth	George Peterson
Harvey Fein	Michael Peterson
J. Paul Fennell	Binh Pho
Liam Flynn	Harry Pollitt
Donald Frith	Joey Richardson
David Groth	Sam Maloof
Robyn Horn	Woodworking
Michael Hosaluk	Norm Sartorius
Todd Hoyer	Merryll Saylan
David Huang	Betty Scarpino
William Hunter	Eric Serritella
Tex Isham	Steve Sinner
John Jordan	Hayley Smith
Ron Kent	Laurie Swim
Stoney Lamar	Holly Tornheim
Bud Latven	Joël Urruty
Ron Layport	Jacques Vesery
Art Liestman	Derek Weidman
Alain Mailland	Hans Weissflog
Bert Marsh	Jakob Weissflog

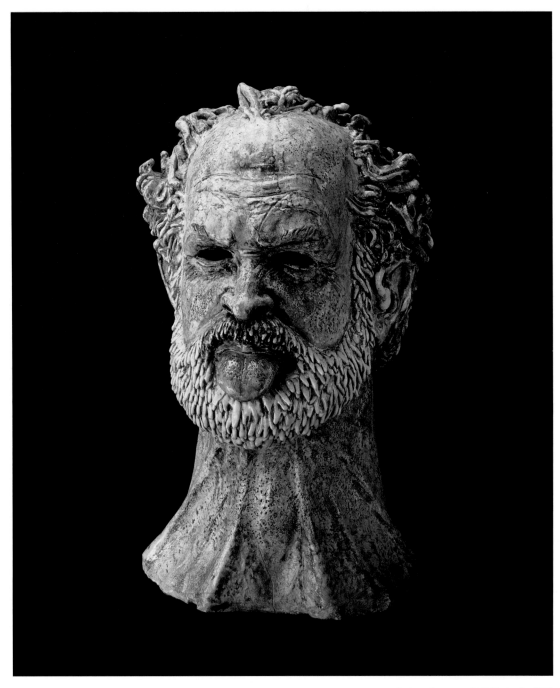

Robert Arneson, **Self Portrait,** *1971*
ceramic, glazes, 24 x 18

Donna Schneier Fine Arts

Modern masters in ceramics, glass, fiber, metal and wood
Staff: Donna Schneier; Leonard Goldberg; Jesse Sadia

By Appointment
Palm Beach FL &
Claverack, NY
voice 518.441.2884
dnnaschneier@mhcable.com
donnaschneier.com

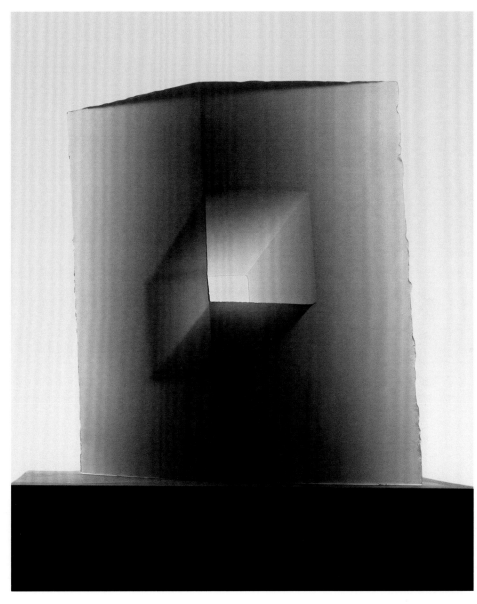

Stanislav Libenský and Jaroslava Brychtová, **Faces**
cast glass, 18 x 18

Exhibiting:
Robert Arneson
Rudy Autio
Jaroslava Brychtová
Dale Chihuly
Dan Dailey
Viola Frey
David Gilhooly
Kreg Kallenberger
Stanislav Libenský
Marvin Lipofsky
Harvey K. Littleton
Michael Lucero
Wendy Maruyama
Klaus Moje
William Morris
Joel Philip Myers
Barbara Packer
Ed Rossbach
Mary Shaffer
Paul Stankard
Lino Tagliapietra
Bertil Vallien
Howard Werner
Beatrice Wood
Betty Woodman
Toots Zynsky

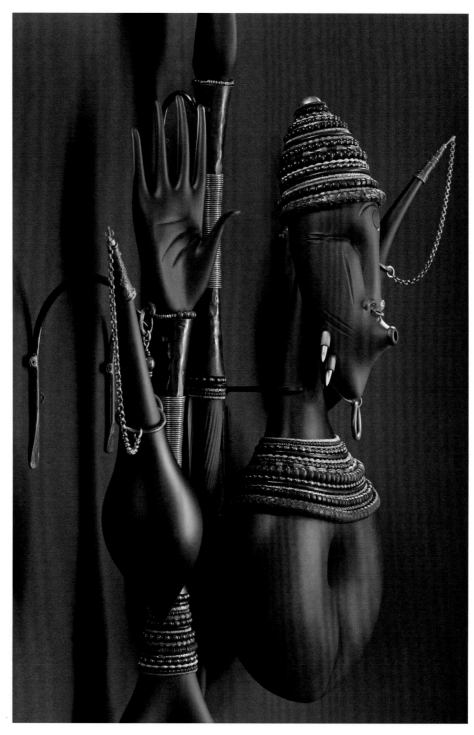

Jenny Pohlman and Sabrina Knowles, **Forest Keeper,** *2010*
off-hand sculpted and blown glass, ferrous and non-ferrous metals, beads, 50 x 44 x 6
photo: Russell Johnson

Duane Reed Gallery

Contemporary painting, sculpture, glass, ceramics and fiber by internationally recognized artists
Staff: Duane Reed; Merrill Strauss; Glenn Scrivner

4729 McPherson Avenue
St. Louis, MO 63108
voice 314.361.4100
fax 314.361.4102
info@duanereedgallery.com
duanereedgallery.com

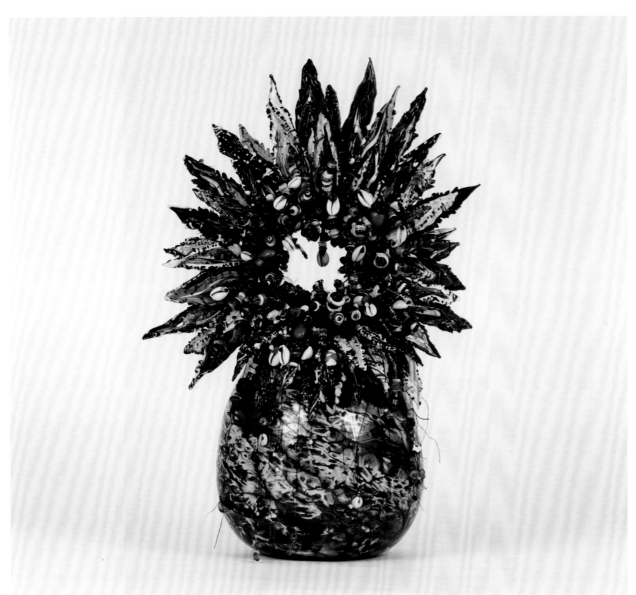

Exhibiting:
Rudy Autio
Laura Donefer
Paul Dresang
Misty Gamble
Mary Giles
Jamie Harris
Kreg Kallenberger
Margaret Keelan
Sabrina Knowles
Tracy Krumm
Jiyong Lee
Max Lehman
Marvin Lipofsky
Mari Meszaros
Jenny Pohlman
Ross Richmond
Bonnie Seeman
Veruska Vagen

Laura Donefer, Ruapehu Bonnechance Basket, *2010*
blown glass with beadwork, 21 x 9

Sergei Isupov, **Eunuch,** *2010*
woodfired stoneware, 20 x 18 x 11

Ferrin Gallery

Contemporary art and sculpture in all media, specializing in ceramics;
special SOFA presentation with Perimeter Gallery, Nude in Chicago
Staff: Leslie Ferrin; Donald Clark; Lauren Levato

437 North Street
Pittsfield, MA 01201
voice 413.442.1622
fax 413.442.1672
info@ferringallery.com
ferringallery.com

Chris Antemann, A Slip Betwixt the Cup and the Lip, *2010*
porcelain, decals, glaze, 23 x 20 x 14

Exhibiting:
Chris Antemann
Christa Assad
Cynthia Consentino
Lucy Feller
Gerit Grimm
Molly Hatch
Sergei Isupov
Dana Major Kanovitz
Myungjin Kim
Beverly Mayeri
Richard Notkin
Seth Rainville
Kelly Garrett Rathbone
Mara Superior
Akio Takamori
Shannon Trudell
Jason Walker
Kurt Weiser
Red Weldon-Sandlin
Gwendolyn Yoppolo

Curtiss Brock, **Starfire,** *2009*
cast, cut and hand polished glass, 12 x 12 x 3.5
photo: John Lucas

FLAME RUN

Contemporary Glass
Staff: Brook F. White, Jr., owner; Tiffany Ackerman, director

828 East Market Street
Louisville, KY 40206
voice 502.584.5353
fax 502.584.5332
gallery@flamerun.com
flamerun.com

Exhibiting:
Devyn Baron
Curtiss Brock
Matthew Cummings
Bryan Holden
Alexandra Marchant
Jeanne Nelson
Susie Slabaugh
David Walters
Brook F. White, Jr.

Devyn Baron, **Good or Bad,** *2010*
blown and sculpted glass, sequins, steel, metal spring, 16 x 10 x 7

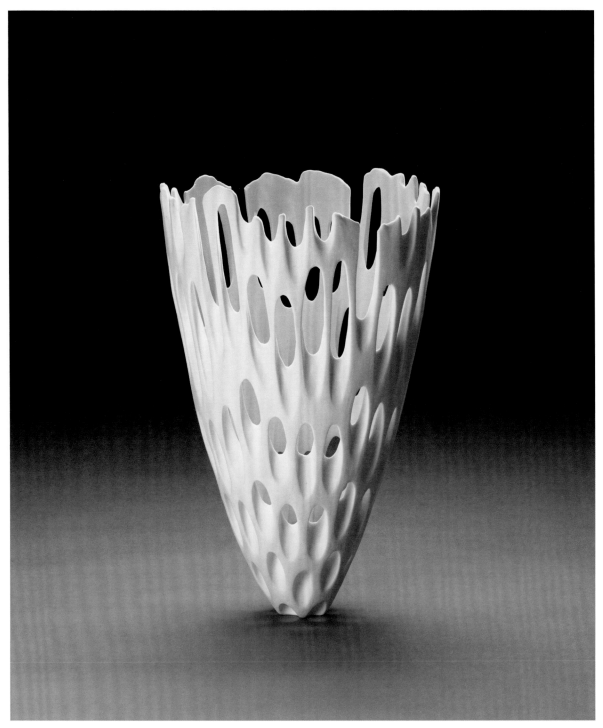

Yasuko Sakurai, **Vertical Flower,** *2010*
porcelain, 20 x 13 x 4
photo: Daido Yukiyo

Floating World Gallery

Fine Japanese art

Staff: Bill Stein, president; Roberta Stein, vice president; Elias Martin, director of exhibitions; *Reiko Machi, Naoko Lewis and Jeff Kuhnie, gallery assistants*

1925 North Halsted Street
Chicago, IL 60614
voice 312.587.7800
fax 312.575.3565
artwork@floatingworld.com
floatingworld.com

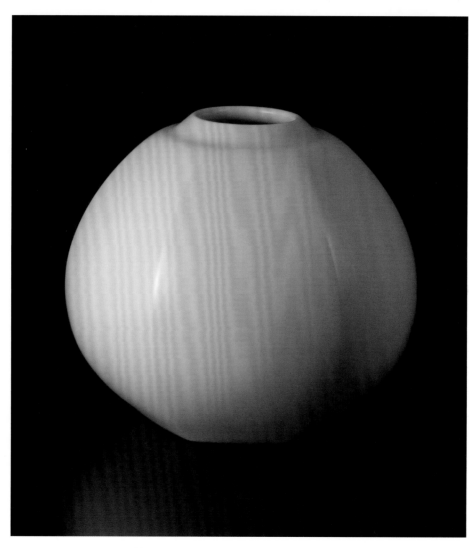

Exhibiting:
Sueharu Fukami
Masahiko Ichino
Katsumi Kako
Tomoko Kawakami
Ryoji Koie
Akihiro Maeta
Takuo Nakamura
Yasuko Sakurai
Gaku Shakunaga
Yasuyoshi Sugiura
Atsushi Takagaki

Maeta Akihiro, **Hakuji Mentori Tsubo (White Porcelain Faceted Vase),** *2010*
white porcelain with clear glaze, 8.75 x 11.5
photo: Daido Yukiyo

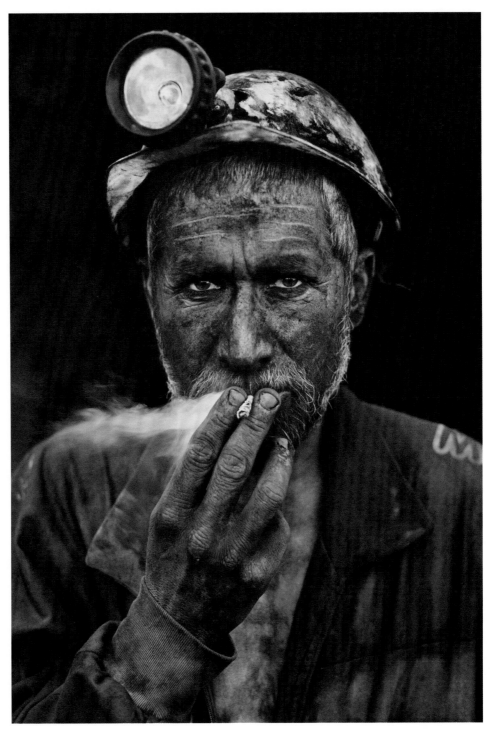

Steve McCurry, **Miner Man,** *2007*
photography

Frederic Got Gallery

Contemporary art, original painting, sculptures in bronze and photography
Staff: Frederic Got, owner; Gabriel Eid, art consultant

64 Rue Saint Louis en L'île
Paris 75004
France
voice 33.14.326.1033
fax 33.14.326.1033
got3@wanadoo.fr
artchic.com

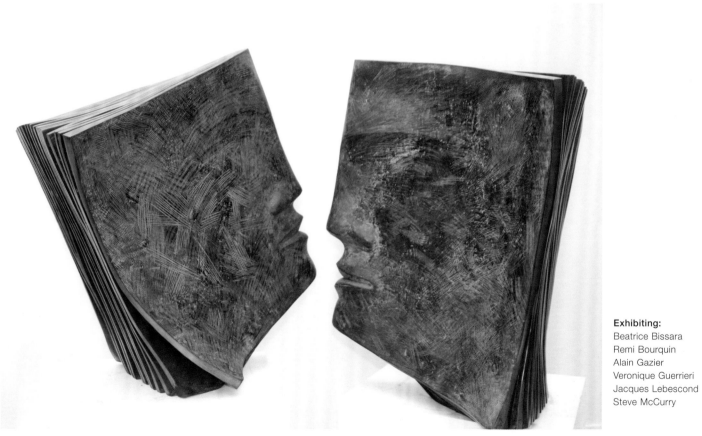

Exhibiting:
Beatrice Bissara
Remi Bourquin
Alain Gazier
Veronique Guerrieri
Jacques Lebescond
Steve McCurry

Jacques Lebescond, **Cantate & Psaum,** *2010*
bronze

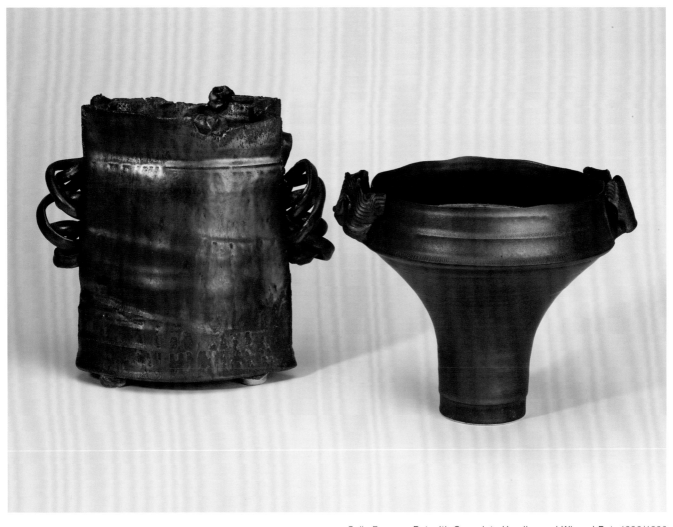

Colin Pearson, **Pot with Convolute Handles and Winged Pot,** *1996/1990*
stoneware/porcelain, bronze glaze, 8.5 and 7 inches high
photo: Alan Tabor

Galerie Besson

International contemporary ceramics
Staff: Matthew Hall, manager

15 Royal Arcade
28 Old Bond Street
London W1S 4SP
United Kingdom
voice 44.20.7491.1706
fax 44.20.7495.3203
matthew@galeriebesson.co.uk
galeriebesson.co.uk

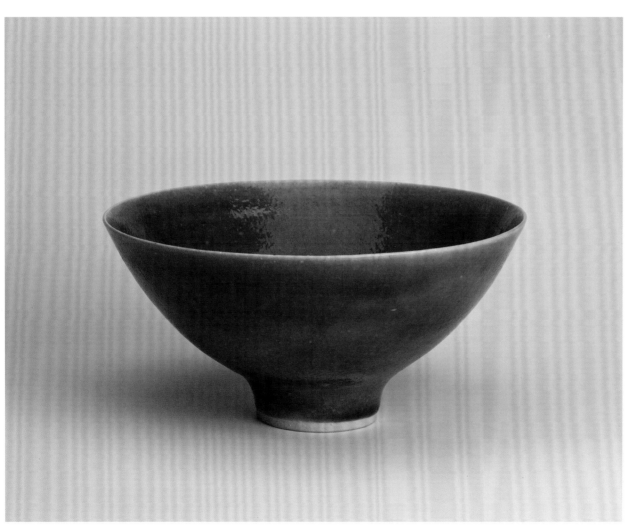

Exhibiting:
Ian Auld
Gordon Baldwin
Claudi Casanovas
Hans Coper
Bernard Dejonghe
Ruth Duckworth
Deirdre Hawthorne
Kirsi Kivivirta
Colin Pearson
Gwyn Hanssen Pigott
Lucie Rie
Kristina Riska
Kati Tuominen-Niittyla

Lucie Rie, **Footed Green Bowl,** *c. 1960*
porcelain, 5 x 10.5
photo: Alan Tabor

Detlef Gotzens, **Form Quest #3,** *2010*
oxide powder, glass, metal, 26 x 16 x 6
photo: Michel Dubreuil

Galerie Elena Lee

New directions of contemporary art glass and mixed media for over 30 years
Staff: Elena Lee; Diana Walton; Joanne Guimond; Matt Morein

1460 Sherbrooke West
Suite A
Montreal, Quebec H3G 1K4
Canada
voice 514.844.6009
info@galerieelenalee.com
galerieelenalee.com

Exhibiting:
Annie Cantin
Detlef Gotzens
Mathieu Grodet
Steve Heinemann
Tanya Lyons
Caroline Ouellette
Patrick Primeau
Cathy Strokowsky

Patrick Primeau, **Blue Janolus (Janolus Series),** *2010*
blown glass, incalmo, reticello, 11 x 18 x 18
photo: Michel Dubreuil

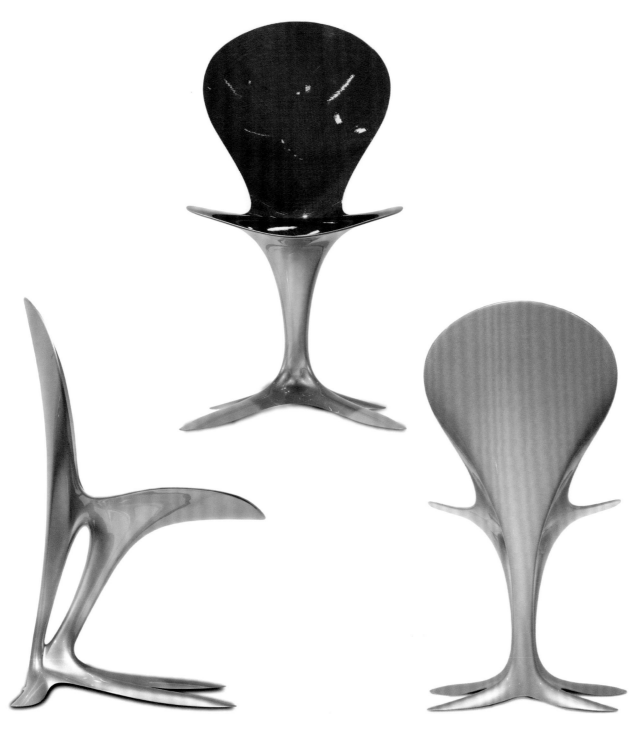

Philipp Aduatz, **Flower Chair**, edition of 24, *2008*
cfk, 35.4 x 19.7 x 22.8

Galerie Suppan Contemporary Design

Established and young contemporary art and design
Staff: Martin Suppan; Claudia Suppan; Sebastian Suppan

Habsburgergasse 5
Vienna 1010
Austria
voice 43.1.535.535.435
fax 43.1.535.535.435
info@suppancontemporary.com
suppancontemporary.com

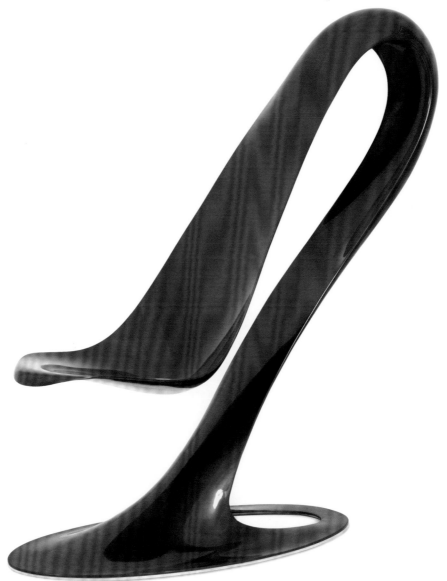

Exhibiting:
Philipp Aduatz

Philipp Aduatz, Red Spoon Chair, edition of 12, *2009*
cfk, 49.5 x 20.5 x 47.2

Martin Janecky, **Duo Jongleur,** *2010*
hot sculpted glass, 24.5 x 24 x 16.6

Habatat Galleries

Acquiring and exhibiting the finest contemporary works created in glass
Staff: Ferdinand Hampson; Kathy Hampson; Corey Hampson; John Lawson; Aaron Schey; Debbie Clason; Rob Bambrough; Rob Schimmell; Barak Fite

4400 Fernlee Avenue
Royal Oak, MI 48073
voice 248.554.0590
fax 248.554.0594
info@habatat.com
habatat.com

Margit Toth, **Air Water,** *2010*
cast glass, 24.25 x 8.25 x 10.5

Exhibiting:
Howard Ben Tré
David Bennett
Alex Gabriel Bernstein
Martin Blank
Stanislaw Jan Borowski
Emily Brock
Jaroslava Brychtová
Daniel Clayman
Deanna Clayton
Keith Clayton
Eric Hilton
Tomas Hlavicka
Petr Hora
Martin Janecky
Stanislav Libenský
Steve Linn
Charlie Miner
Paul Nelson
Marc Petrovic
Clifford Rainey
Davide Salvadore
Tim Tate
Margit Toth
Janusz Walentynowicz
Leah Wingfield
Ann Wolff
Toots Zynsky

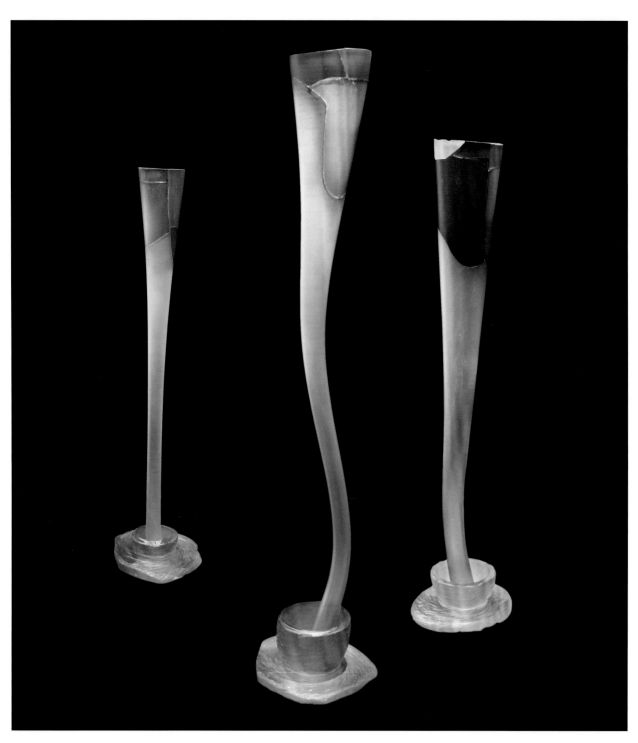

Danny Perkins, **Number 11, 14 and 7,** *2010*
hot sculpted glass, tallest: 47 inches high

Hawk Galleries

Modern masters through emerging artists in contemporary glass
Staff: Thomas Hawk; Susan Janowicz; Eric Rausch; Jesse Mills

153 East Main Street
Columbus, OH 43215
voice 614.225.9595
fax 614.225.9550
tom@hawkgalleries.com
hawkgalleries.com

Christopher Ries, **Blue Cross,** *2010*
cut, ground and polished optical crystal, 11.25 x 11.25 x 4.5
photo: James Kane

Exhibiting:
Cassandria Blackmore
Nancy Callan
Danny Perkins
Christopher Ries

Nancy Callan, **Geminid Orb,** *2010*
blown glass, 14.5 x 14.5 x 14.5

Cassandria Blackmore, **Kandake,** *2010*
reverse painting on glass, 40 x 40 x 2

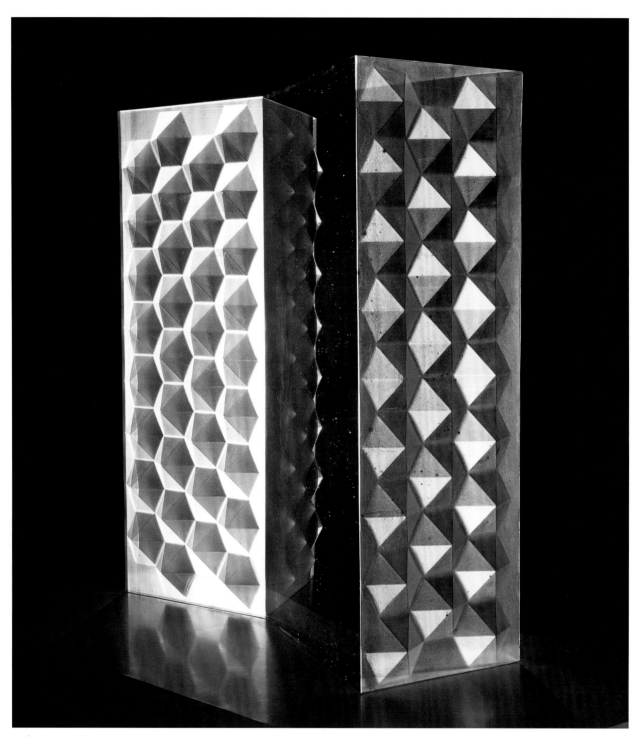

Vladimíra Klumpar, **Rhythm and Reflection,** *2010*
kiln-cast crystal, cut and polished, 29 x 32 x 8
photo: Eva Heyd

Heller Gallery

Exhibiting sculpture using glass as a fine art medium since 1973
Staff: Douglas Heller; Katya Heller; Michael Heller

420 West 14th Street
New York, NY 10014
voice 212.414.4014
fax 212.414.2636
info@hellergallery.com
hellergallery.com

Exhibiting:
Jaroslava Brychtová
Nicole Chesney
Steffen Dam
Luke Jerram
Vladimíra Klumpar
Stanislav Libenský
Ivan Mareš
Tobias Møhl
Ivana Šrámková

Luke Jerram, **Sars 3/5,** *2010*
glass, 8 x 8 x 8

Steffen Dam, **Flowerblock,** *2010*
glass, 14.25 x 11 x 1.75

Ivan Mareš, **Wing,** *2010*
glass, 49.25 x 51.25 x 29.5
photo: Ondřej Kocourek

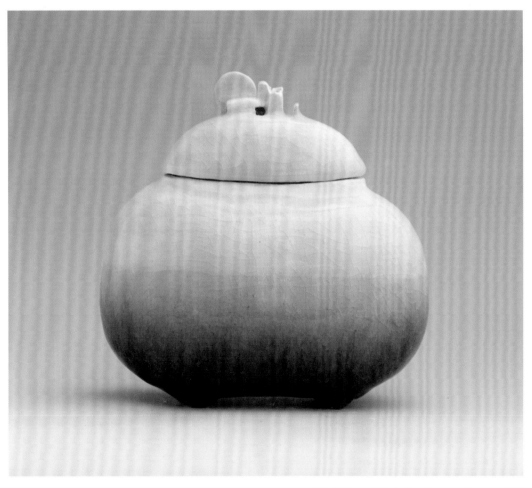

Shin Fujihira, **Cobalt Blue Incense Burner,** *1990*
ceramic, 6.25 x 6 x 3.25

Ippodo Gallery

Japanese contemporary arts and crafts
Staff: Shoko Aono, director

521 West 26st Street, #B1
New York, NY 10001
voice 212.967.4899
fax 212.967.4889
mail@ippodogallery.com
ippodogallery.com

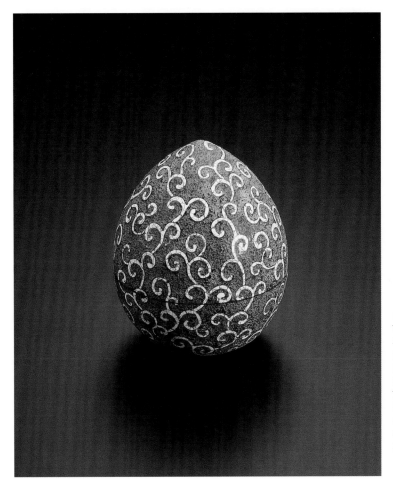

Exhibiting:
Yasushi Fujihira
Shin Fujihira
Keiji Ito
Ryoji Koie
Maeda Masahiro
Toru Matsuzaki
Kohei Nakamura
Katsuyuki Sakazume
Shigeru Uchida
Shinya Yamamura

Shinya Yamamura, **Sacred Jewel,** *2009*
green lacquer, eggshell, gold powder, 2.75 x 2.75

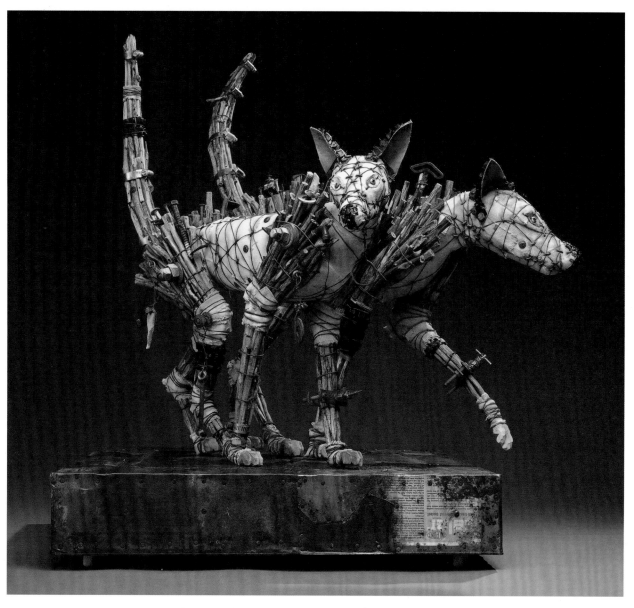

Geoffrey Gorman, **The Trek of Galgupha and Saldula,** *2010*
mixed media, 24 x 38 x 24
photo: James Hart

Jane Sauer Gallery

Nationally and internationally renowned artists in a variety of media
Staff: Jane Sauer, owner/director; Jorden Nye, gallery manager; Richard Boyle, director of communications; Angela Pennock, registrar and shipping manager

652 Canyon Road
Santa Fe, NM 87501
voice 505.995.8512
fax 505.995.8507
jsauer@jsauergallery.com
jsauergallery.com

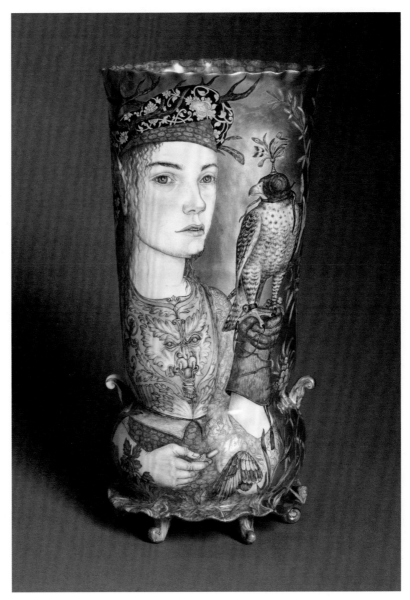

Exhibiting:
Adam Aaronson
Adrian Arleo
Giles Bettison
Carol Eckert
Katherine Glover
Geoffrey Gorman
Noel Hart
Cindy Hickok
Jan Hopkins
Lissa Hunter
Jane Kenyon
Charla Khanna
Gugger Petter
Lesley Richmond
Jon Eric Riis
Randall Rosenthal
Charles Savoie
Nancy Scheinman
Barbara Lee Smith
Dawn Walden
Brent Kee Young
Irina Zaytceva

Irina Zaytceva, **Forest Prince and His Falcon Vase,** *2010*
handbuilt porcelain, overglaze painting, 24k gold lustre, 12.5 x 6.5 x 6
photo: Ross Stout

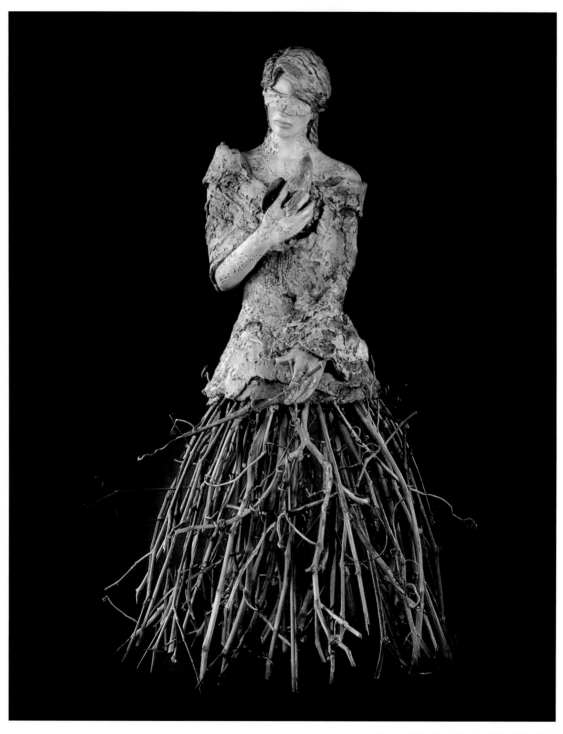

Susan Saladino, **The Last Bird #8,** *2010*
clay, twigs, oxides, underglazes, applied pigment, 23 x 14 x 14

Jean Albano Gallery

Contemporary painting and sculpture by internationally recognized artists
Staff: Jean Albano Broday, owner/director; Theresa Murray, assistant director; Emanuel Aguilar, preparator

215 West Superior Street
Chicago, IL 60654
voice 312.440.0770
fax 312.440.3103
jeanalbano@aol.com
jeanalbanogallery.com

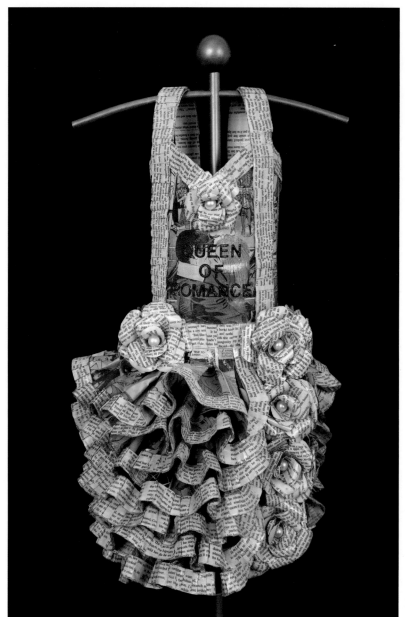

Exhibiting:
Fletcher Benton
Diane Cooper
Claudia DeMonte
John Geldersma
Donna Rosenthal
Susan Saladino
Peter Skvara
Mindy Weisel
Margaret Wharton

Donna Rosenthal, **Queen of Romance,** *2010*
vintage romance novels and comics, gel medium, steel, 64 x 17 x 17

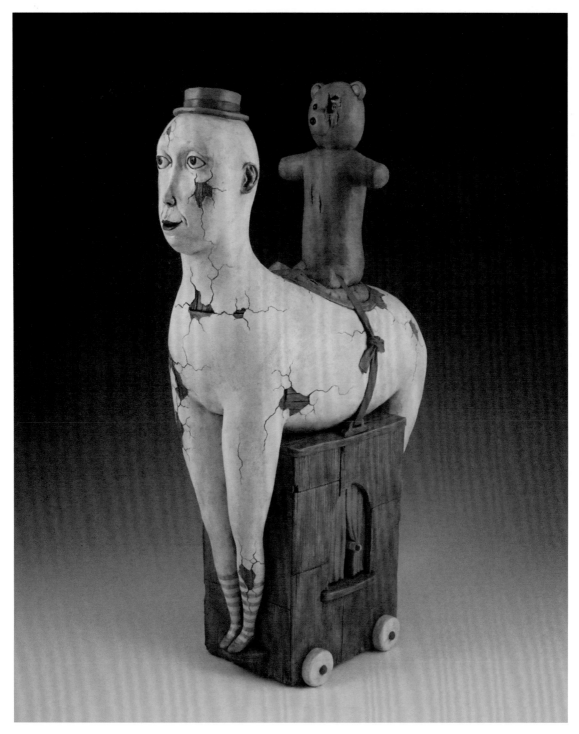

Avery Palmer, **The Rider,** *2010*
ceramic, 23 x 14 x 7
photo: Michael Trask

John Natsoulas Gallery

West coast figurative ceramics, California funk
Staff: John Natsoulas, owner; Nancy Resler, director

521 First Street
Davis, CA 95616
voice 530.756.3938
art@natsoulas.com
natsoulas.com

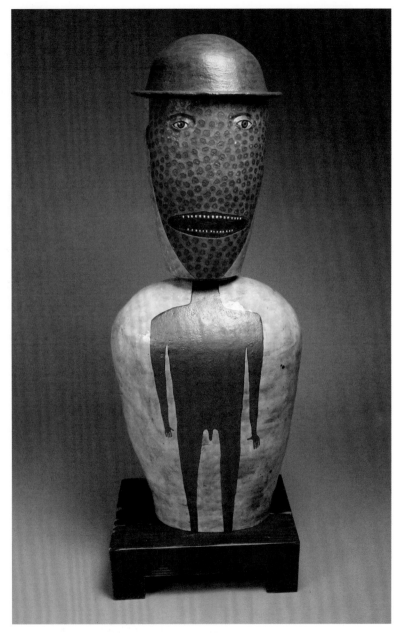

Wesley Anderegg, **Head Spinner (2),** *2010*
ceramic, 50 x 18 x 13
photo: Michael Trask

Exhibiting:
Nick Agid
Amber Aguirre
Wesley Anderegg
Robert Arneson
Lisa Clague
Arthur Gonzalez
Nemo Gould
May Izumi
Margaret Keelan
Louis Marak
Cara Moczygemba
Tomoko Nakazato
Avery Palmer
Juan Santiago
Richard Shaw
Esther Shimazu
Claudia Tarantino

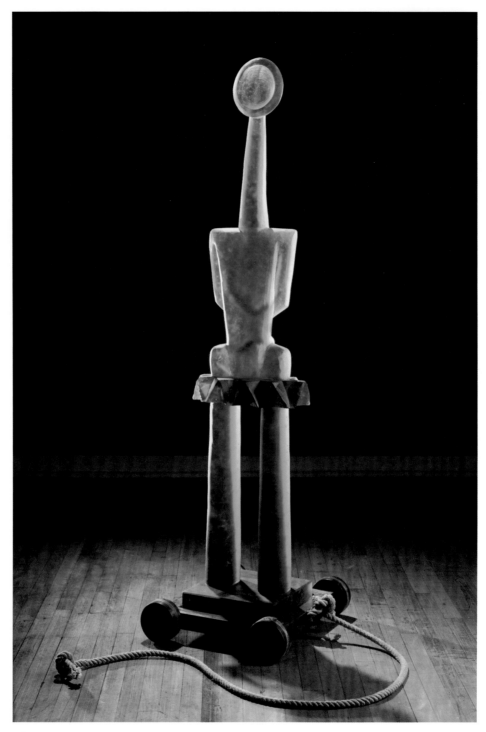

Rick Beck, **Grace (Pull Toy)**, *2010*
cast glass, 69.75 x 20 x 21

140

Ken Saunders Gallery

The most innovative and important artists working in glass in the world
Staff: Ken Saunders, director; Jo-Nell Sieren, assistant director; Joe Salgado

230 West Superior Street
Chicago, IL 60654
voice 312.573.1400
fax 312.573.0575
gallery@kensaundersgallery.com
kensaundersgallery.com

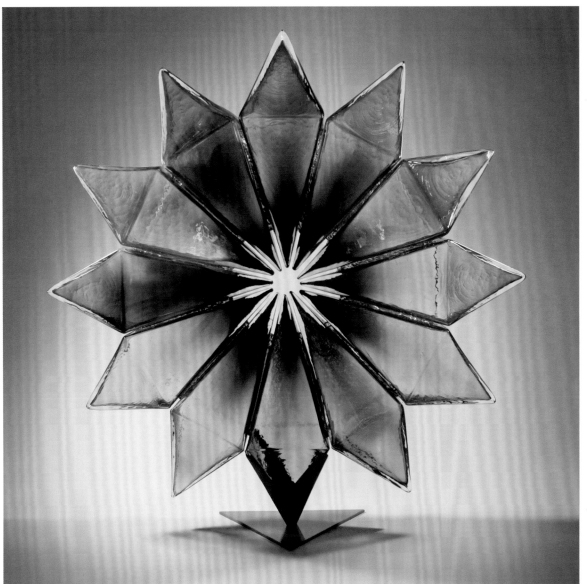

Exhibiting:
Rick Beck
William Carlson
José Chardiet
Sidney Hutter
Jon Kuhn
Carmen Lozar
Dante Marioni
Jay Musler
Stephen Rolfe Powell
Richard Ritter
Richard Royal
David Schwarz
Thomas Scoon
Paul Stankard
Lisabeth Sterling
Richard Whiteley

Richard Royal, **Water Wheel,** *2010*
hot sculpted and mold blown glass, metal stand, 38 x 38 x 10

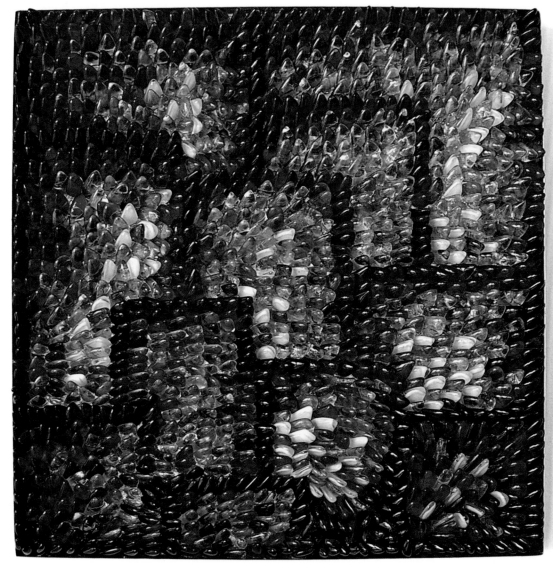

Emma Varga, FireBush #1 Wall Panel, *2010*
fused glass elements assembled onto stainless steel plate, 19 x 19 x 1

Kirra Galleries

Leaders in the Australian contemporary art glass movement supporting established and emerging artists
Staff: Suzanne Brett, gallery manager; Vicki Winter, administration manager

Federation Square
Cnr Swanston and Flinders Streets
Melbourne, Victoria 3000
Australia
voice 61.3.9639.6388
fax 61.3.9639.8522
gallery@kirra.com
kirragalleries.com

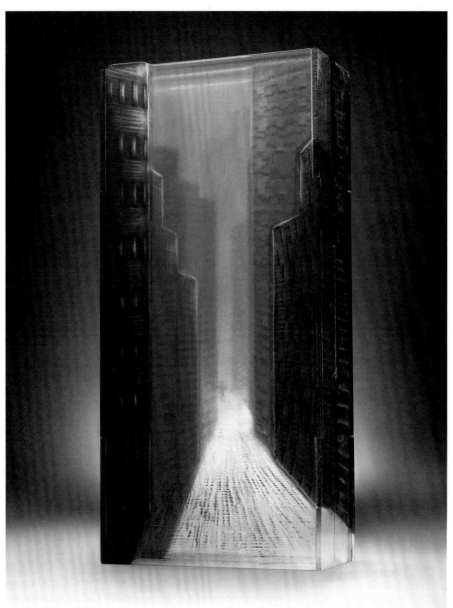

Exhibiting:
Masahiro Asaka
George Aslanis
Tegan Empson
Annabel Kilpatrick
Jennifer Ashley King
Brent King
Simon Maberley
Ruth McCallum-Howell
Ruth Oliphant
Tim Shaw
Crystal Stubbs
Emma Varga

Ruth Oliphant, **Haze,** *2010*
fused and coldworked glass, constructed, 24 x 6 x 11
photo: Rob Little

JeeSeon Park, **Narcissus,** *2009*
ceramic, stainless steel, 23 x 10 x 10
photo: DaeKyu Choi

The Korea Design & Craft Foundation

Introducing Korean craft and design to the world
Staff: JungSim Choi, director; HiSook Jo, department head; YooYun Jung

5F HaeYoung Bldg., 148
Chongro-gu
AnKook-dong
Seoul 110-240
Republic of Korea
voice 82.2.398.7900
fax 82.2.398.7999
yyjung@kcdf.kr
kcdf.kr

Exhibiting:
JongKwan Choi
HyeWook Huh
SungIm Jeon
MiHwa Joo
HaeCho Jung
KyungHee Kim
JoonYong Kim
Jung Suk Kim
SooYeon Lee
SangMin Lee
JiSeon Park
EunJung Park
JeeWoon Choi Yetovah

K HyeWook Huh, **To Be One 5,** *2009*
glass, 15 x 11 x 3
photo: KC Studio

Steen Ipsen, **Tied Up #39,** *2010*
ceramic, pvc, 26.5 x 11.75
photo: Søren Nilsen

Lacoste Gallery

Contemporary ceramics: vessel and sculpture
Staff: Lucy Lacoste; Alinda Zawierucha

25 Main Street
Concord, MA 01742
voice 978.369.0278
info@lacostegallery.com
lacostegallery.com

Exhibiting:
Barbro Åberg
Morten Løbner Espersen
Michael Fujita
Nina Hole
Steen Ipsen
Karen Karnes
Ani Kasten
Bodil Manz
Nathan Prouty
Don Reitz
Mark Shapiro
Alev Ebüzziya Siesbye
Toshiko Takaezu

Karen Karnes, **Three Forms,** *2003*
salt-glazed and wood-fired stoneware, left: 25.5 x 5; middle: 22.5 x 5; right: 26.5 x 5
photo: George Bouret

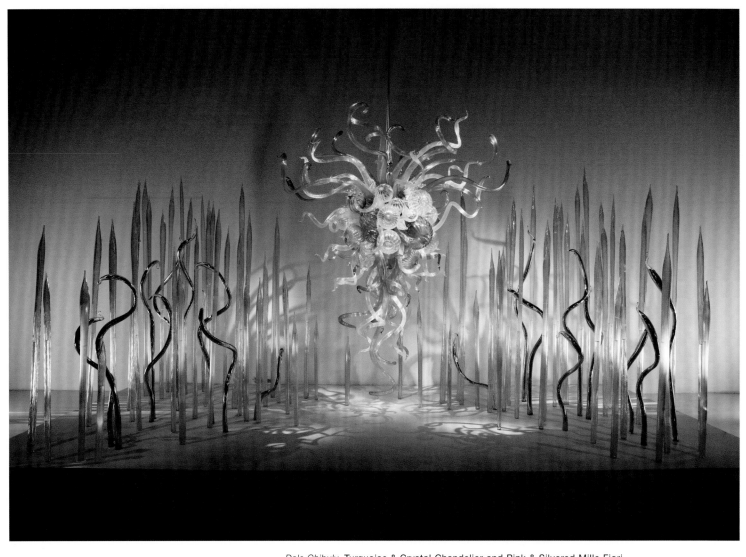

Dale Chihuly, **Turquoise & Crystal Chandelier and Pink & Silvered Mille Fiori,**
hand-blown glass, 100 x 99 x 90; 100 x 209 x 131
photo: Scott Mitchell Leen

Litvak Gallery

Exclusive projects created by the world's leading contemporary glass artists
Staff: Muly Litvak, founder; Orit Ephrat-Moscovitz, director

4 Berkovitz Street
Tel Aviv 64238
Israel
voice 972.3.695.9496
fax 972.3.695.9419
info@litvak.com
litvak.com
sofa.litvak.com

Exhibiting:
Alex Arbell
Peter Bremers
Lucio Bubacco
Dale Chihuly
Václav Cigler
Zora Palova
Boris Shpeizman
Lior Vagima
Julius Weiland

Dale Chihuly, **Silvered Blanket Cylinder,** *2010*
hand-blown glass, 32 x 9 x 9
photo: David Emery

Peter Bremers, **Marble Wash, Deserts and Canyons 43,** *2010*
kiln-cast crystal, 20 x 18 x 4
photo: Paul Niessen

Peter Bremers, Icebergs & Paraphernalia 66, *2006*
kiln-cast glass, 23.5 x 39.5 x 4
photo: Paul Niessen

*Julius Weiland, **Wave IV,** 2010*
fused glass tubes, 20 x 47 x 23.5
photo: Andre Bockhold

Boris Shpeizman, **Les Petits Plaisirs de la Vie,** *2010*
blown glass, copper, 23 x 23 x 23
photo: Avraham Hay and Yona Schley

Lucio Bubacco, **Virgo Mask**
lampworked glass, 14 x 19 x 5.5
photo: Anna Lott Donadel

Václav Cigler, **Cylinder with Chamfered Surface,** *2010*
optic glass, 18 x 18 x 3
photo: Avraham Hay and Yona Schley

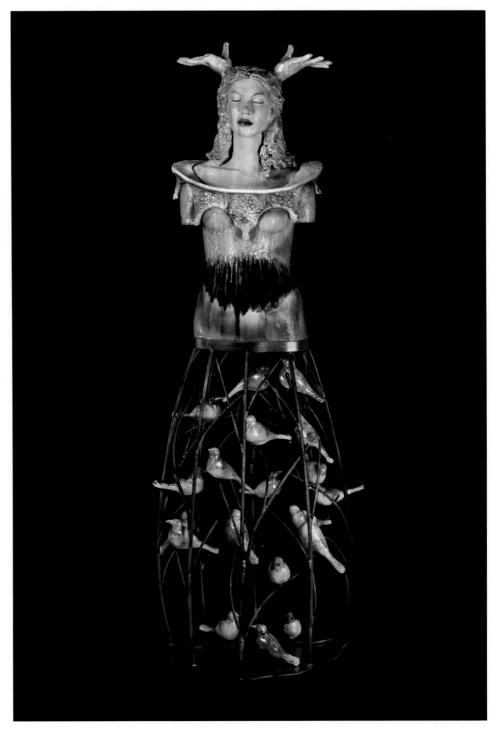

Caroline Douglas, **Earth Song,** *2010*
salt-fired stoneware with slips, glazes, iron skirt, 74 x 23 x 22
photo: Russell McDougal

Maria Elena Kravetz Gallery

Different contemporary art with a focus on Latin American expressions
Staff: Maria Elena Kravetz, director; Raul Nisman; Belen Menaldi and Matias Alvarez, assistants

San Jeronimo 448
Cordoba X5000AGJ
Argentina
voice 54.351.422.1290
mek@mariaelenakravetz
 gallery.com
mariaelenakravetzgallery.com

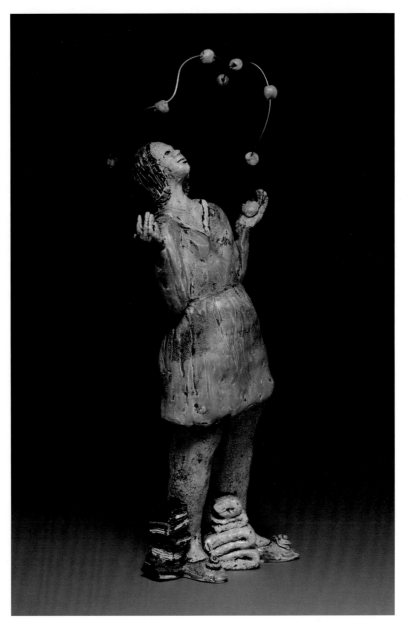

Exhibiting:
Lina Amariglio Weiss
Nathan Bennett
Caroline Douglas
Faba
Susanne Fraser
Elizabeth Gavotti
Linda Lewis
David Marshall
Ana Mazzoni
Polimnia Sepulveda
Tim Shockley
Jeannine Young

Linda Lewis, **Juggling Life,** *2009*
coil-built clay with glazes, 24 x 7 x 6

Lina Amariglio Weiss, **Mate in Space Necklace,** *2010*
18k gold, pearl, Rudraksha bead, dimensions vary
photo: Avner Richard

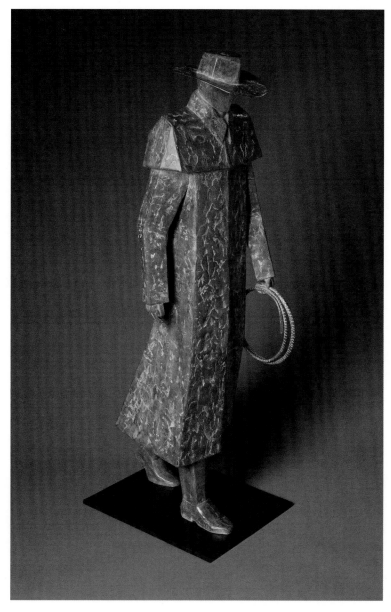

Jeannine Young, **Storm's Brewing,** *2007*
bronze edition of 25, 33 x 10 x 13

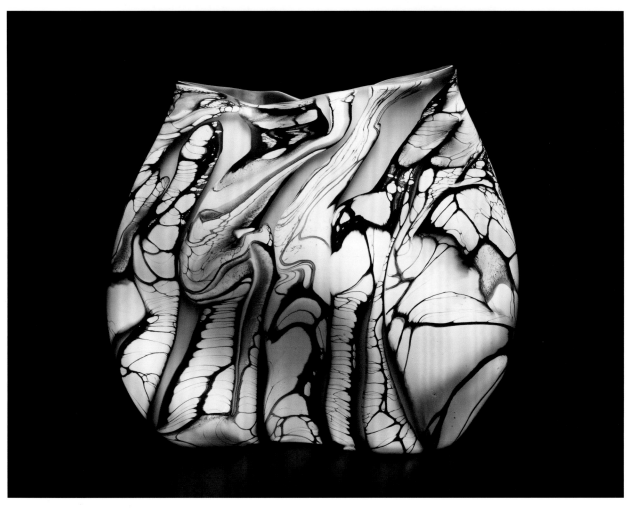

Peter Layton, **Glacial Wave,** *2010*
glass, 11 x 13 x 4
photo: Ester Segarra

Mattson's Fine Art

Contemporary glass art with ceramic and southwestern U.S. pottery
Staff: Gregory Mattson, director; Walter Mattson; Skippy Mattson

2579 Cove Circle, N.E.
Atlanta, GA 30319
voice 404.636.0342
fax 404.636.0342
sundew@mindspring.com
mattsonsfineart.com

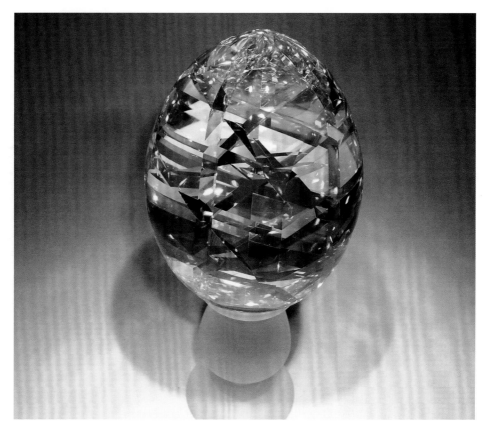

Jack Storms, **Vivi Ovo,** *2010*
leaded optic crystal with dichroic glass, 9 x 7

Exhibiting:
Marvin Blackmore
Rafal Galazka
Przemyslaw Lasak
Peter Layton
Bruce Marks
Keith Rowe
Mirek Stankiewicz
Jack Storms
James Wilbat
Maciej Zaborski

Michael Janis, **Altered Memories,** *2010*
kilnformed glass, 37 x 19 x 2

Maurine Littleton Gallery

Sculptural work of contemporary masters in glass and ceramics
Staff: Maurine Littleton, director; Lisa Zangerl, associate; Drew Storm Graham, preparator

1667 Wisconsin Avenue NW
Washington, DC 20007
voice 202.333.9307
fax 202.342.2004
info@littletongallery.com
littletongallery.com

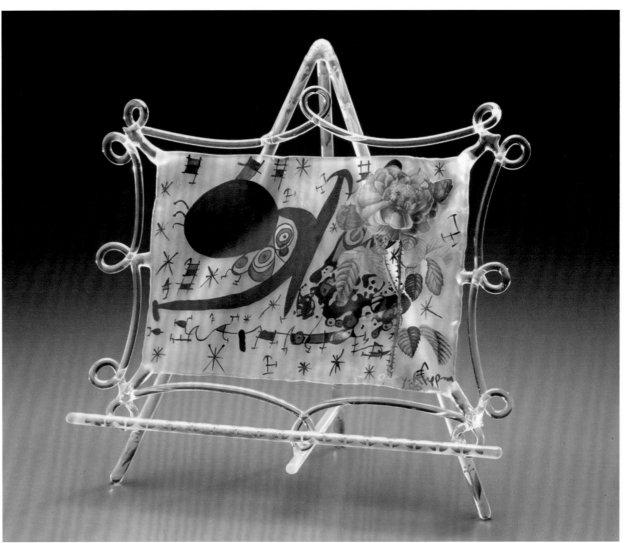

Exhibiting:
Lu Chi
Drew Storm Graham
Michael Janis
Judith LaScola
John Littleton
Harvey K. Littleton
Allegra Marquart
Richard Marquis
Colin Reid
Ginny Ruffner
Therman Statom
Kate Vogel

Ginny Ruffner, **Subatomic Schematic of a Beauty Gene,** *2006*
flameworked glass, mixed media, 17 x 17 x 9

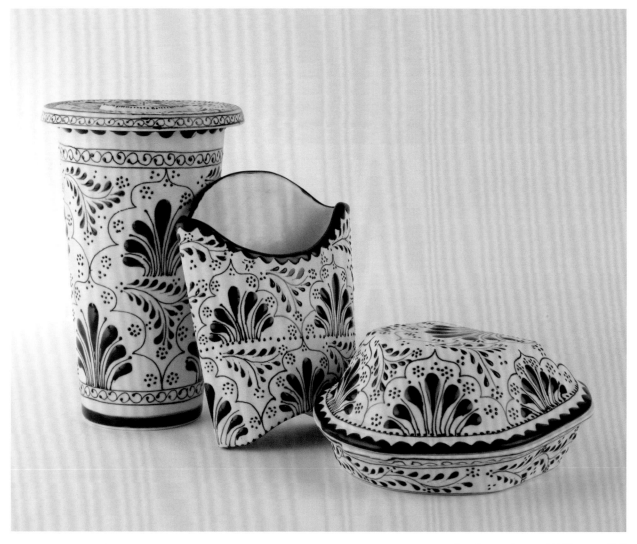

Ana Gomez, **Personal Tableware,** *2010*
slip casting, stoneware, glaze, various sizes
photo: Luis Tierrasnegras

Medellín 174

Platform for innovative visions and concepts in different media
Staff: Minu Paredes and Zinna Rudman, directors

Medellín 174
Col. Roma
Mexico City 06700
Mexico
voice 52.55.557.40918
fax 52.55.561.67928
medellin174@hotmail.com
medellin174.com

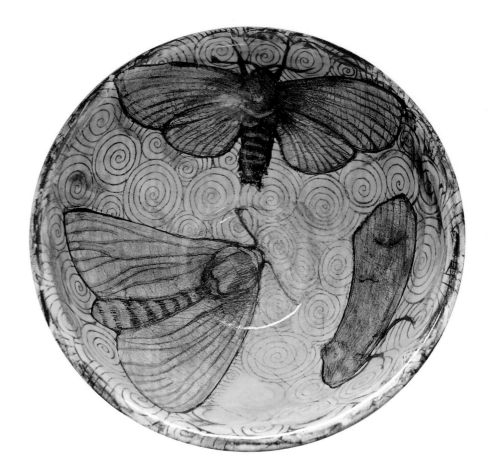

Exhibiting:
Marlov Barrios
Ana Gomez
Maritza Morillas
Tsimani Design

Maritza Morillas, **Cossus Cossus,** *2010*
enamel, metal, 2.75 x 7.75

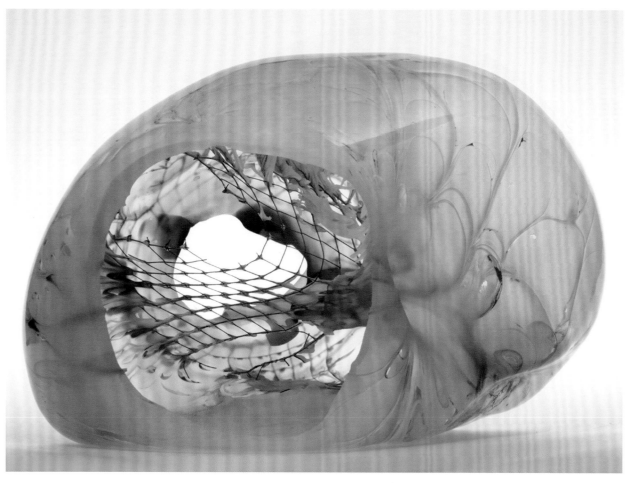

Jorg Zimmermann, **Paint Splash,** *2009*
glass, metal, 9 x 14 x 9

Mostly Glass Gallery

Contemporary art, novel and technically challenging

Staff: Sami Harawi, owner; Marcia Lepore and Elizabeth Hopkins, associates; Michael Martz, director of operations

34 Hidden Ledge Road
Englewood, NJ 07631
voice 201.816.1222
fax 201.503.9488
info@mostlyglass.com
mostlyglass.com

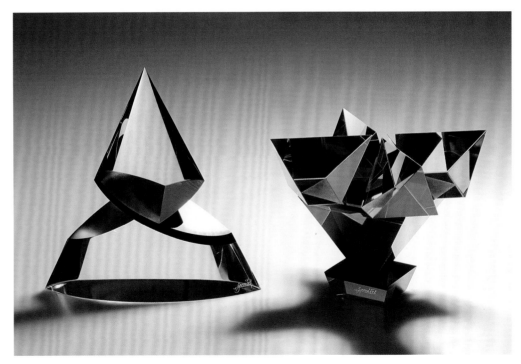

Exhibiting:
Christine Barney
Mary Darwall
Miriam Di Fiore
Elizabeth Hopkins
Hildegund Ilkerl
Vlastislav Janacek
Marcia Lepore
Gabriele Malek
Martie Negri
Margaret Neher
Joel O'Dorisio
Kevin O'Grady
Fabienne Picaud
Gateson Recko
Madelyn Ricks
Erica Rosenfeld
Alison Ruzsa
Jorg Zimmermann

Vlastislav Janacek, **Pieces from the Chess Set,** *2010*
glass, 7 x 26 x 26 (set)
photo: Jiri Koudelka

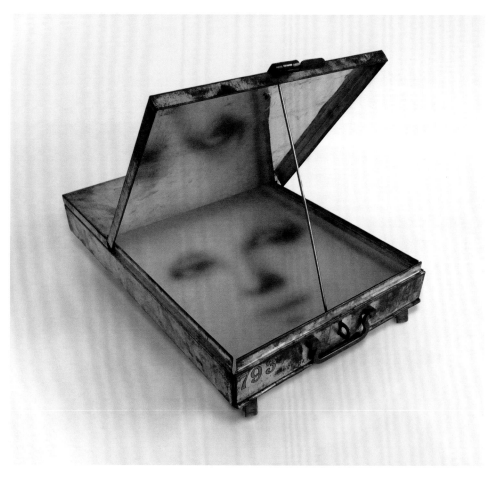

Jens Gussek, **Save Me I,** *2010*
kiln cast glass, reverse painting, metal, 34 x 28 x 45 cm
photo: Jens Gussek

New Glass Art & Photography

Championing emerging, mid-career and established artists working in glass
Staff: Nadania Idriss, owner and director

Linienstrasse 154
Berlin D-10115
Germany
voice 49.302.787.9386
info@nadaism.de
nadaism.de

Exhibiting:
Simone Fezer
Jens Gussek
Ursula Huth
Ulrich Precht
Susanne Precht
Gerhard Ribka
Sebastian Richter
Gerd Sonntag

Gerhard Ribka, **Silbenrein,** *2010*
kiln cast glass, brass, aluminum, 10 x 6 x 6
Photo: Gerhard Ribka

Mark Chatterley, **Building Blocks,** *2010*
clay sculpture, life size figures

Next Step Studio & Gallery

Introducing young and upcoming talent to the art world with a strong eye on clay artists
Staff: Kaiser Suidan, owner/director; Rebecca Myers, curator

530 Hilton Road
Ferndale, MI 48220
voice 248.414.7050
cell 248.342.5074
nextstepstudio@aol.com
nextstepstudio.com

Exhibiting:
Matt Catt
Mark Chatterley
Todd A. Erickson
Robert Hessler
Eric Hoefer
Dean Lucker
Rebecca Myers
Craig Paul Nowak
Tom Phardel
Joan Rasmussen
Michael Schunke
Kaiser Suidan
Graceann Warn
Betsy Youngquist

Graceann Warn, **Abacus Diptych,** *2010*
wax encaustic, oil and objects on wood panels, 56 x 68 x 2
photo: Patrick Young

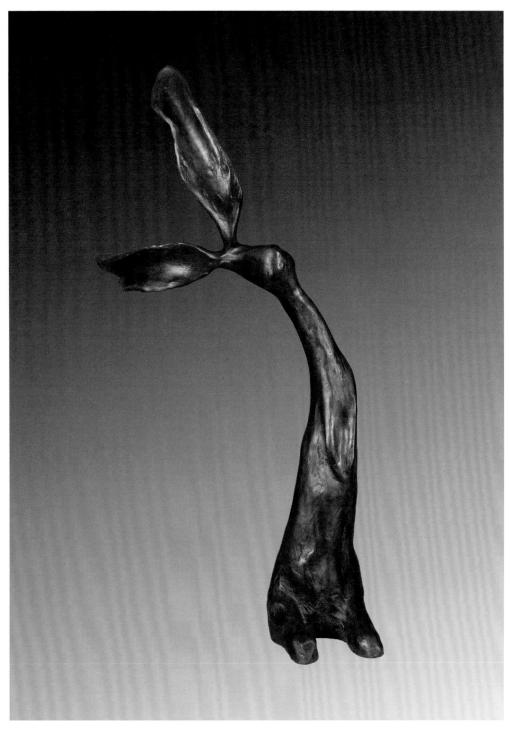

Jim Budish, **Chauncey Blowing in the Wind,** *2009*
cast bronze, 14 x 5
photo: Tom Van Eynde

Niemi Sculpture Gallery & Garden

Contemporary sculpture

Staff: Bruce A. Niemi, owner; Susan Niemi, director

13300 116th Street
Kenosha, WI 53142
voice 262.857.3456
fax 262.857.4567
gallery@bruceniemi.com
bruceniemi.com

Exhibiting:
Kevin Box
Jim Budish
Bruce A. Niemi
Kimberly Willcox

Kevin Box, **Nesting Cranes,** *2010*
cast stainless steel and bronze on character stone/unique, various sizes
photo: Bill Stengle

Alex & Lee/Lee Brooks and Greg Franke, **Moonlight Saguaro Necklace,** *2010*
natural abalone pearl, raw diamonds, fossilized scorpion claws and coral,
hammered and etched sterling, 12 x 5 x 1
photo: Hap Sakwa

Oliver & Espig

Glass, gemstones and metal sculptures by recognized artists
Staff: Marcia Ribeiro; Marilia Ribeiro; Tielle Larson

1108 State Street
Santa Barbara, CA 93101
voice 805.962.8111
oliverandespig@cox.net
oliverandespig.com

Exhibiting:
Goph Albitz
Karen Arthur
Lee Brooks
Ingerid Ekeland
Glenn Espig
Judith Evans
Greg Franke
Michael Good
Lucy M. Harvey
Susan Helmich
Josh Helmich
Steven Kretchmer
Claudia Kretchmer
Nancy Linkin
Bernd Munsteiner
Tom Munsteiner
George Sawyer
Konstantino Sioulas
Robert Wander
Phillip Youngman
Philip Zahm

Judith Evans and John Dyer, **Effervescent Pendant**
62.52 citrine cut by John Dyer, tsavorite garnet accents, diamonds,
18k yellow gold, 4.6 x 1.6 x .5

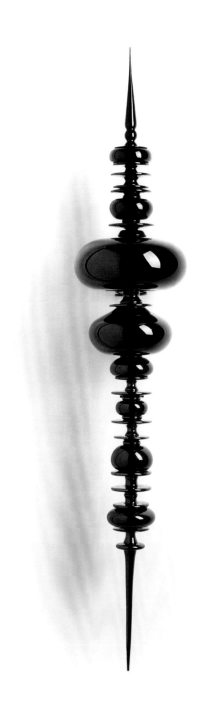

Tyler Rock, **Ingress,** *2010*
blown and solid sculpted glass, 53 x 9.5
photo: John Dean

Option Art/Galerie Elca London

Work by outstanding Canadian contemporary mixed media craft artists; established in 1985
Staff: Barbara Silverberg and Mark London, directors; Philip Silverberg and Dale Barrett, assistants

Option Art
4216 de Maisonneuve Blvd. W.
Montreal, Quebec H3Z 1K4
Canada
voice 932.3987
info@option-art.ca
option-art.ca

Galerie Elca London
224 Saint Paul West
Montreal, Quebec
Canada H2Y 1Z9
voice 514.282.1173
info@elcalondon.com
elcalondon.com

Exhibiting:
Ashevak Adla
Noo Atsiaq
Lalie Douglas
Noelle Hamlyn
Janis Kerman
Jim Lorriman
Veronique Louppe
Jay Macdonell
Mel Munsen
Agata Ostrowska
David Ruben Piqtoukun
Susan Rankin
Julia Reimer
Tyler Rock
David Samplonius
Axangayuk Shaa
Naoko Takenouchi
Orest Tataryn
Ashevak Tunnillie
Ovilu Tunnillie
Wendy Walgate
Vanessa Yanow

Janis Kerman, **Earrings,** *2010*
18k yellow and palladium white gold, 0.18ct white diamonds,
0.98ct black diamonds, cultured Tahitian mabe pearls

Bahram Shabahang, **Rising Tide,** *2010*
fiber, 108 x 149

Orley Shabahang

Contemporary Persian carpets
Staff: Geoffrey Orley and Bahram Shabahang, owners; Mehran Iravani, director

241 East 58th Street
New York, NY 10022
voice 212.421.5800
fax 212.421.5888
newyork@orleyshabahang.com
orleyshabahang.com

326 Peruvian Avenue
Palm Beach, FL 33480
voice 561.655.3371
fax 561.655.0037
palmbeach@orleyshabahang.com

223 East Silver Spring Drive
Whitefish Bay, WI 53217
voice 414.332.2486
fax 414.332.9121
whitefishbay@orleyshabahang.com

Exhibiting:
Bahram Shabahang

Bahram Shabahang, **Aspen Fall,** *2010*
fiber, 106 x 148

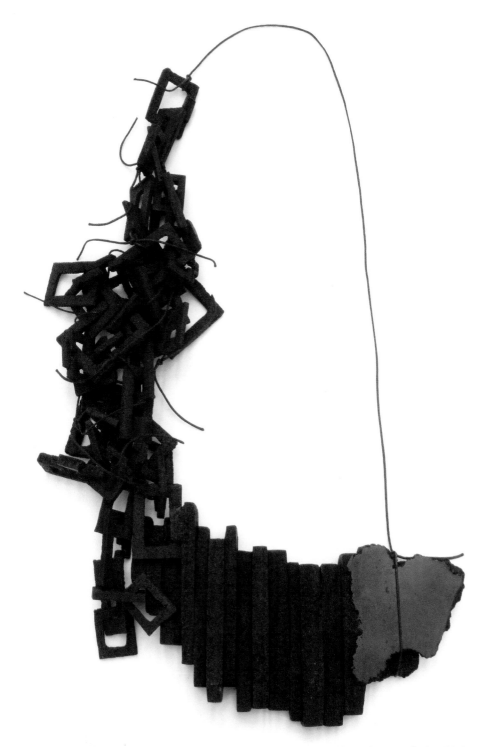

Agnes Larsson, **Carbo,** *2010*
carbon, thread, 16 inches in length

Ornamentum

International contemporary jewelry
Staff: Laura Lapachin; Stefan Friedemann

506.5 Warren Street
Hudson, NY 12534
voice 518.671.6770
fax 518.822.9819
info@ornamentumgallery.com
ornamentumgallery.com

Exhibiting:
David Bielander
Sara Borgegard
Helen Britton
Gemma Draper
Sam Tho Duong
Iris Eichenberg
Ute Eitzenhoefer
Jantje Fleischhut
Maria Rosa Franzin
Caroline Gore
Adam Grinovich
Rebecca Hannon
Hanna Hedman
Stefan Heuser
Idiots
John Iversen
Sergey Jivetin
Dan Jocz
Jiro Kamata
Jutta Klingebiel
Beate Klockmann
Agnes Larsson
Helena Lehtinen
Eija Mustonen
Ted Noten
Ruudt Peters
Camilla Prasch
Mary Preston
Katja Prins
Gerd Rothmann
Philip Sajet
Constanze Schreiber
Giovanni Sicuro
Silke Spitzer
Claudia Stebler
Jennifer Trask
Julia Turner
Tarja Tuupanen
Tanel Veenre
Petra Zimmermann

Giovanni Sicuro, Ring, 2010
silver, niello, 1.6 x .9 x .75

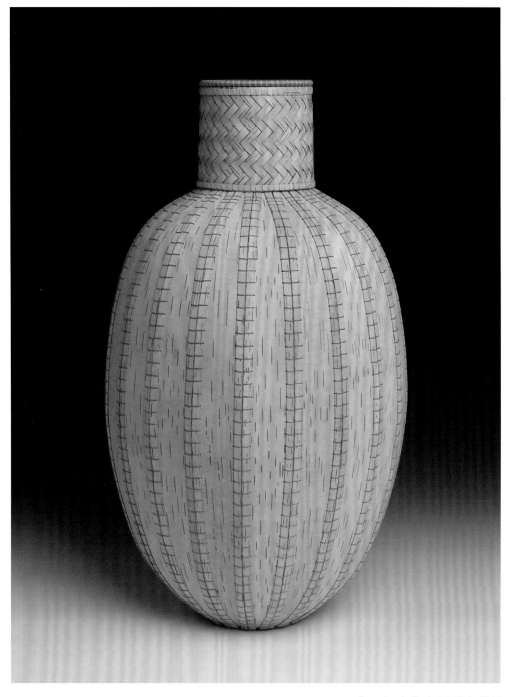

Dona Look, Basket #10-4, *2010*
white birch bark, waxed silk thread, 17.25 x 11.5 x 11.5
photo: Tom Van Eynde

Perimeter Gallery

*Ceramics and fiber art from contemporary masters and emerging artists;
special SOFA presentation with Ferrin Gallery,* Nude in Chicago
Staff: Frank Paluch, director; Scott Ashley, assistant director

210 West Superior Street
Chicago, IL 60654
voice 312.266.9473
fax 312.266.7984
perimeterchicago
 @perimetergallery.com
perimetergallery.com

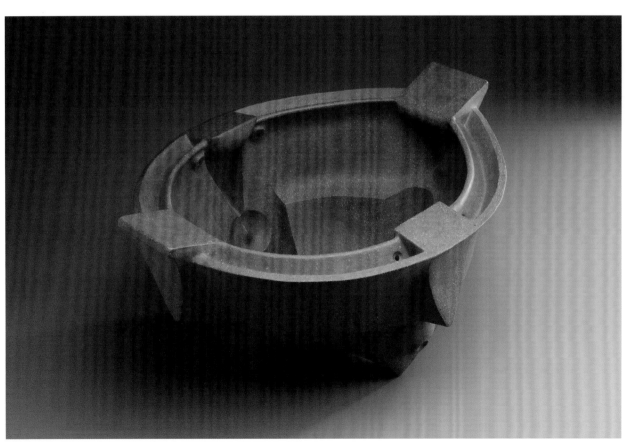

William Daley, **C-Venture Vesica,** *2007*
unglazed stoneware, 15 x 23 x 28
photo: John Carlano

Exhibiting:
Christie Brown
Lia Cook
William Daley
Jack Earl
Edward Eberle
Bean Finneran
Jeffrey Forsythe
Verne Funk
Kiyomi Iwata
Dona Look
Karen Massaro
Beverly Mayeri
Joseph Shuldiner
Vanessa L. Smith
Jay Strommen
Toshiko Takaezu
The Estate of Margaret Ponce Israel
Peter Voulkos
Patti Warashina
Julie York

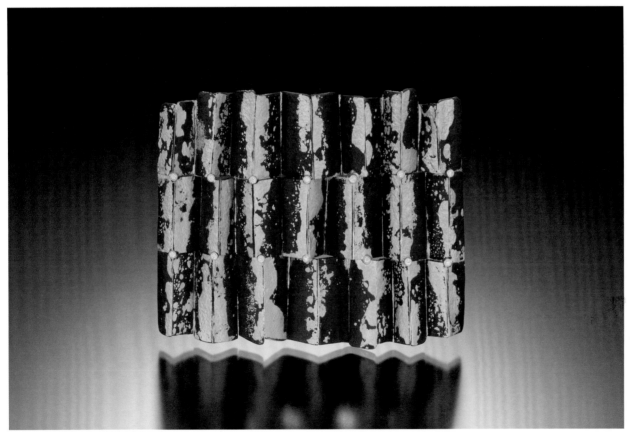

Pat Flynn, **What Lies Beneath Brooch**
iron, 22k, diamonds

Pistachios

Contemporary jewelry and crafts
Staff: Yann Woolley, director; Catherine Coe, manager; Sarah Osbourne; Cherise Fleming

55 East Grand Avenue
Chicago, IL 60611
voice 312.595.9437
fax 312.595.9439
pistachi@ameritech.net
pistachiosonline.com

Exhibiting:
Talya Baharal
Pat Flynn
Pawel Kaczynski
Gudrun Meyer
Biba Schutz

Talya Baharal, **Urban Landscape #34 Necklace**
silver, steel, copper, concrete

Karen Halt, **Higher Learning,** *2010*
hand-painted fiber, beeswax, resin, 62 x 16 x 16
photo: Fred Ficher/Maria Antonieta Oquendo

Portals Ltd.

Contemporary two and three dimensional art including sculpture, fiber, metal and glass
Staff: Nancy and William McIlvaine; Maria Antonieta Oquendo; Kelly Baas

744 North Wells Street
Chicago, IL 60654
voice 312.642.1066
fax 312.642.2991
artisnow@aol.com
portalsgallery.com

Milton Tomlinson, **Glass Fix,** *2010*
blown glass, steel, 30 x 36 x 13.5
photo: Maria Antonieta Oquendo

Exhibiting:
Ken Forst
Ted Gall
Karen Halt
Barbara Kohl-Spiro
Constance Roberts
Joel Sanderson
Milton Tomlinson

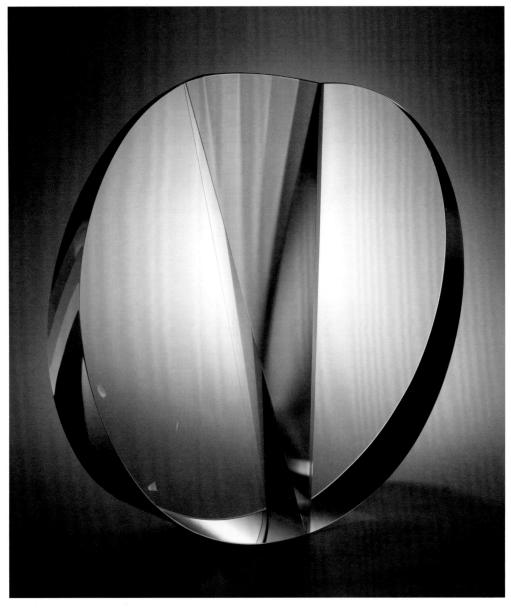

Martin Rosol, **Opus,** *2010*
laminated optical glass, 17 x 17.5 x 5
photo: David Stansbury

PRISM Contemporary/Patrajdas Contemporary Art Consulting

Creative excellence in contemporary fine art, objects and design
Staff: D. Scott Patria and Amy Hajdas, co-directors

PRISM Contemporary
Chicago, IL
voice 312.243.4885
info@prismcontemporary.com
prismcontemporary.com

Patrajdas Contemporary
Art Consulting
Chicago, IL
voice 312.226.3444
info@patrajdas.com
patrajdas.com

Exhibiting:
Shane Caryl
Martin Hlubucek
Chad Holliday
SangSik Hong
Kathleen Mulcahy
Junbum Park
Martin Rosol
Jeff Wallin

SangSik Hong, **Promise,** *2010*
drinking straws, 15.75 x 12 x 6.5

Lina Fanourakis, Beaubourg Necklace
18k rose gold and rose cut diamonds

SABBIA

75 East Walton
Chicago, IL 60611
voice 312.440.0044
sabbiafinejewelry@hotmail.com
sabbia.com

Elegant and imaginative jewelry; a blend of modern designs with classic motifs
Staff: Deborah Friedmann; Tina Vasiliauskaite; Amy Endres; Lourdes McKillop

Exhibiting:
Eclat
Lina Fanourakis
Yossi Harari
Federica Rettore
Alex Sepkus
Shamballa

Lina Fanourakis, **Blue Poppy Ring**
hand-painted gold

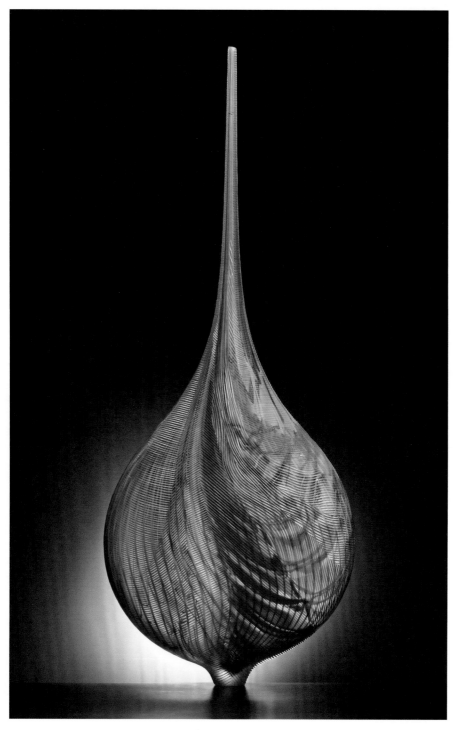

Lino Tagliapietra, Maui, 2010
blown glass, 43.5 x 7.75 x 7.25
photo: Russell Johnson

Schantz Galleries

Contemporary glass

Staff: Jim Schantz, owner/director; Kim Saul, owner/director of publications;
Stanley Wooley, sales associate; Ron Bill, shipping manager; James Bill, preparator

3 Elm Street
Stockbridge, MA 01262
voice 413.298.3044
jim@schantzgalleries.com
schantzgalleries.com

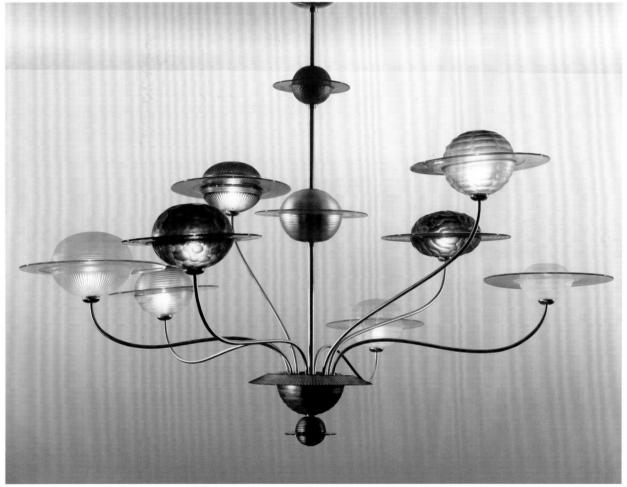

Exhibiting:
Lino Tagliapietra

Lino Tagliapietra, **Saturno Chandelier,** *2010*
illuminated sculpture with blown glass, steel, 58 x 60 x 60
photo: Rob Vinnedge

Mary Van Cline, Ivory Figure with Jade Leaves, *2010*
pâte-de-verre, 60 x 55 x 9

Scott Jacobson Gallery

Contemporary art in glass and furniture
Staff: Scott Jacobson; Eric Troolin

114 East 57th Street
New York, NY 10022
voice 212.872.1616
fax 212.872.1617
info@scottjacobsongallery.com
scottjacobsongallery.com

Exhibiting:
Richard Jolley
Seth Randal
Michael Taylor
Cappy Thompson
Mary Van Cline
Steven Weinberg

Richard Jolley, **Black Doves with Pomegranate Branches,** *2009*
glass, 36 x 54 x 12

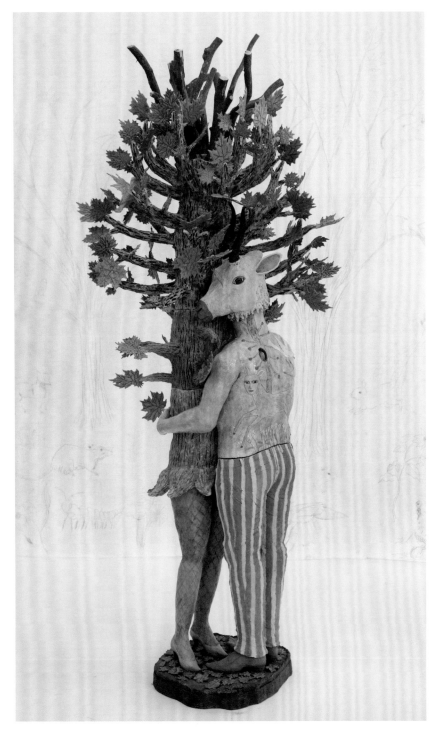

Kathy Ruttenberg, **Tree Hugger,** *2010*
bronze, ceramic, wood, 91 x 35 x 40

Sherrie Gallerie

Contemporary ceramic sculpture, fine art and art jewelry
Staff: Sherrie Riley Hawk, owner; Steve Louis; Hayley Hawk

694 North High Street
Columbus, OH 43215
voice 614.221.8580
fax 614.221.8550
sherrie@sherriegallerie.com
sherriegallerie.com

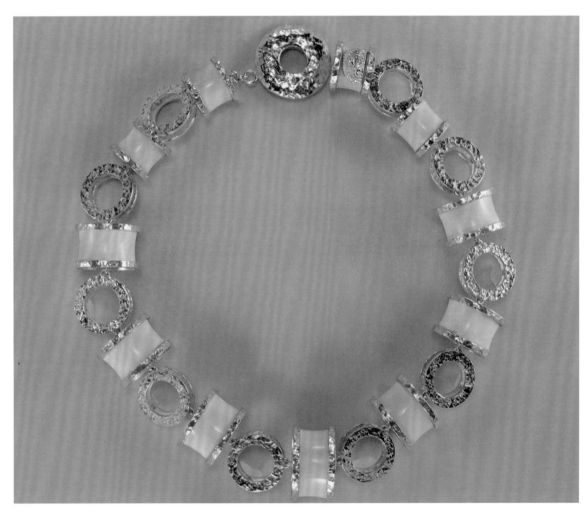

Sharon Meyer, **Ice Age**, *2010*
prehistoric woolly mammoth ivory, sterling silver, 17 inches in length
photo: Sharon Meyer

Exhibiting:
Jack Earl
Julie Elkins
Christian Faur
Duncan McClellan
Sharon Meyer
Kathy Ruttenberg
Keith Schneider
Janis Mars Wunderlich

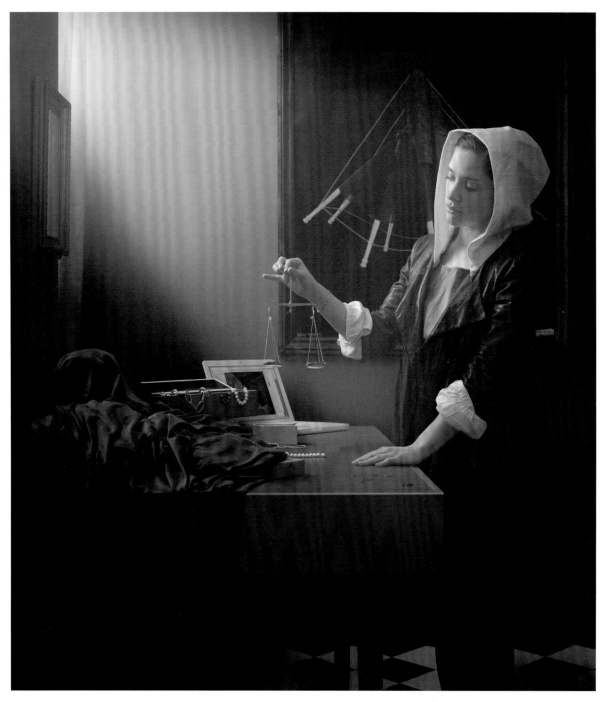

Maisie Broadhead, **Which Weigh to Go,** *2009*
digital C-type print, 15 x 17

Sienna Gallery

Contemporary art + object, specializing in studio jewelry
Staff: Sienna Patti, director

80 Main Street
Lenox, MA 01240
voice 413.637.8386
sienna@siennagallery.com
siennagallery.com

Exhibiting:
Giampaolo Babetto
Jamie Bennett
Suzanne Beautyman
Melanie Bilenker
Maisie Broadhead
Lola Brooks
Raissa Bump
Noam Elyashiv
Lauren Fensterstock
Gésine Hackenberg
Arthur Hash
Lauren Kalman
Anya Kivarkis
Esther Knobel
Monika Krol
Daniel Kruger
Myra Mimlitsch-Gray
Seth Papac
Tina Rath
Barbara Seidenath
Sondra Sherman
Kiff Slemmons
Bettina Speckner
Tracy Steepy
Johan van Aswegen
Sayumi Yokouchi

Maisie Broadhead, **Big Fake Little Real Gold Chain,** *2009*
18k gold, plastic

Lanny Bergner, Circles (detail), *2010*
bronze mesh, glass frit, silicone, 26 x 82 x 4

Snyderman-Works Galleries

Contemporary fiber, ceramic, jewelry, glass, wood, studio furniture, painting and sculpture
Staff: Rick and Ruth Snyderman, proprietors; Francis Hopson, director; Kathryn Moran, assistant director; Stacy Wyn Sarno, gallery assistant; Michael Bukowski, preparator

303 Cherry Street
Philadelphia, PA 19106
voice 215.238.9576
fax 215.238.9351
kat@snyderman-works.com
snyderman-works.com

Exhibiting:
Wesley Anderegg
Lucy Arai
Lanny Bergner
Karin Birch
Douglas Bucci
Dorothy Caldwell
Margaret Cusack
Kate Cusack
Marcia Docter
Steven Ford
David Forlano
Karen Gilbert
Doug Herren
Ron Isaacs
Kay Khan
Hongsock Lee
Ed Bing Lee
Gary Magakis
Bruce Metcalf
Marilyn Pappas
Huib Petersen
Joh Ricci
Cynthia Schira
Warren Seelig
Eva Steinberg
Elise Winters

Gary Magakis, **Landscape Doors,** *2010*
steel, bronze, 42 x 32 x 16

Richard Landis, Sevens, *1987*
double weave, mercerized cotton thread, 21 x 10.25

TAI Gallery

Contemporary Japanese bamboo art and photography, and museum-quality textiles
Staff: Rob Coffland; David Halpern; Everett Cole; Steve Halvorsen

1601 B Paseo de Peralta
Santa Fe, NM 87501
voice 505.984.1387
gallery@textilearts.com
taigallery.com

Exhibiting:
Abe Motoshi Kiraku
Fujinuma Noboru
Fujitsuka Shosei
Hatakeyama Seido
Honda Syoryu
Katsushiro Soho
Hirasawa Noboru
Monden Kogyoku
Morigami Jin
Nagakura Kenichi
Nakatomi Hajime
Yamaguchi Ryuun
Kawashima Shigeo
Shono Tokuzo
Kawano Shoko
Tanabe Takeo/Shochiku III
Torii Ippo
Ueno Masao
Naoki Honjo
Honma Hideaki
Masaru Tatsuki
Tanabe Mitsuko
Seiju Toda
Sugita Jozan
Yako Hodo
Tanaka Kyokusho
Hayakawa Shokosai V
Kibe Seiho
Tanioka Shigeo
Kajiwara Aya
Kajiwara Koho
Yoshihiko Ueda
Yufu Shohaku
Honma Kazuaki
Oki Toshie

Shono Tokuzo, **Move,** *2006*
madake bamboo, rattan, 11.5 x 18
photo: Gary Mankus

Elisabett Gudmann, **Shadow of a Dream: 1,** *2010*
etched copper panel, unique chemical patinas, 60 x 30 x 2

ten472 Contemporary Art

Contemporary art
Staff: Hanne Sorensen; Catherine Conlin; E. Gudmann; Rebecca O'Leary

By Appointment
Grass Valley, CA
voice 707.484.2685
fax 707.484.2685
info@ten472.com
ten472.com

Exhibiting:
Geoff Buddie
Elisabett Gudmann
Lissa Herschleb
Gino Miles
Chris Rom
Kirk H. Slaughter

Chris Rom and Geoff Buddie, **Brushes,** *2009*
hand-felted wool, stoneware, 9 x 5 x 3

John Miller, **Do Not Duplicate: Hot Rod Series,** *2010*
hot sculpted glass, forged steel, 28 x 12 x 6

Thomas R. Riley Galleries

Offering timeless forms of museum quality with an emphasis on service and education
Staff: Thomas R. Riley and Cynthia Riley, owners; Cheri Discenzo, director

28699 Chagrin Boulevard
Cleveland, OH 44122
voice 216.765.1711
fax 216.765.1311
trr@rileygalleries.com
rileygalleries.com

Exhibiting:
Ricky Bernstein
Latchezar Boyadjiev
Eoin Breadon
Jason Chakravarty
Josh Cole
Matthew Curtis
Donald Derry
Cherry Goldblatt
Merrilee Hall
Mark Yale Harris
Sung Soo Kim
Lucy Lyon
John Miller
Janis Miltenberger
Nick Mount
Binh Pho
Doug Randall
David Reekie
Sally Rogers
Harriet Schwarzrock
Lisa Smith
Philip Soosloff
Ethan Stern
Jake Stout
Stephanie Trenchard
Jennifer Violette

Binh Pho, **Gateless Dream,** *2010*
cast glass, paint, gold, 6 x 14

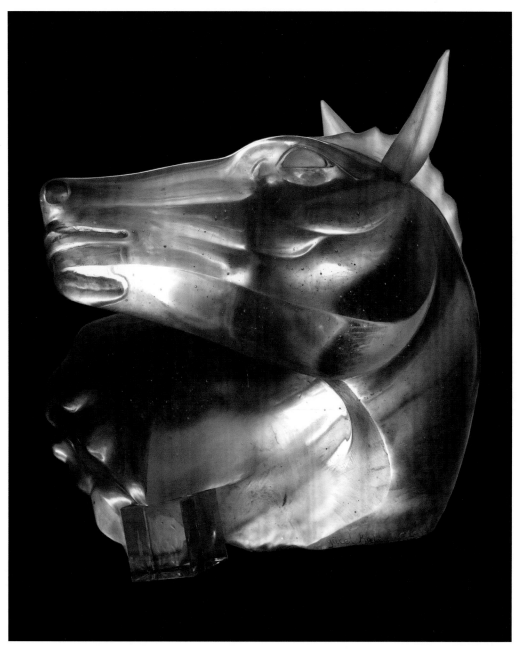

*Yucel Kale, **Untitled**, 2010*
glass, 25.75 x 25.75 x 19.75
photo: Ebru Yilmaz Kale

Turkish Cultural Foundation

Devoted to promoting and preserving Turkish culture, art and heritage
Staff: Carol Ann Jackson, Boston; Nurten Ural, Detroit; Hulya Yurtsever, Istanbul; Bonnie Joy Kaslan, Sonoma; Guler Koknar, Washington, DC

Locations in Boston; Detroit; Sonoma; Washington, DC and Istanbul, Turkey
voice 202.370.1399
fax 202.370.1398
director@turkishculture.org
turkishculturalfoundation.org

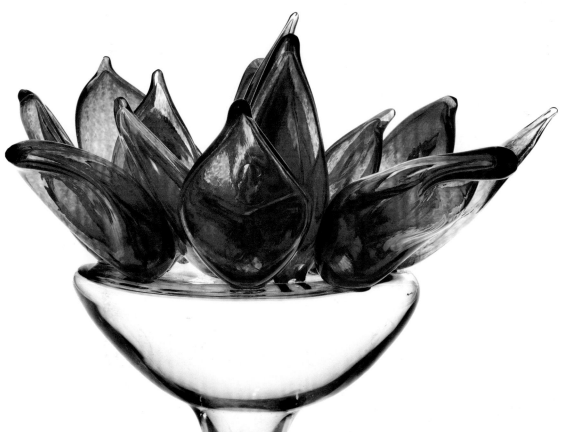

Exhibiting:
Yasemin Aslan Bakiri
Gamze Araz Eskinazi
Yucel Kale
Seckin Pirim
Yasemin Sayinsoy

Gamze Araz Eskinazi and Yasemin Sayinsoy, **Lotus,** *2008*
handblown glass, 16.5 x 23.75 x 16.5
photo: Bulent Unsal

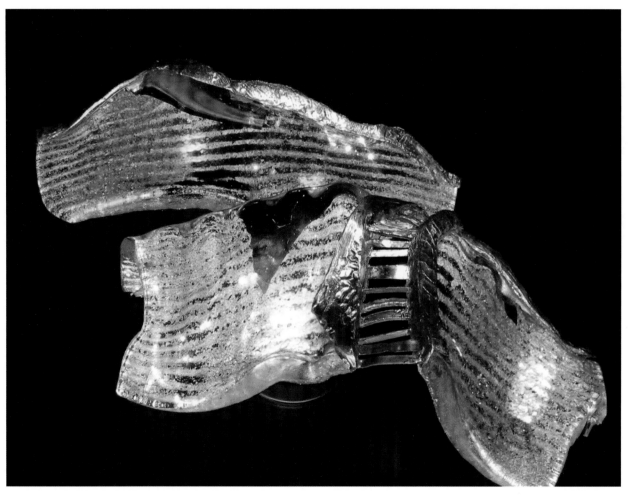

Yasemin Aslan Bakiri, **Mystery**, *2005*
sand, brass, 4.25 x 8.25 x 30.25
photo: Necati Ufuk Baskir

Turkish Cultural Foundation

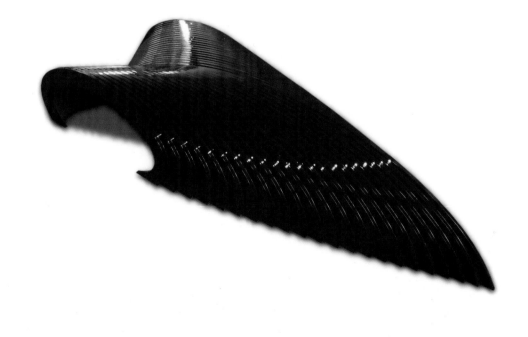

Seckin Pirim, **Composure Cabin,** *2009*
lacquered wood, 98.5 x 27.75 x 23.75
photo: Seckin Pirim

*Joseph Cavalieri, **D&G**, 2010*
vitreous enamel, layered stained glass, flashed glass, solder, 27 x 19 x 2

UrbanGlass

UrbanGlass fosters innovative art and advances glass as a creative medium
Staff: Dawn Bennett, executive director; Becki Melchione-Kapelusznik, associate director; Kristin Solomon, associate development officer

647 Fulton Street
Third Floor
Brooklyn, NY 11217
voice 718.625.3685
fax 718.625.3889
info@urbanglass.org
urbanglass.org

Charlene Foster, **These Prisms Are Brighter Than Those Diamonds,** *2010*
wrap necklace made of glass, 49 inches in length
photo: Axel Dupeux

Exhibiting:
Joseph Cavalieri
Charlene Foster
Helene Safire
Melanie Ungvarsky

David Trubridge, **Glide,** *2010*
ash, stainless steel screws, 87 x 31 x 28
photo: photo courtesy of the artist

Wexler Gallery

Specialists in museum-quality contemporary glass, art and design
Staff: Lewis Wexler and Sherri Apter Wexler, owners; Sienna Freeman, director; Michele Amicucci, gallery administrator

201 North 3rd Street
Philadelphia, PA 19106
voice 215.923.7030
fax 215.923.7031
info@wexlergallery.com
wexlergallery.com

Exhibiting:
Wendell Castle
Dale Chihuly
Morgan Craig
Brian Gladwell
Michael Glancy
Tomas Hlavicka
David Huchthausen
Thomas Hucker
Harvey K. Littleton
Materialise.MGX
William Morris
Tom Patti
Mark Peiser
Alex Roskin
Judith Schaechter
Timothy Schreiber
Paul Stankard
Dirk Staschke
Lino Tagliapietra
David Trubridge
Toots Zynsky

Mark Peiser, Section One, Seer, from the Palomar Series, *2009*
cast glass, aluminum stand, 25.75 x 9.5 x 9.5
photo: photo courtesy of the artist

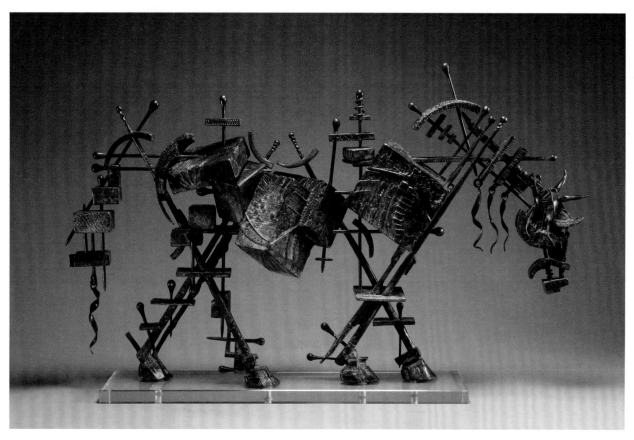

David Crawford, **Hippus Opus,** *2010*
bronze, edition of 9, 17.5 x 30.5 x 5.5

William Zimmer Gallery

Superior contemporary studio arts
Staff: William Zimmer and Lynette Zimmer, owners

PO Box 263
Mendocino, CA 95460
voice 707.937.5121
wzg@mcn.org
williamzimmergallery.com

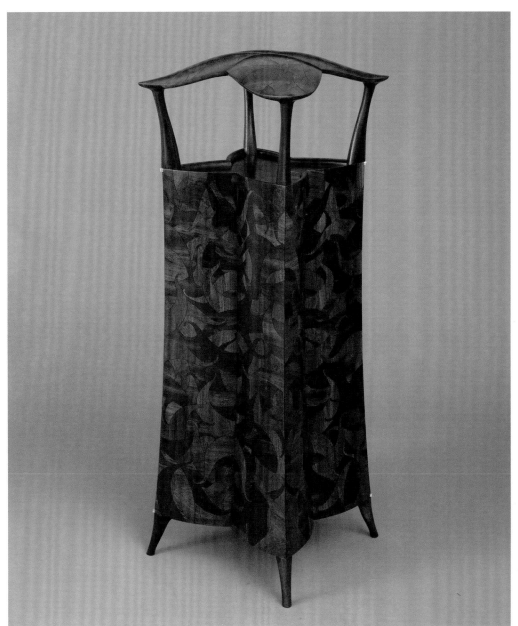

Brian Newell, **Untitled Cabinet,** *2010*
jichumu wood, 60 x 30 x 30

Exhibiting:
Carolyn Morris Bach
Bennett Bean
Timothy Coleman
David Crawford
John Dodd
Rebecca Gouldson
Thomas Huang
Tom Hucker
Tai Lake
Hiroki Morinoue
Brian Newell
Elizabeth Rand
Kent Townsend
Jeff Wise
Susan Wise
Rusty Wolfe

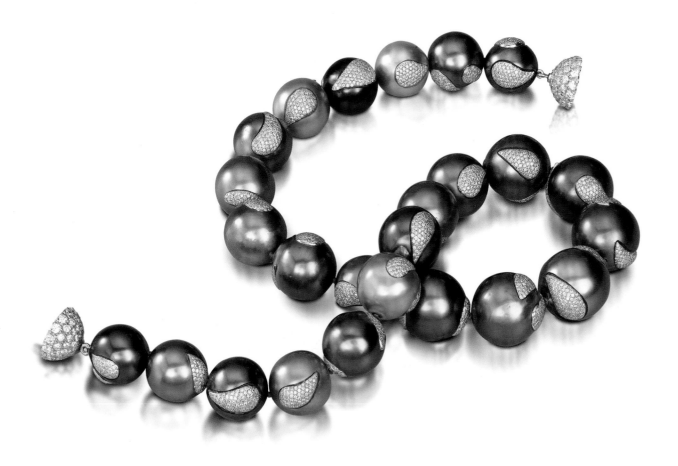

Isaac Levy, Gray Baroque Tahitian Pearl Necklace
17.34ct diamonds from the Yvel Black and White Collection, 18k white gold clasp

Yvel

High-end jewelry featuring pearls, natural sapphires, diamonds and gold
Staff: Isaac and Orna Levy, owners

1 Yechiel Shteniberg Street
Ramat Motza
Jerusalem 91101
Israel
voice 972.2.673.5811
fax 972.2.673.5812
yvel@yvel.com
yvel.com

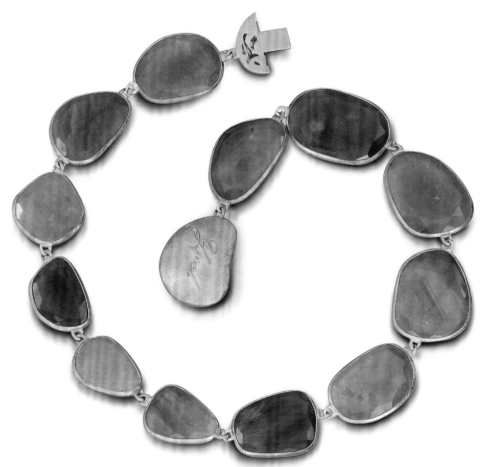

Exhibiting:
Isaac Levy
Orna Levy

Isaac Levy, **Necklace**
18k yellow gold, 404.00ct natural multi color sapphires from the Yvel Rainbow Collection

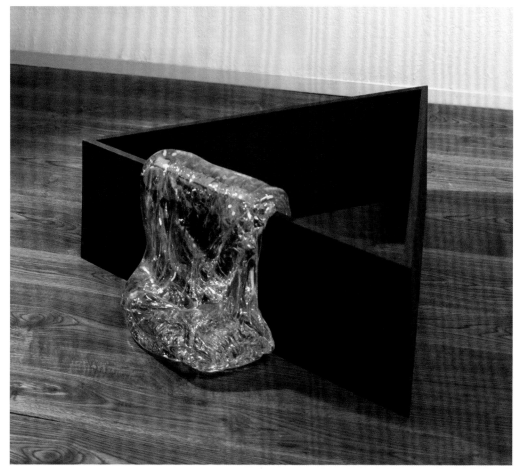

Mary Shaffer, **Triangle Fold #72898,** *2010*
hot glass, metal, 9 x 24 x 27

Zane Bennett Galleries

Blue-chip, internationally-known established and emerging artists working in all media
Staff: Sandy Zane and Ned Bennett, owners; Christian Cheneau, artistic director; Mark Di Prima and Nancy Boshers, sales directors; Amanda Olesen, administrator

435 South Guadalupe Street
Santa Fe, NM 87501
voice 505.982.8111
fax 505.982.8160
zanebennett@aol.com
zanebennettgallery.com

Exhibiting:
Stephen Auger
Dunham Aurelius
Stephen Buxton
Mark di Suvero
Guy Dill
Bruce Dorfman
Maria Hwang Levy
Pascal
Michael Petry
Holly Roberts
Joshua Rose
Mary Shaffer
Rachel Stevens
Denise Yaghmourian
Karen Yank

Pascal, **Adamawa On Me,** *2010*
mahogany, 48 x 48

Re

sources

american craft

Abstraction pitcher, 2010, wheel-thrown, carved white stoneware with Chanjari blue glaze, 9 x 6½ x 8½ in.
Abstraction vase, 2010, carved white stoneware with evergreen glaze, 6½ x 3½ x 6 in.

Quality Magazines of Art, Antiques & Decoration

The number one art, antiques and decoration magazine of Turkey, **Antik Dekor**, publishes the news regarding the important auctions, art and antiques fairs worldwide.

With richly illustrated and academically proven essays written by scholars the secrets of world's masterpieces in every field of art are revealed. In every issue a special section on the latest decoration trends and fashionably decorated houses are presented to our quality readers together with the interviews with renowned artists and watch makers. In depth coverage of art and antiques market is also provided alongside twenty pages devoted to the latest art books and exhibitions worldwide.

From now on **Antik Dekor** is two magazine. **Artam Global Art** which informs readers about changes, improvements in Modern and Contemporary Art all around the world is going to be on kiosks together with **Antik Dekor**. Exhibitions, fairs, biennials, auctions, interviews with internationally acclaimed artists, academically proven essays written by scholars with richly illustrated images will be covered in **Artam Global Art**. Paintings, sculptures, installations, videos of contemporary artists will be examined. **Artam Global Art** is ready to take part in libraries with its new graphic design and content.

st way to follow the rising Turkish Art Market: ARTAM Global Art + **ANTİKDEKOR**

Burhan Doğançay (1929)
"Symphony in Blue"

Erol Akyavaş (1932-1999)
"The Siege"

Fahr El Nissa Zeid
"London"

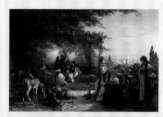

Alois Schönn (1825-1897)
"Les Repos Sous Les Ombrages
à Constantinople"

Şevket Dağ (1876-1944)
"Hagia Sophia"

Süleyman Seba Cd. Talimyeri Sk. Maçka 34357 Istanbul/TURKEY ENQUIRIES: +90 212 236 24 60 www.antikas.com

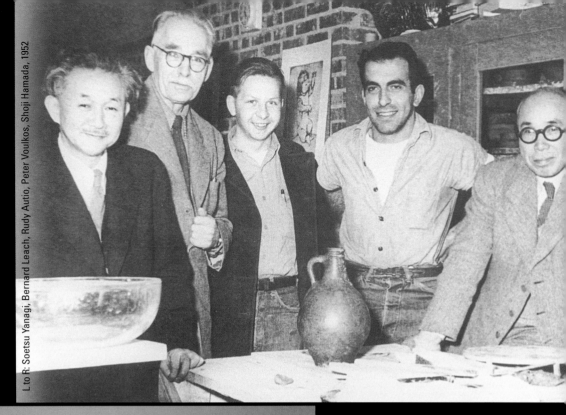

2011 FROM THE CENTER TO THE EDGE
60 YEARS OF CREATIVITY AND INNOVATION AT THE ARCHIE BRAY FOUNDATION

L to R: Soetsu Yanagi, Bernard Leach, Rudy Autio, Peter Voulkos, Shoji Hamada, 1952

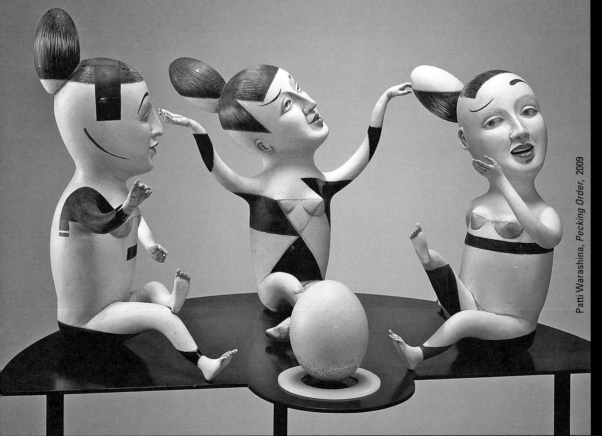

Patti Warashina, *Pecking Order*, 2009

SOFA CHICAGO EXHIBITION:
NOVEMBER 5–7, 2010

Participating artists:
Aaron Benson, Birdie Boone, Robert Brady, Nathan Craven, Josh DeWeese, Sean Erwir Julia Galloway, Martha Grover, Sarah Jaege Steven Young Lee, Richard Notkin, Courtney Murphy, Kelly Garrett Rathbone, Don Reitz, Steven Roberts, Kevin Snipes, Chris Staley, Tip Toland, Patti Warashina, Kurt Weiser, Kensuke Yamada, and Gwendolyn Yoppolo.

LECTURE: *From the Center to the Edge: Celebrating 60 years of Creativity and Innovation at the Archie Bray Foundation* by Resident Artist Director Steven Young Le Saturday, November 6, 2–3 PM
Reception to follow at exhibition space

60TH ANNIVERSARY EVENT:
JUNE 23–25, 2011
60th.archiebray.org

archiebrayfoundation
for the ceramic arts

2915 Country Club Ave, Helena, MT 69602
406/443-3502 • www.archiebray.org

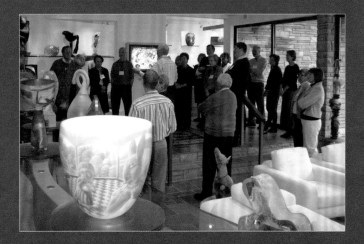

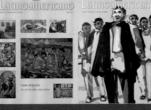
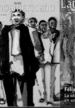

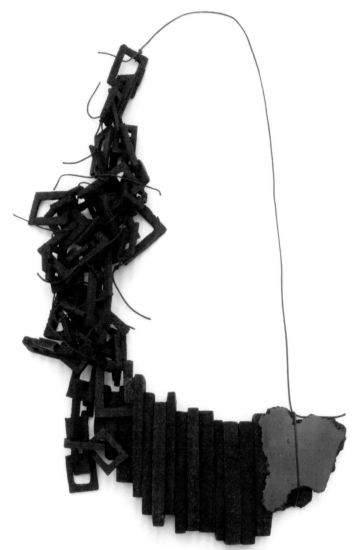

AGNES LARSSON
2010 EMERGING ARTIST AWARD

The Art Jewelry Forum Emerging Artist Award acknowledges promise, innovation and individuality in the work of emerging artists. Agnes Larsson from Stockholm, Sweden, was chosen from 117 entries from 38 countries as this year's winner of our award. To lend your support join Art Jewelry Forum today at www.artjewelryforum.org.

Photo: Agnes Larsson, Carbo, 2010, mixed media, 16 x 18 x 1 inches
AJF P.O. Box 823 Mill Valley, CA 94942 415.522.2924 artjewelryforum.org

In sync with art

Judith Villamayor
Jennifer Fay
Alexei Marroquin
Martonette Borromeo
Dharmendra Nathoo
Cecilia Arrospide
Ofer Mizrachi
Vera Tataro
Despina Papadopoulou
Monica Bedini
Katarzyna Gajewska
Daniela Vargas
Ang Yiansann
RJacquline De St. Aubin
Maria Pia Barberi
Ted Barr
Gregory Stocks
Carmela Slavutzky
Hazel NY
Robert Gaudreau
Federico Mazza
Robyn Desposito
Jan-Oliver Wenzel
Hans Johansson
Ariane Garnier
Shoshana Kertesz
Gayle Reynolds
Winibey Lopez
Josep Mane
Ben Allen
Sofia Amar
Anita Roessler

artn•w
online.com

www.artnowonline.com • info@artnowonline.com

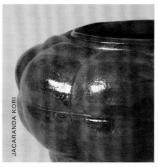

JACARANDA KORI

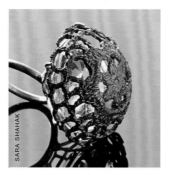

SARA SHAHAK

110 E. 59th Street
26th Floor
New York, NY 10022
Tel: (212) 931-0110
Fax: (212) 931-0080
www.AIDAarts.org

NOA NADIR

GIL LEITERSDORF

NATI AMOILS

ANAT GELBARD

SAMY D

AIDA
association of israel's decorative arts

ADI ZLOTTOGORA

IRIT ABBA

YAEL AIZMONY

TALIA RATZON

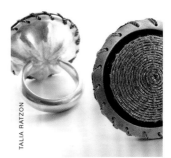

VERED TANDLER DAYAN

DAFNA KAFFEMAN

Bonhams
1793
AUCTIONEERS & APPRAISERS

20th Century Decorative Arts

Tuesday December 14
at 1pm
New York

Preview
December 11-13

Inquiries
Frank Maraschiello
+1 212 644 9059
frank.maraschiello@bonhams.com

Angela Past
+1 323 436 5422
angela.past@bonhams.com

Jason Stein
+1 323 436 5405
jason.stein@bonhams.com

Illustrated Catalog: $35

Harvey Littleton
Loop, 1979
internally decorated, blown,
shaped and polished glass
Estimate: $6,000 - 9,000

www.bonhams.com/newyork

London · New York · Paris · San Francisco · Los Angeles · Hong Kong · Sydney · D

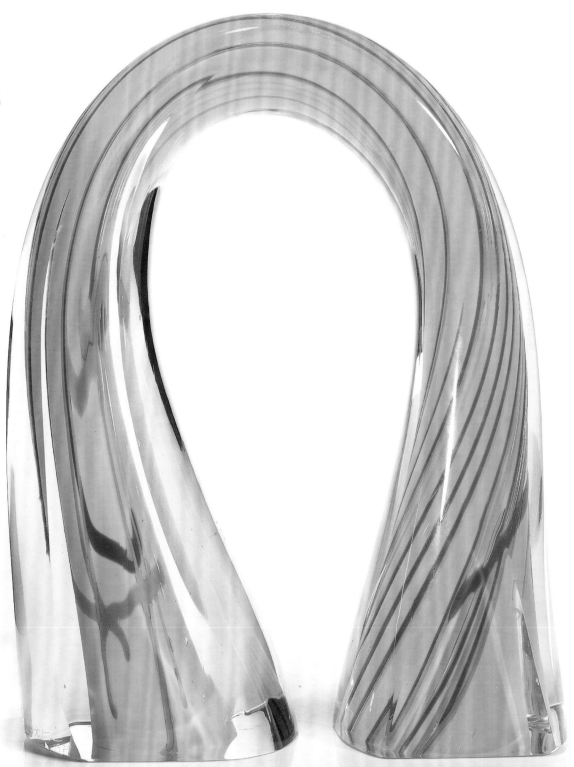

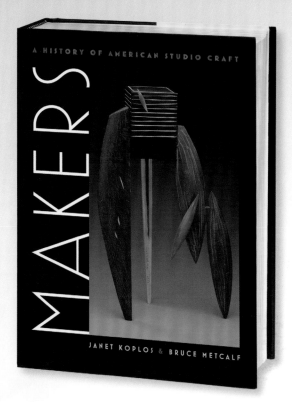
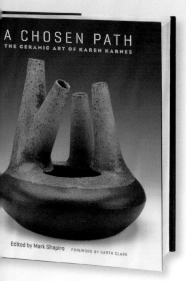
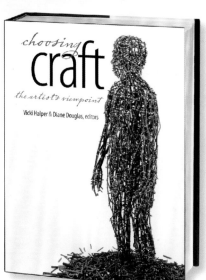

CERAMICREVIEW

The Magazine of Ceramic Art and Craft

CERAMIC REVIEW
The Magazine of Ceramic Art and Craft
Issue 245 September/October 2010 £6.30
www.ceramicreview.com

Emmanuel Cooper
Potter, writer, educator, critic

JULIAN STAIR
Carefully grouped
vessel objects

SARA MOORHOUSE
Brightly banded bowls with
an optical twist

MICHAEL DOOLAN
The darker side of
fairy tales

CERAMIC REVIEW
The Magazine of Ceramic Art and Craft
Issue 237 May/June 2009 £6.30
www.ceramicreview.com

Ken Eastman

EVA HILD
JOHN MALTBY
JONATHAN GARRATT
GAOLYARD POTTERY
JUDITH DAVIES
LOUISA TAYLOR

CERAMIC REVIEW
The Magazine of Ceramic Art and Craft
Issue 236 March/April 2009 £6.30
www.ceramicreview.com

Barbara Nanning

KAORI TATEBAYASHI JILL FANSHAWE KATO
CHRIS KEENAN ROBERT DAWSON VALLAURIS BIENNALE

SUBSCRIBE NOW GET ONE COPY FREE*

Ceramic Review is the leading British magazine
of studio pottery, which has been read by all
those engaged with contemporary ceramic art
and craft around the world since 1970

One year subscription 6 issues **£42**
Two year subscription 12 issues **£76**

TEL **+44 (0) 20 7439 3377**
EMAIL **subscriptions@ceramicreview.com**
WEB **www.ceramicreview.com**

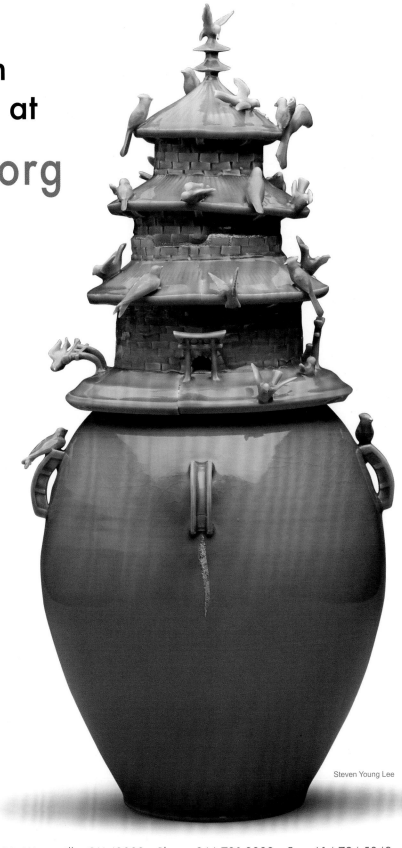

nally—a software that does everything...

- ✔ catalog any type of collection in brief or in detail
- ✔ link contacts, literature, valuations and insurance policies to your objects
- ✔ personalize drop-down lists, description screens, entry wizards to speed data entry
- ✔ record condition, provenance and more
- ✔ consign and sell easily with the Consignment screen and reports
- ✔ build up-to-date or historical records on designers, artists, makers or factories
- ✔ add live web sites and email addresses and link directly to them
- ✔ track financial details like purchases, expenses and revenues
- ✔ convert currency and measurements easily
- ✔ substantiate an object's value using the Comparison screen
- ✔ specify blanket policy details and all itemized objects
- ✔ plan your estate using the Beneficiary screen
- ✔ communicate directly with your financial manager
- ✔ automate reminders of poicy renewals, shipping dates, consignments
- ☐ wash your car

Well, *practically* everything...

collectify

Chicago Gallery News - the most comprehensive guide to art galleries, resources + events since 1983

- Gallery exhibition dates + details
- Opening receptions
- Exhibiting artists list
- Galleries by specialty
- Artist, collector, + dealer interviews
- Art resources + businesses
- Calendar of city-wide art events
- Pull-out district maps + Google Maps
- Alternative space, studio, + nonprofit directory

To subscribe advertise, please contact us:
Chicago Gallery News
730 N. Franklin
Chicago, IL 60654
Tel 312 649 0064
info@chicagogallerynews.com
www.chicagogallerynews.com

Chicago Gallery News is published in print in January, April and September

CRAFT ARTS INTERNATIONAL

is one of the oldest and most respected periodicals in its field. It has attracted worldwide acclaim for its "international scope" of the variety of contemporary visual and applied arts it documents in a lucid editorial style and graphic format. In 2010 the magazine celebrates almost three decades of continuous publishing. Our online index includes every article and artist that has appeared in the magazine since it was launched in 1984.

Each issue of the magazine contains 128 pages in full color with over 400 color images of innovative concepts and new work by leading artists and designer/makers, supported by authoritative texts, that provides essential reading for those interested in the contemporary visual and applied arts.

Visit our secure website to subscribe online.

www.craftarts.com.au

PO Box 363, Neutral Bay, NSW 2089, Australia
Tel: +61 2 9908 4797 Fax: +61 2 9953 1576
Email: info@craftarts.com.au

Limited stocks of back issues may be ordered online

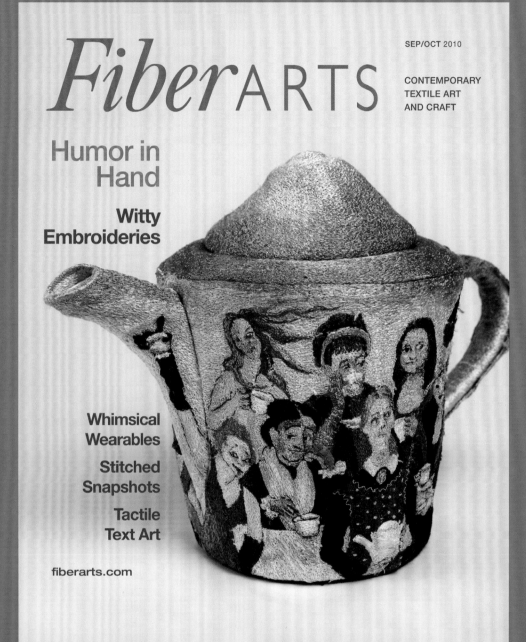

GLASHAUS
2/2010
7,50 EUR

www.glashaus-magazin.de
www.glasshouse.de

ISSN 1435-8565
K49413

GLASHAUS
Internationales Magazin für Studioglas

GLASSHOUSE

Eun Su
Choi

Michaela
Swade

Joseph
Cavalieri

Dagmar
Pankova

Das Glas, die
Lampe und Ich

www.glasshouse.de

CONTEMPORARY FIBER ART

Who directs, advises and belongs to
Friends of Fiber Art International?
Learn about members' achievements.

WHO

What is contemporary fiber art?
See the side-bar gallery.
Discover the organization's mission.

WHAT

When are
Friends of Fiber Art International's
programs?

WHEN

Where in the world
may I see contemporary fiber art
exhibitions in museums and galleries?

WHERE

Why should I support Friends
of Fiber Art International?
What unique benefits will I enjoy?

WHY

How do I join, post my fiber show in
Friends' WHERE calendar,
or apply for a grant?

HOW

LEARN THE ANSWERS

TO THESE QUESTIONS

WHEN YOU VISIT

OUR NEW WEB SITE

www.FriendsofFiberArt.org

LASS ART SOCIETY

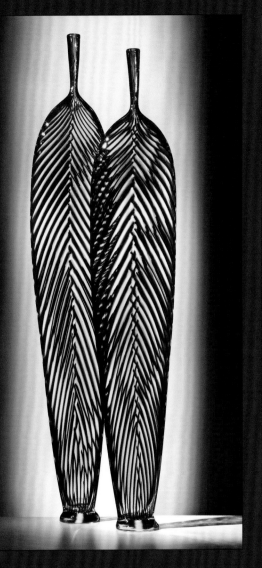

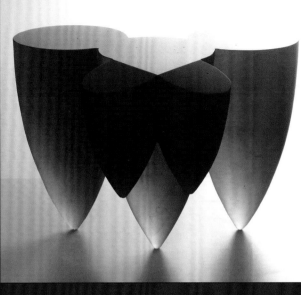

OIN US in Seattle, Washington, r the 41st annual GAS conference, *reative Crossroads*, June 1-5, 2011

www.jra.org

The James Renwick Alliance is an independent national non-profit organization, created to celebrate the achievements of America's craft artists and to foster scholarship, education, and public appreciation of craft art. Founded in 1982, the Alliance helps support the nation's showcase of contemporary American craft, the Renwick Gallery of the Smithsonian American Art Museum, Washington, D.C.

James Renwick Alliance

WASHINGTON DC

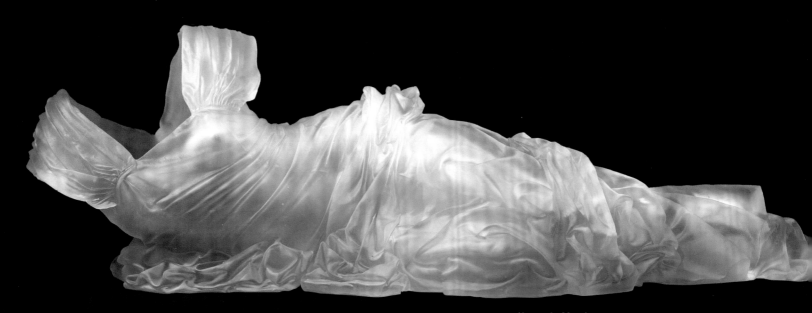

Karen LaMonte
Reclining Dress Impression with Drapery, 2009, glass
Smithsonian American Art Museum, Renwick Gallery
Gift of the James Renwick Alliance and Colleen and John Kotelly

Join

a national community of contemporary craft enthusiasts

Come to DC for our major fund-raising event
Spring Craft Weekend March 24–27, 2011

metalsmith

...he thinking person's guide to
...e world of metalsmithing…

For three decades, the
award-winning *Metalsmith*
magazine has been the
critical forum for the studio
jewelry and metals field.

The Brass Age
Objects of Remembrance
Poetic Truths

Conceptual Ornament
Mining History
Artist of Essence

The Secret Life of Light
Metalsmiths Against War
A Broadband Virtuoso

metalsmith

ART
DESIGN
JEWELRY
METAL

$8.50 USA | SNAGMETALSMITH.ORG

...ou can count on
...*etalsmith* to be smart,
...rovocative, and beautiful.

...ee what you think.

Published by the Society of
North American Goldsmiths
Artists. Designers.
Jewelers. Metalsmiths.
www.snagmetalsmith.org

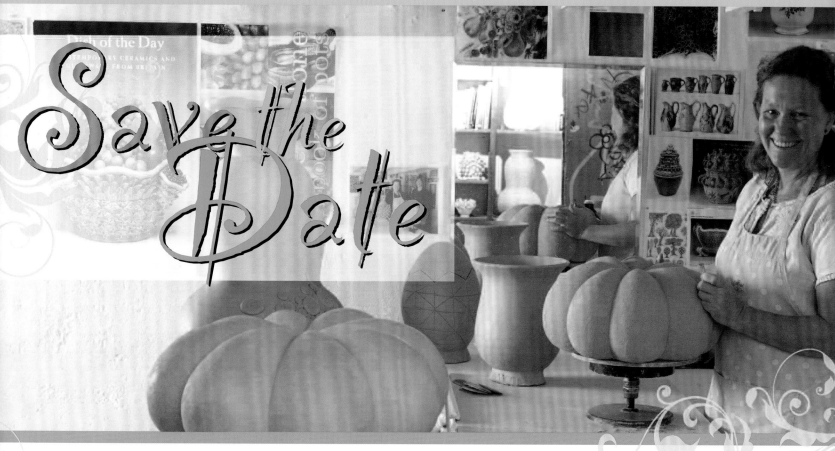

Ten Year Anniversary of the Mint Condition Gala

A Benefit Auction for the Mint Museum of Craft + Design

Saturday, March 12, 2011

Save the Date

Guest artist Kate Mal

featuring:

Guest artist Kate Malone, Cocktail Party, Silent and Live Auctions, Gourmet Dinner and Dancing.

Sponsored by

The Founders' Circle Ltd. the National Support Affiliate of the Mint Museum of Craft + Design
www.founderscircle.org | founderscirclemmcd@gmail.com | 704.999.5417

The Mint Museum of Craft + Design, **Opening October 1, 2010** at the Levine Arts Center, 500 S. Tryon St, Charlotte, NC 28202

NEW CERAMICS
THE EUROPEAN CERAMICS MAGAZINE

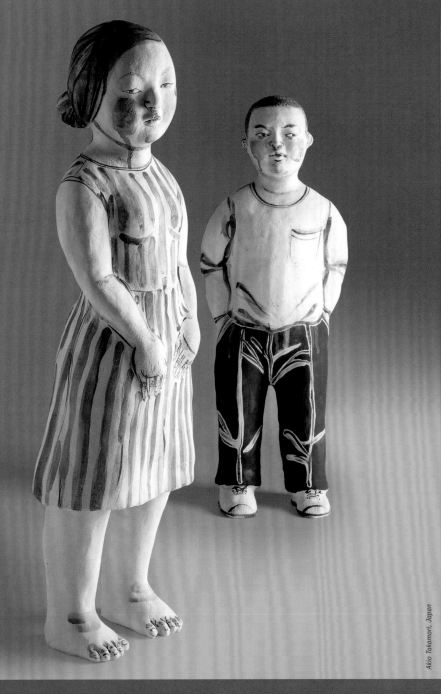

Akio Takamori, Japan

NEW CERAMICS - 6 issues a year
ANNUAL SUBSCRIPTION:
Europe: surface mail € 45,- | US$ 59,- | £ 39,-
Europe: airmail € 49,-
World: surface mail € 47,- | US$ 59,- | £ 39,-
World: airmail € 60,- | US$ 78,- | £ 50,-
Price of single copy: € 9,- | US$ 11,-| £ 7,-

NEW CERAMICS GmbH, Steinreuschweg 2
D-56203 Hoehr-Grenzhausen, Germany
Tel. +49 2624-948068 Fax: -948071
www.neue-keramik.de info@neue-keramik.de
ONLINE SUBSCRIPTION: www.new-ceramics.com

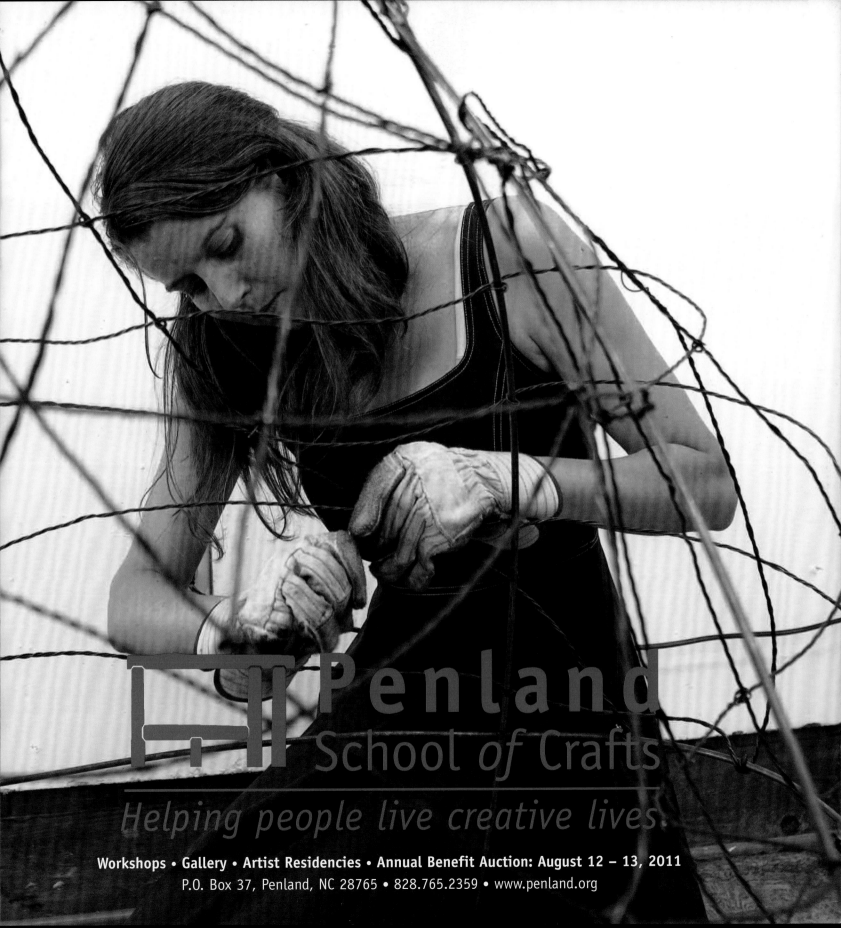

Penland
School of Crafts

Helping people live creative lives.

Workshops • Gallery • Artist Residencies • Annual Benefit Auction: August 12 – 13, 2011

P.O. Box 37, Penland, NC 28765 • 828.765.2359 • www.penland.org

PILCHUCK GLASS SCHOOL

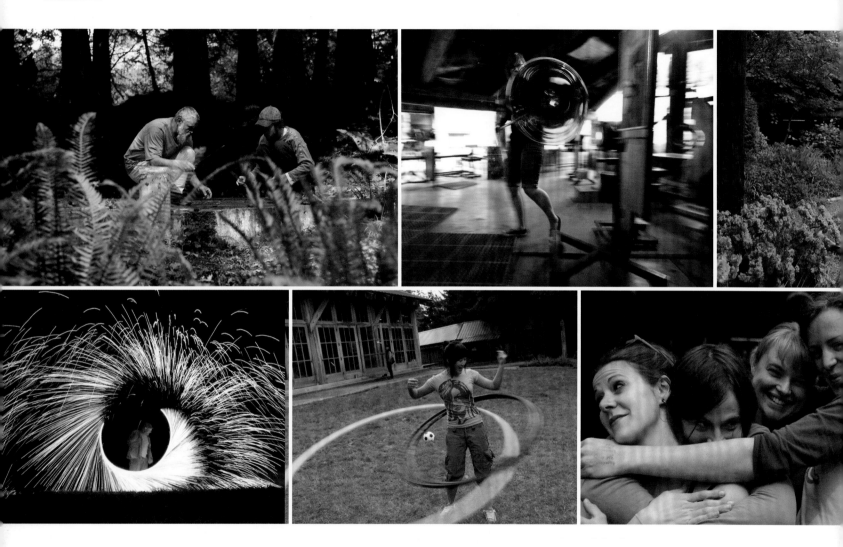

PILCHUCK INSPIRES CREATIVITY, TRANSFORMS INDIVIDUALS AND BUILDS COMMUNIT

CAMPUS: 1201-316th St NW Stanwood, WA 98292 T: 360.445.3111 F: 360.445.55
ADMINISTRATION: 430 Yale Ave N Seattle, WA 98109 T: 206.621.8422 F: 206.621.07

Or visit us online at pilchuck.cor

COME AND TASTE OUR WINES AND MEET THE WINEMAKER

THREE WINE COMPANY

three 3

Through December 31, 20

Forget Me NOT

SELF-TAUGHT PORTRAITS

William Matthew Prior (1806-1873), *Double Portrait of Mary Cary and Susan Elizabeth Johnson*, 1848, Terra Foundation for American Art, Daniel J. Terra Collection, Chicago, 1992.122

Intuit: The Center for Intuitive and Outsider Ar
756 N. Milwaukee Ave · Chicago, IL · www.art.org

UrbanGlass

647 Fulton Street • Brooklyn, NY 11217

www.urbanglass.org • 718-625-3685

UrbanGlass is a leading resource for both
aspiring and established artists wishing to
create with glass. We foster innovative art
and advance the use and appreciation of
glass as a creative medium.

collect

The International Art Fair
for Contemporary Objects

Presented by the Crafts Council
www.craftscouncil.org.uk

6 - 9 May 2011

Saatchi Gallery
Duke of York's HQ
King's Road, London

To register for event details
and the VIP programme, ema
d_wells@craftscouncil.org.u

Crafts Council Registered Charity Number 280956

Supported by
**ARTS COUNCIL
ENGLAND**

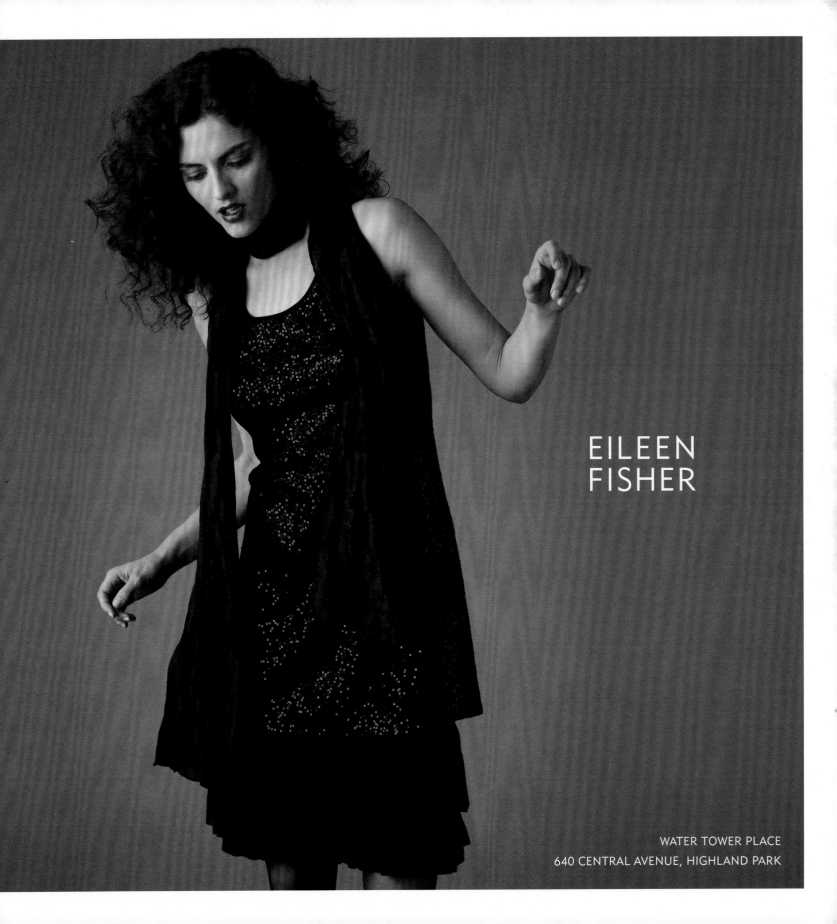

EILEEN
FISHER

WATER TOWER PLACE
640 CENTRAL AVENUE, HIGHLAND PARK

INTERNATIONAL EDITION

THE ART NEWSPAPER

FOR US SUBSCRIPTIONS:

+1 888 475 5993

FOR UK AND REST OF THE WORLD SUBSCRIPTIONS:

+44 1795 414 863

WWW.THEARTNEWSPAPER.COM

ART TRANSPORTS ALL OF US.

American Airlines is proud to sponsor the 17th Annual SOFA CHICAGO Art Fair.

We know why you fly **AmericanAirlines**

AA.com

xhibitors

Aaron Faber Gallery
666 Fifth Avenue
New York, NY 10103
212.586.8411
fax 212.582.0205
info@aaronfaber.com
aaronfaber.com

Adamar Fine Arts
4141 NE 2nd Avenue
Suite 107
Miami, FL 33137
305.576.1355
fax 305.576.1922
adamargal@aol.com
adamarfinearts.com

Amaridian
31 Howard Street
New York, NY 10013
917.463.3719
fax 917.463.3728
info@amaridianusa.com
amaridianusa.com

Ann Nathan Gallery
212 West Superior Street
Chicago, IL 60654
312.664.6622
fax 312.664.9392
nathangall@aol.com
annnathangallery.com

Barry Friedman Ltd.
515 West 26th Street
2nd floor
New York, NY 10001
212.239.8600
fax 212.239.8670
contact@barryfriedmanltd.com
barryfriedmanltd.com

Beaver Galleries
81 Denison Street, Deakin
Canberra, ACT 2600
Australia
61.26.282.5294
fax 61.26.281.1315
mail@beavergalleries.com.au
beavergalleries.com.au

Blue Rain Contemporary
130 Lincoln Avenue
Suite C
Santa Fe, NM 87501
505.954.9902
info@blueraingallery.com
blueraingallery.com

browngrotta arts
By Appointment
Wilton, CT
203.834.0623
fax 203.762.5981
art@browngrotta.com
browngrotta.com

Bruno Dahl Gallery
Stockflethsvej 12
Ebeltoft 8400
Denmark
45.86.259.594
info@brunodahl.dk
brunodahl.dk

Bullseye Gallery
300 NW 13th Avenue
Portland, OR 97209
503.227.0222
fax 503.227.0008
gallery@bullseyeglass.com
bullseyegallery.com

Charon Kransen Arts
By Appointment
817 West End Avenue, Suite 11C
New York, NY 10025
212.627.5073
fax 212.663.9026
charon@charonkransenarts.com
charonkransenarts.com

**Chiaroscuro
Contemporary Art**
702 1/2 Canyon Road
Santa Fe, NM 87501
505.992.0711
fax 505.992.0387
john@chiaroscurosantafe.com
chiaroscurosantafe.com

Crea Gallery
350 St. Paul Street East
Montreal, Quebec H2Y 1H2
Canada
514.878.2787, ext. 2
fax 514.861.9191
crea@creagallery.com
creagallery.com

Dai Ichi Arts, Ltd.
By Appointment
New York, NY
212.230.1680
fax 212.230.1618
info@daiichiarts.com
daiichiarts.com

David Richard Contemporary
130 Lincoln Avenue
Suite D
Santa Fe, NM 87501
505.983.9555
fax 505.983.1284
info@davidrichardcontemporary.com
davidrichardcontemporary.com

del Mano Gallery
2001 Westwood Boulevard
Los Angeles, CA 90025
310.441.2001
gallery@delmano.com
delmano.com

Donna Schneier Fine Arts
By Appointment
Palm Beach FL &
Claverack, NY, FL
518.441.2884
dnnaschneier@mhcable.com
donnaschneier.com

Duane Reed Gallery
4729 McPherson Avenue
St. Louis, MO 63108
314.361.4100
fax 314.361.4102
info@duanereedgallery.com
duanereedgallery.com

Ferrin Gallery
437 North Street
Pittsfield, MA 01201
413.442.1622
fax 413.442.1672
info@ferringallery.com
ferringallery.com

FLAME RUN
828 East Market Street
Louisville, KY 40206
502.584.5353
fax 502.584.5332
gallery@flamerun.com
flamerun.com

Floating World Gallery
1925 North Halsted Street
Chicago, IL 60614
312.587.7800
fax 312.575.3565
artwork@floatingworld.com
floatingworld.com

Frederic Got Gallery
64 Rue Saint Louis en L'île
Paris 75004
France
33.14.326.1033
fax 33.14.326.1033
got3@wanadoo.fr
artchic.com

Galerie Besson
15 Royal Arcade
28 Old Bond Street
London W1S 4SP
United Kingdom
44.20.7491.1706
fax 44.20.7495.3203
matthew@galeriebesson.co.uk
galeriebesson.co.uk

Galerie Elena Lee
1460 Sherbrooke West
Suite A
Montreal, Quebec H3G 1K4
Canada
514.844.6009
info@galerieelenalee.com
galerieelenalee.com

**Galerie Suppan
Contemporary Design**
Habsburgergasse 5
Vienna 1010
Austria
43.1.535.535.435
fax 43.1.535.535.435
info@suppancontemporary.com
suppancontemporary.com

Habatat Galleries
4400 Fernlee Avenue
Royal Oak, MI 48073
248.554.0590
fax 248.554.0594
info@habatat.com
habatat.com

Hawk Galleries
153 East Main Street
Columbus, OH 43215
614.225.9595
fax 614.225.9550
tom@hawkgalleries.com
hawkgalleries.com

Heller Gallery
420 West 14th Street
New York, NY 10014
212.414.4014
fax 212.414.2636
info@hellergallery.com
hellergallery.com

Ippodo Gallery
521 West 26st Street, #B1
New York, NY 10001
212.967.4899
fax 212.967.4889
mail@ippodogallery.com
ippodogallery.com

Jane Sauer Gallery
652 Canyon Road
Santa Fe, NM 87501
505.995.8512
fax 505.995.8507
jsauer@jsauergallery.com
jsauergallery.com

Jean Albano Gallery
215 West Superior Street
Chicago, IL 60654
312.440.0770
fax 312.440.3103
jeanalbano@aol.com
jeanalbanogallery.com

John Natsoulas Gallery
521 First Street
Davis, CA 95616
530.756.3938
art@natsoulas.com
natsoulas.com

Ken Saunders Gallery
230 West Superior Street
Chicago, IL 60654
312.573.1400
fax 312.573.0575
gallery@kensaundersgallery.com
kensaundersgallery.com

Kirra Galleries
Federation Square
Cnr Swanston and Flinders
Streets
Melbourne, Victoria 3000
Australia
61.3.9639.6388
fax 61.3.9639.8522
gallery@kirra.com
kirragalleries.com

**The Korea Design &
Craft Foundation**
5F HaeYoung Bldg., 148
Chongro-gu
AnKook-dong
Seoul 110-240
Republic of Korea
82.2.398.7900
fax 82.2.398.7999
yyjung@kcdf.kr
kcdf.kr

L

Lacoste Gallery
25 Main Street
Concord, MA 01742
978.369.0278
info@lacostegallery.com
lacostegallery.com

Litvak Gallery
4 Berkovitz Street
Tel Aviv 64238
Israel
972.3.695.9496
fax 972.3.695.9419
info@litvak.com
litvak.com
sofa.litvak.com

Maria Elena Kravetz Gallery
San Jeronimo 448
Cordoba X5000AGJ
Argentina
54.351.422.1290
mek@mariaelenakravetzgallery.com
mariaelenakravetzgallery.com

Mattson's Fine Art
2579 Cove Circle, N.E.
Atlanta, GA 30319
404.636.0342
fax 404.636.0342
sundew@mindspring.com
mattsonsfineart.com

Maurine Littleton Gallery
1667 Wisconsin Avenue NW
Washington, DC 20007
202.333.9307
fax 202.342.2004
info@littletongallery.com
littletongallery.com

Medellín 174
Medellín 174
Col. Roma
Mexico City 06700
Mexico
52.55.557.40918
fax 52.55.561.67928
medellin174@hotmail.com
medellin174.com

Mostly Glass Gallery
34 Hidden Ledge Road
Englewood, NJ 07631
201.816.1222
fax 201.503.9488
info@mostlyglass.com
mostlyglass.com

**New Glass Art &
Photography**
Linienstrasse 154
Berlin D-10115
Germany
49.302.787.9386
info@nadaism.de
nadaism.de

Next Step Studio & Gallery
530 Hilton Road
Ferndale, MI 48220
248.414.7050
cell 248.342.5074
nextstepstudio@aol.com
nextstepstudio.com

**Niemi Sculpture
Gallery & Garden**
13300 116th Street
Kenosha, WI 53142
262.857.3456
fax 262.857.4567
gallery@bruceniemi.com
bruceniemi.com

Oliver & Espig
1108 State Street
Santa Barbara, CA 93101
805.962.8111
oliverandespig@cox.net
oliverandespig.com

**Option Art /
Galerie Elca London**
Option Art
4216 de Maisonneuve Blvd. W.
Montreal, Quebec H3Z 1K4
Canada
514.932.3987
info@option-art.ca
option-art.ca

Galerie Elca London
224 St. Paul West
Montreal, Quebec H2Y 1Z9
Canada
514.282.1173
info@elcalondon.com
elcalondon.com

Orley Shabahang
241 East 58th Street
New York, NY 10022
212.421.5800
fax 212.421.5888
newyork@orleyshabahang.com
orleyshabahang.com

326 Peruvian Avenue
Palm Beach, FL 33480
561.655.3371
fax 561.655.0037
palmbeach@orleyshabahang.com

223 East Silver Spring Drive
Whitefish Bay, WI 53217
414.332.2486
fax 414.332.9121
whitefishbay@orleyshabahang.com

Ornamentum
506.5 Warren Street
Hudson, NY 12534
518.671.6770
fax 518.822.9819
info@ornamentumgallery.com
ornamentumgallery.com

Perimeter Gallery
210 West Superior Street
Chicago, IL 60654
312.266.9473
fax 312.266.7984
perimeterchicago
 @perimetergallery.com
perimetergallery.com

Pistachios
55 East Grand Avenue
Chicago, IL 60611
312.595.9437
fax 312.595.9439
pistachi@ameritech.net
pistachiosonline.com

Portals Ltd.
744 North Wells Street
Chicago, IL 60654
312.642.1066
fax 312.642.2991
artisnow@aol.com
portalsgallery.com

**PRISM Contemporary /
Patrajdas Contemporary
Art Consulting**
Chicago, IL
312.243.4885
312.226.3444
info@prismcontemporary.com
info@patrajdas.com
prismcontemporary.com
patrajdas.com

SABBIA
75 East Walton
Chicago, IL 60611
312.440.0044
sabbiafinejewelry@hotmail.com
sabbia.com

Schantz Galleries
3 Elm Street
Stockbridge, MA 01262
413.298.3044
jim@schantzgalleries.com
schantzgalleries.com

Scott Jacobson Gallery
114 East 57th Street
New York, NY 10022
212.872.1616
fax 212.872.1617
info@scottjacobsongallery.com
scottjacobsongallery.com

Sherrie Gallerie
694 North High Street
Columbus, OH 43215
614.221.8580
fax 614.221.8550
sherrie@sherriegallerie.com
sherriegallerie.com

Sienna Gallery
80 Main Street
Lenox, MA 01240
413.637.8386
info@siennagallery.com
siennagallery.com

Snyderman-Works Galleries
303 Cherry Street
Philadelphia, PA 19106
215.238.9576
fax 215.238.9351
kat@snyderman-works.com
snyderman-works.com

TAI Gallery
1601 B Paseo de Peralta
Santa Fe, NM 87501
505.984.1387
gallery@textilearts.com
taigallery.com

ten472 Contemporary Art
By Appointment
Grass Valley, CA
707.484.2685
fax 707.484.2685
info@ten472.com
ten472.com

Thomas R. Riley Galleries
28699 Chagrin Boulevard
Cleveland, OH 44122
216.765.1711
fax 216.765.1311
trr@rileygalleries.com
rileygalleries.com

Turkish Cultural Foundation
Locations in Boston, Detroit,
Sonoma, Washington DC &
Istanbul, Turkey
202.370.1399
fax 202.370.1398
director@turkishculture.org
turkishculturalfoundation.org

UrbanGlass
647 Fulton Street
Third Floor
Brooklyn, NY 11217
718.625.3685
fax 718.625.3889
info@urbanglass.org
urbanglass.org

Wexler Gallery
201 North 3rd Street
Philadelphia, PA 19106
215.923.7030
fax 215.923.7031
info@wexlergallery.com
wexlergallery.com

William Zimmer Gallery
PO Box 263
Mendocino, CA 95460
707.937.5121
wzg@mcn.org
williamzimmergallery.com

Yvel
1 Yechiel Shteinberg Street
Ramat Motza
Jerusalem 91101
Israel
972.2.673.5811
fax 972.2.673.5812
yvel@yvel.com
yvel.com

Zane Bennett Galleries
435 South Guadalupe Street
Santa Fe, NM 87501
505.982.8111
fax 505.982.8160
zanebennett@aol.com
zanebennettgallery.com